10	OOK FOR!
L	*
_	Books
1	Booklets CDs
1	Charts =
_	DVDs &
-	Inserts \(\frac{2}{3} \)
_	Maps
_	Music parts
-	par es

cheat IN PHOTOSHOP Elements 8

Discover the magic of Adobe's best kept secret

David Asch and Steve Caplin

AMSTERDAM • BOSTON • HEIDELBERG • LONDON • NEW YORK • OXFORI

PARIS • SAN DIEGO • SAN FRANCISCO • SINGAPORE • SYDNEY • TOKYO

Focal Press is an imprint of Fleavier

GLENVIEW PUBLIC LIBRARY 1930 Glenview Road Glenview, IL 60025 First edition 2010

Copyright © 2010 David Asch & Steve Caplin. Published by Elsevier Ltd. All rights reserved.

The rights of David Asch & Steve Caplin to be identified as the authors of this work has been asserted in accordance with the Copyright, Designs and Patents Act 1988

No part of this publication may be reproduced or transmitted in any form or by any means, electronic or mechanical, including photocopying, recording, or any information storage and retrieval system, without permission in writing from the publisher. Details on how to seek permission, further information about the Publisher's permissions policies and our arrangement with organizations such as the Copyright Clearance Center and the Copyright Licensing Agency, can be found at our website: www.elsevier.com/permissions

This book and the individual contributions contained in it are protected under copyright by the Publisher (other than as may be noted herein).

Notices

Knowledge and best practice in this field are constantly changing. As new research and experience broaden our understanding, changes in research methods, professional practices, or medical treatment may become necessary.

Practitioners and researchers must always rely on their own experience and knowledge in evaluating and using any information, methods, compounds, or experiments described herein. In using such information or methods they should be mindful of their own safety and the safety of others, including parties for whom they have a professional responsibility.

To the fullest extent of the law, neither the Publisher nor the authors, contributors, or editors, assume any liability for any injury and/or damage to persons or property as a matter of products liability, negligence or otherwise, or from any use or operation of any methods, products, instructions, or ideas contained in the material herein.

British Library Cataloguing in Publication Data A catalogue record for this book is available from the British Library

Library of Congress Control Number: 2009940044

ISBN: 978-0-240-52187-9

For information on all Focal Press publications visit our website at www.focalpress.com

Book design and cover by Steve Caplin

Printed and bound in Canada

09 10 11 12 11 10 9 8 7 6 5 4 3 2 1

Working together to grow libraries in developing countries

www.elsevier.com | www.bookaid.org | www.sabre.org

ELSEVIER B

BOOK AID

Sabre Foundation

Contents

	Acknowledgments viii How to use this book 1 Getting up to speed 2	3
1	Selection techniques4Marquee selections6More selection tools8The Magnetic Lasso tool10Quick selection + refine edge12Magic selection14Magic extraction16Working with selections18Interlude: Setting up Elements20	
2	Montage essentials: layers22	
	Three card tricks. 24 Divide and multiply 26 Importing layers 28 Think smart! 30 Staying in shape 32 Adding a little style 34 Protect your work 36 The power of adjustment 38 Exploring blend modes 40 Banqueting arrangements 42	4

	Cut-up collage	44
	Interlude: Keep up, no slacking	46
3	Hiding and showing	48
	Cheating with layer masks 1	50
	Cheating with layer masks 2	52
	Smudge masking	54
	On golden pond	56
	Part of the scene	58
	Polaroid-style photos	60
	Spectacular fireworks	62
	Fairy gets her wings	64
	Extending the scene	66
	Reusable images	68
	Panorama power	70
	Interlude: Digital cameras	72
1	Image adjustments	74
	Adjusting images with Levels	76
	Shadows and highlights	78
	Bee flat to bee sharp	80
	RAW adjustment	82
	Photomerge: exposure	84
	All that glitters	86
	The perfect respray	88
	Shifting seasons	90

Contents

	A splash of color 92		Tricky selections
	Smart bling		Locket and load
	Changing skies 96		Wrapping around surfaces150
	Making rainbows 98		Making curls and folds 152
	Catching the drops 100		The ripple effect154
	0-60 in ten minutes		A flag for all nations 156
	Real world modeling 104		Not-so-extreme close-up 158
	Sunset silhouette106		Smoke without fire160
	That's snow business 108		Troublesome perspective 162
	Interlude: But is it art? 110		It's a kind of magic 164
			Keep your composure166
5	Light and shade 112		Interlude: Drawing comparisons 168
	Shadows on ground and wall 114	mmingg	Materials and textures 170
	Painting soft shadows 116		Widefield and textures 170
	Turning day into night118	AM .	Curtains with a difference172
	Making fire		Quick and easy wood grain174
	Instant candlelight122		Pattern forming176
	Stage lighting124		Lying on a bed of satin 178
	Divine light126		Making notepaper 180
	Shading using Hard Light 128		The art of paper tearing182
	Deceiving the eye130		Creating old paper184
	Flashlight illumination132		Ageing a photo in minutes 186
	Cooking up a storm		A quick repair job188
6	Interlude: Can I get a job doing this?. 136		Letting the dust settle190
		You spin me round192	
	Transformation	A little light relief 194	
	and distortion138		Stamp duty196
	The science of transformation 140 Distorted field of vision		Finger-friendly stained glass198
			Blueprint for design200
	Simple perspective distortion 144		Unfinished illustration202

	Interlude: Finding images for free 204	10	Shiny surfaces 258
8	Working with text 206	10	Upon reflection
	Carving in stone		Complex reflections
	Neon signs with layer styles 210		Window reflections 264
	Instant chrome		From railway to waterway 266
	No mess pumpkin carving 214		Goo, slime and molasses 268
	Write on the button		Preserving the occasion 270
	Three-dimensional text 218		Interlude: Keeping it real 272
	Writing in the sand 220	44	The third dimension 274
	Chop and change 222		THE UNITE UNITED STORY
	Elements of design		Lifting the lid 276
	Interlude: Image size		Lifting the lid 2 278
			Tiling the floor 280
9	People and animals 228		Opening doors
	Heads on bodies		Using perspective
	Photomerge: faces 232		Make your own jigsaws
	Cosmetic surgery: healing 234		Out of bounds
	Cosmetic surgery: weight loss 236		Interlude: RGB or CMYK? 290
	Age and youth	12	Print and the internet 292
	Cleaning up the scene 242		Saving files for the internet 294
	Eyes wide shut 244		Presenting your work
	Warhol-style pop-art246		Animated GIFs
	Hollywood glamor 248		Easy print matching 300
	Bobblehead caricature 250		
	All in the mind 252		Glossary
	Dog in a basket		What's on the CD
	Interlude: Tiffs, JPEGs and the rest 256		Index

How to cheat, and why

The truth about cheating

We've used the word 'cheating' in the title of this book in two ways. The most obvious is that we're describing how to make images look like photographs, when they're not. In this sense, it simply means creating photographic work without the need for a studio.

The other sense of 'cheating' is finding shortcuts to help you work more quickly and more economically. Wherever possible, we've used the quickest solutions we can find to achieve the results.

Each workthrough in this book is designed as a double page spread. That way, you can prop the book up behind your keyboard while going through the associated file on the CD.

At the end of each chapter you'll find an Interlude, in which we discuss an issue of relevance to the Elements artist. Some cover essential information about file sizes and types, color mode, and so on; others take a broader view. Think of them as light relief, and read them to save eye strain from staring at the screen for too long.

Who is the book for?

As the 'baby brother' to the full Photoshop CS5, Photoshop Elements has long suffered the stigma of being a cheap, unprofessional product. Cheap it may be, but it contains 90% of the features found in the full Photoshop and, as we've seen from user-created artwork, it's anything but unprofessional.

It's true that Elements is rarely used in a graphics studio or publishing company. But this is mainly because it doesn't include the high-end prepress features found in Photoshop; using Elements doesn't mean that you're working with a substandard application.

Some Elements users simply want to enhance their digital captures, perhaps adding a caption or two. But there are also those who want to take their work further: to explore the field of photomontage, and to make reality from the dreams locked in their heads. It's for these users that *How to Cheat in Photoshop Elements 8* will be of most benefit, helping them to release that potential and get their ideas out of their heads and onto the screen.

As a montage application, Elements is only as limited as your imagination. It can realize any montage you can conceive, as long as you have

the technical skill required. We aim to provide you with that skill set, enabling you to unleash your creativity. Whether you're montaging missing family members into a group portrait, or creating a complex work of art, Elements can help you achieve your goal.

What's on the CD?

We've included all the photographic images from the workthroughs in this book on the CD, so that after reading about them you can open up the original files and experiment with them for yourself. There are also a number of QuickTime movies showing specific techniques in action: sometimes it's better to see how to achieve an effect than merely to be told about it.

The CD also includes a set of layer styles and custom shapes that we've created in Photoshop. Although you can't create these effects in Elements, you can import them and apply them to your own artwork – and modify them to quite a large degree.

Going further

Visit the book's website at www.howtocheatinphotoshopelements.com and you'll find the user forum. This is where you can post questions or problems, and exchange ideas with other readers; we'll also do our best to solve any Elements-related issues that may be troubling you. If you get stuck, either on a tutorial in the book or elsewhere in Elements, this is your first place to look for a solution.

Steve Caplin and David Asch London and Brighton, 2009

Acknowledgments

This book is dedicated to Jules and Carol, for putting up with us while we wrote it.

We're grateful to the following:

David Albon of Focal Press

Keith Martin, for helping to create the keyboard shortcuts font

Adobe Systems Inc., for making Photoshop Elements

Many of the images in this book are from royalty-free photo libraries. Most of them are from the best subscription sites we know of: photos.com and absolutvision.com. With a huge range of royalty-free photographs available for download, they're always our first stops when we're looking for the perfect image. Many thanks to them for allowing us to include low resolution versions of many of their excellent pictures in the tutorials in this book.

How to use this book

We doubt that any readers of this book are going to start at the beginning and work their way diligently through to the end. In fact, you're probably only reading this section because your computer's just crashed and you can't follow any more of the workthroughs until it's booted up again. This is the kind of book you should be able to just dip into and extract the information you need.

But we'd like to make a couple of recommendations. The first four chapters deal with the basics of photomontage: making selections, working with layers, and adjusting your images. There are many Elements users who have never learnt how to make layer masks, or picked up the essential keyboard shortcuts. Because we talk about these techniques throughout the book, we need to bring everyone up to speed before we get to the harder stuff.

Although the book is designed for users of Elements 8, most of the tutorials will apply to those who have earlier versions of the program as well. We've indicated on each page where Elements 8 is specifically required to perform the task in hand.

The techniques in each chapter build up as you progress through the workthroughs. Frequently, we'll use a technique that's been discussed in more detail earlier in the same chapter, so it may be worth going through the pages in each chapter in order, even if you don't read every chapter in the book.

The CD icon on each tutorial page indicates that the source file for that tutorial is on the CD, so you can open it up and try it out for yourself. The Movie icon indicates that there's an associated QuickTime movie on the CD.

If you get stuck anywhere in the book, or in Elements generally, visit the Reader Forum, accessed through the main website or directly via this address:

www.howtocheatinphotoshopelements.com/htcbb

This is where you can post queries and suggestions. We visit the forum every day, and will always respond directly to questions from readers. But expect other forum members to weigh in with their opinions as well!

Getting up to speed

Getting up to speed

EGARDLESS OF YOUR SKILL LEVEL, it's always useful to have a refresher on the basics. We've used these two pages to not only document some of Elements' standard features but also to illustrate how they are used and referred to throughout the book.

The Layers panel

We use the Layers panel all the time when we're editing images in Elements. It displays all sorts of information about how layers interact with each other. It's worth taking the time to get to know how it works, and how to use the icons and settings to make our layers behave as we want them to.

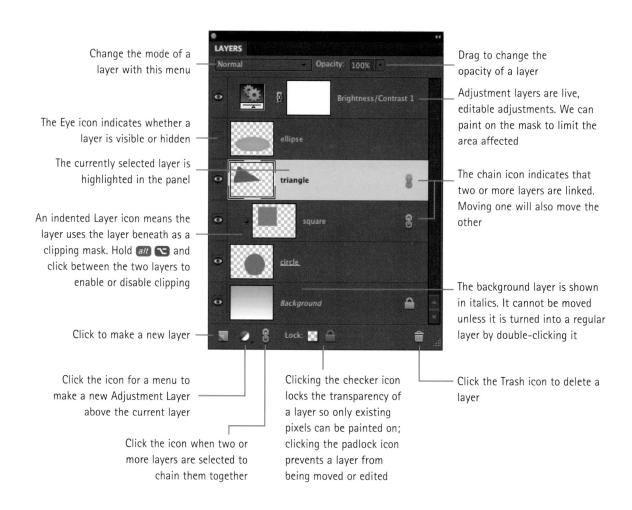

The Toolbox

The Toolbox is the most important part of the Elements editor. Tools can be selected by either clicking their icons or pressing their corresponding keyboard shortcuts.

Many of the tools have two or more options – denoted by a small black triangle next to their icons. These can be selected by clicking and holding the mouse to display the sub-menu or by pressing the shortcut key repeatedly to cycle through them.

The various settings for each tool appear in the Options bar. This is found at the top of the Elements window under the menus.

Here is a list of the tools along with their shortcuts. These are mainly the same for both the Windows and Mac versions – differences are shown in color.

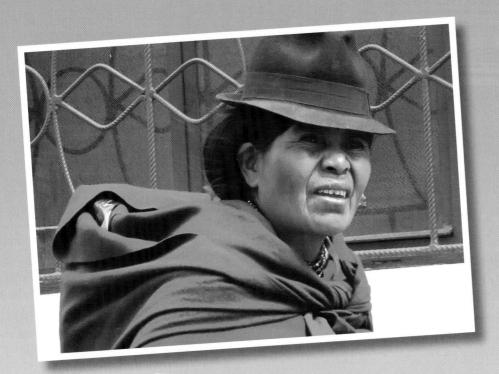

The photograph of a woman in Ecuador, above, shows a strong face, brightly colored clothes and a neatly incongruous hat. But that background is just confusing; how much better it is when we change it for the view across the street. Removing the woman from her background is easier than you might think!

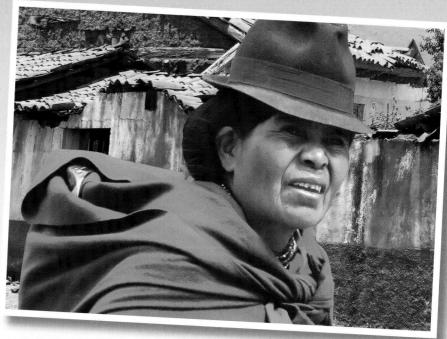

Selection techniques

WORKING IN PHOTOSHOP ELEMENTS almost always involves making selections. Whether you're combining images from several sources into a single montage, or simply replacing an overcast sky with a bright sunny one, you need to make selections within your image.

Elements offers a range of tools for the purpose. Some are automatic, and will find areas of similar color; some involve tracing around an object's edge; some combine the two methods, making complex selections easy to do.

Whether you're new to Elements or an old hand, it's worth your while going through this chapter to make sure you're up to speed on the selection methods that are available to you.

Marquee selections

HE MARQUEE TOOL is the basic tool for making selections in Elements. Pressing is the keyboard shortcut for this tool; pressing the key again will toggle between the standard Rectangular Marquee and the Elliptical Marquee.

Every Elements user should be aware of the ability to hold the smile key to draw a square or a circle, rather than a rectangle and an ellipse, and to hold smile to draw a selection from the center out.

We're not limited to just one selection at a time, however; by holding combinations of the all and shiff keys, we're able to add and subtract additional selections – and we can even create intersections of the old and the new.

1 By default the Marquee tool draws selections from corner to corner. Hold the tool as you drag, and when you release you'll have a rectangular selection, with the start and end points of the drag at opposite corners.

If you hold an after you start to drag with the tool, it will draw a selection from the center out. This can be useful when you want, for instance, a circular selection centered on a point in the image.

5 As well as adding to our existing selection, we can also subtract from it. This time, rather than the Snin key, hold down all ≥ before starting to draw the new selection. This time, the thin vertical selection (above

left) is drawn on top of the existing selection. Note how now the crosshair cursor has a – sign next to it to show subtraction. Once this selection is removed from the original, we're left with the selection shown above right.

How to Cheat in Photoshop Elements 8

Holding (Shift) after you start to drag will turn a rectangle into a perfect square, and an ellipse into a perfect circle. This is essential for

starting to draw square floor tiles, or

even moons and suns.

4 Different things happen if you hold keys down before you begin to draw a selection. Here, the square is our initial selection; if we hold still before we make a new selection, the effect is to add the new selection

to the old one. Note how the cursor crosshair now displays a tiny + sign next to it to indicate an additional selection. The result of making the two selections, above left, is shown on the right.

The order in which you press the keys and the mouse button makes a difference to the result. Holding the keys shown here before pressing the mouse button will affect how the selections interact; pressing them afterwards will make a square or a circle, or draw from the center out.

One additional tip is to hold the Spacebar as you're drawing a selection. This will allow you to move the selection around while you're still drawing it; release the Spacebar (but not the mouse button) to continue.

two selections overlap. The cursor now shows a tiny x with the crosshair. The result of making an intersection of the original selection, above left, is shown in the selection above right.

All these key combinations work for elliptical as well as rectangular selections, and can be used in combination. To make this ring selection, above, we first painted a tiny dot to mark the center. An elliptical selection was made, holding all to draw from the center out, and then adding shill to make the ellipse into a circle. Next, we held all before drawing to subtract from the selection, then released this key and held all shill solve shill to draw another circle from the center out.

The final key combination is a mixture of the two previous ones. If you hold all Shift Shift before making a new selection, the result will be the intersection of the new with the old: in other words, the area where the

SHORTCUTS
MAC WIN BOTH

Selection techniques

More selection tools

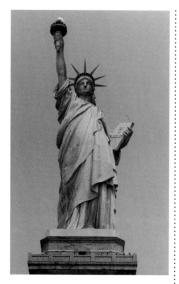

E LOOKED AT the Marquee tools on the previous pages – but what if you want to make a selection that isn't rectangular or round? There are several other tools we can use for this purpose.

Here, we'll look at the Lasso, Magic Wand, and Selection Brush tools. While the Magic Wand selects a range of colors, the other two select only those regions you trace. They're three quite different tools, but they each have their uses, as we'll see here.

We're going to use all these tools to remove the sky from this photograph of the Statue of Liberty, beginning with the Magic Wand to select the bulk of the sky.

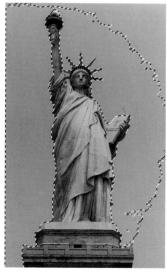

To select all the sky in this image, first use the Magic Wand tool (W). You can change the tolerance to select a smaller or wider range of colors: a setting of 32 works well. Click once to the left of Liberty's body, and you'll see a selection something like this.

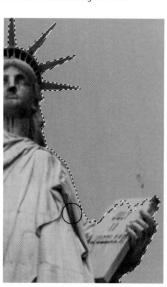

There's a problem with 'leakage' on the other shoulder as well, and we can use the Selection Brush to fix that. The book, however, has straight edges to it; even if we made the Selection Brush really tiny, we'd find it hard to trace those straight lines.

The top-right and bottom-right corners weren't included in the selection, as the color there is just outside the range. To add to the selection, hold **Shift** and click with the Magic Wand in the top-right corner. These colors are now added.

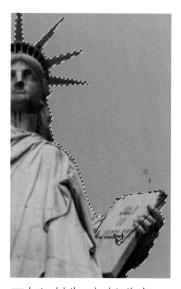

Instead, let's go back to the Lasso tool: this time, we'll use the Polygonal Lasso instead. Holding all before we drag once more, click from inside the body onto each corner of the book to add it with a straight line selection.

ow to Cheat in Photoshop Elements 8

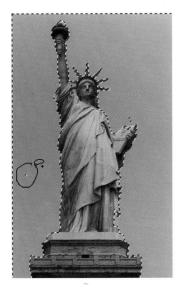

We can see a few stray pixels - most probably dirt on the lens above the book and to the left. Rather than use the Magic Wand, switch to the Lasso tool (L). Hold Shift once more and draw a loop around the stray dots to add them to the selection.

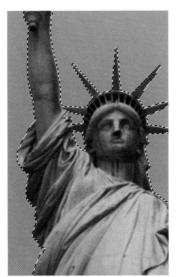

We can add the sky between the crown and the shoulder with the Magic Wand, holding Shift as before. Now that we're zoomed in, we can see a problem: part of the pale green statue has inadvertently been selected along with the sky.

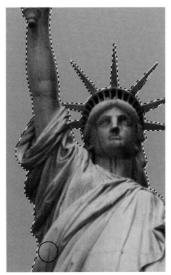

The best tool to use here is the Selection Brush (A). Since we want to subtract from the sky selection, hold all as you drag over the area: everywhere within the radius of the tool will be removed from the selection.

HOT TIP You can make

the radius of the Selection Brush bigger and smaller without opening a panel or dialog: use the square bracket keys (1) and 1 to make the radius smaller and larger in

stages.

In step 7 here, we use the Polygonal Lasso tool, which you can choose from the toolbar when you pick the regular Lasso. As a shortcut, though, you can make the regular Lasso work like the Polygonal Lasso (tracing straight lines between click points) by holding alt as you use it.

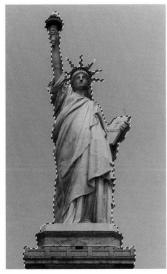

Once we've done a little further Unce we ve using a manage tidying up, our statue is selected. Except, of course, that it's the sky that we've selected rather than Liberty herself. We need to inverse that selection, by pressing ctrl Shift

器 Shift 1.

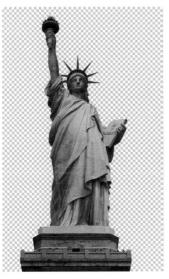

With Liberty now properly selected, we can make a new layer from her by pressing ctrl J # J. When we hide the original layer by clicking on the Eye icon in the Layers panel, we see Liberty cut out against a checkerboard background.

Once the original background has gone, we can replace it with anything we choose - such as this more appealing sky, for example. See the following chapter for more about working with layers.

The Magnetic Lasso tool

LTHOUGH THE LASSO TOOL is useful for tracing outlines, it can be tricky to draw accurately with it. There is another method: the Magnetic Lasso is a variant. As its name implies, this tool sticks to the edges of shapes as you draw around them, making the process of cutting objects or people from their backgrounds very much simpler.

The tool isn't perfect, by any means; it's almost impossible for any computer program to figure out the difference between foreground and background objects with any degree of accuracy. But it's a real time saver, and can be used to make quick selections with ease.

To choose the tool, click on its icon in the Options bar when the Lasso tool is selected, or simply select it from the pop-up Lasso icon in the toolbar.

Start in one corner of the statue and trace along the edge of the object, sticking as close as you can to it. We've zoomed in here and enhanced the Magnetic Lasso edge to show it more clearly. The tool places square 'anchor points' each time it marks a change in direction.

We'll hit a few more of these snags as we work our way around the figure; they occur each time Elements finds a strong line to follow. Once again, it's not a problem; simply delete the misplaced points, and then click the mouse button to add your own.

2 Right away, we hit a problem: when we get to the shoulder, the Magnetic Lasso wants to follow the gold bar, rather than the paler white cloth. No need to start again; simply press **Backspace** to remove the last placed points, backtracking along the traced line.

To make it easier to trace the outline, press the Caps Lock key on your keyboard. This will change the Magnetic Lasso icon to a circle, which shows the perimeter of the area in which it searches for boundaries.

We can now force the tool to go in the direction we want. Drag a little way up the perimeter and, before Elements places another point, get in first by clicking the mouse button to place one of your own. Continue doing this until the tool recognizes the direction in which you're going.

When you get to the end of the object – in this case, the bottom-right corner – it can be tricky to trace back along the bottom to the start, as the tool will think you're still looking for edges. Rather than get this wiggly line, press Enter to turn the path you've drawn into a selection.

HOT TIP

In step 5, we change the icon from a standard Magnetic Lasso to a circle showing the radius. You can make this larger and smaller using the Width setting on the Options bar; make it bigger for straightforward images, smaller for lots of fiddly edges.

The Edge Contrast and Frequency settings determine how much variation the tool looks for, and how often points are added to the path. In practice, you'll rarely need to change these from their default values.

SHORTCUTS

MAC WIN BOTH

1

Quick selection + refine edge

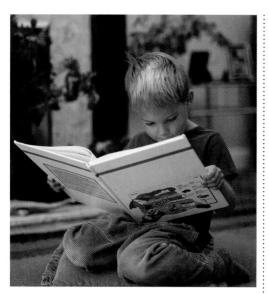

N ELEMENTS 6, the Magic Selection Brush (pages 14-15) was replaced by the more powerful Quick Selection tool, which may well be the fastest method yet for cutting a person or object away from a background.

We've seen several selection methods already in this chapter, but they all involve a fair amount of work on the part of the user. The Quick Selection tool can help the process of lifting a complex subject from a complex background, quickly and painlessly.

The companion to this tool is the Refine Edge dialog, which processes the image after a selection has been made. Here, we can adjust the selection for an even better fit.

The image we'll work with here is of a boy reading in his living room. It's a tricky selection to make: both he and his surroundings include a range of colors and tones, making it harder for automatic selection to take place. But even in cases like this, we can perform the function with ease.

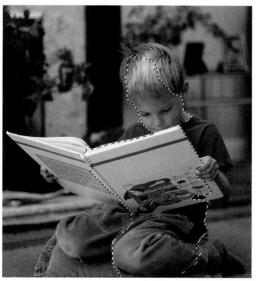

Begin by switching to the Quick Selection tool **A**. Drag a single stroke from the center of the boy's head, across the book and down to his knee. We can see how the selection process guesses our intent: it's selected his face and most of the cover of his book, but stopped short at the pillow he's kneeling on.

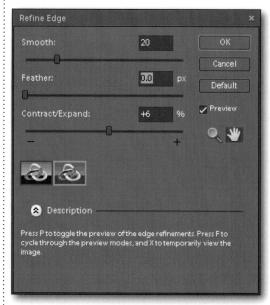

4 With our initial selection made, we can fine tune it by pressing the Refine Edge button on the Options bar above the image. This brings up the Refine Edge dialog: here we can smooth the selection, feather it (add soft edges), and contract or expand it. This latter control is useful in cases where some background has inadvertently crept in.

How to Cheat in Photoshop Elements 8

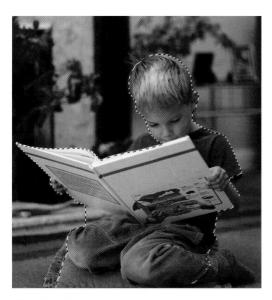

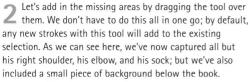

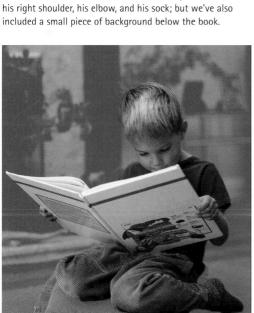

5 While we're working with the Refine Edge dialog open, we can choose to view our image either with standard 'marching ants' selection borders or with a red overlay. The second method gives us a much better idea of how our image will look as a cutout. We can now see precisely what's included, and what isn't.

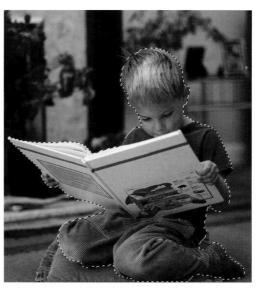

Reduce the size of the brush, and drag over the missing parts to include them in the selection. We can now remove the unwanted portions as well, by holding all saw drag over them: as with all selections, holding this key removes the new selection from the original. With a little work, we can create a perfect selection.

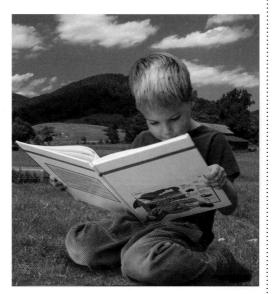

Once the selection is complete, we can either delete the background or make a new layer from the selection. Adding a little smoothing can give unnaturally soft edges when seen against a plain white background, but by the time we've added a new background – such as this pastoral scene – the montage works well.

HOT TIP

The Refine Edge dialog works with all selections, not iust those made with the Quick Selection tool. Use it with the Magic Wand to eliminate rough edges, or with the Lasso to remove hard lines. It's a superior selection technology that becomes useful for just about every type of selection you're likely to make.

Magic selection

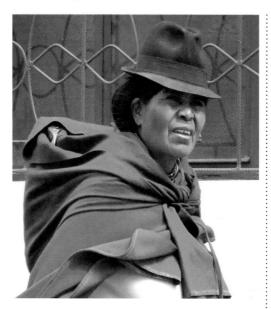

F YOU'VE NOT YET MADE THE LEAP to the latest version of Elements, you won't have the Quick Selection tool. All is not lost, however: in earlier editions we still have a very powerful selection tool at our disposal.

On the previous pages, we looked briefly at the Selection Brush. This has a special variant, called the Magic Selection Brush, which appears on the Options bar when you choose the Selection Brush.

Like the Magic Wand, this tool selects areas of a similar color; the difference is that you begin by dragging the brush over a whole range of colors, and Elements does its best to figure out what you want to keep and what you don't want included in the selection.

This is seriously clever stuff. It doesn't always get it exactly right first time, of course, but it's flexible enough for you to make complicated selections in a very short time.

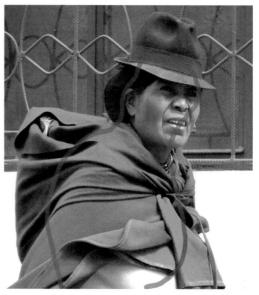

Begin by drawing a wiggly line with the Magic Selection Brush over the person or object you want to cut out. The brush stroke will be shown as a red line. You don't have to be accurate here, but make sure you touch every different color within the object you want to select.

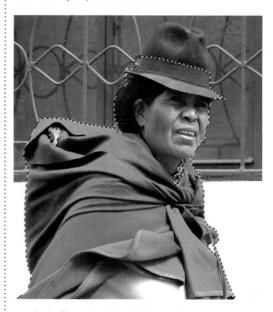

4 Again, Elements will make its selection once you release the mouse button. Now, we can see a huge difference: the person is largely correctly selected. There are a few holes (beneath her chin, the white area within the folds of material and her back) and her hat isn't properly selected, but we can fix that easily.

How to Cheat in Photoshop Elements 8

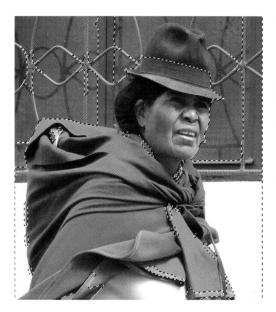

As soon as you release the mouse button, Elements will go to work and start turning that brush stroke into a selection. As we can see, a lot of the background has been included here – most of the wall and large areas of the window. We can fix that next.

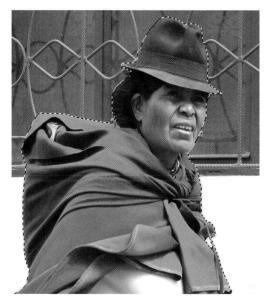

5 We can add the missing regions by painting with the Magic Selection Brush again if we wish. But since her hat's the same color as the window glass, it's always going to be tricky to select one and not the other. It is far easier, in these circumstances, to switch to the regular Selection Brush and add them manually.

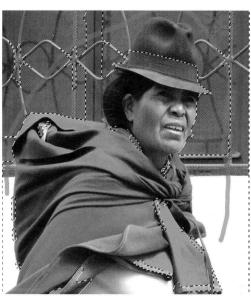

Hold all before drawing with the brush again, and this will tell Elements which areas you don't want included in the selection. Now, draw a line over the background, being sure to paint over all the colors that aren't part of the person we want to cut out.

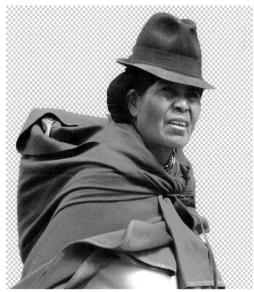

It takes a small amount of experience to know when to persevere with the Magic Selection Brush and when to just paint in the new selection with the regular Selection Brush. Paint to add to the selection; hold (a)) to subtract areas from it. We can control the size of the brush with the left and right square bracket keys (1).

HOT TIP

The Magic **Selection Brush** is a powerful tool, but despite its name - it won't really work magic. Rather than spending ages trying to get it to do all the work, recognize when it's met its match and use a different selection method in conjunction with it. If you're working with a particularly complex foreground or background image, then the Magic Selection Brush may not be able to cope. In this case, try the Magic Extractor instead - see the following pages to find out more about this tool.

Magic extraction

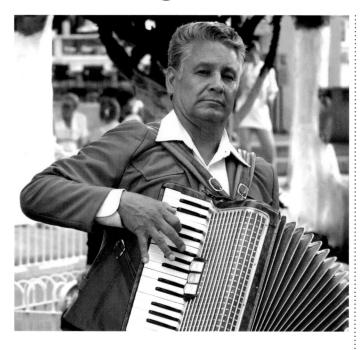

OME TYPES OF IMAGE are just too complex to cut out with the Magic Selection tool or the Magic Wand; photographs such as this one of an accordionist, with his complex instrument photographed against a busy background, would be tricky to trace with the Lasso or Selection Brush.

The Magic Extractor, however, offers a relatively quick and painless solution to this problem. It works within its own dialog, using a range of tools that combine to make difficult object selection far easier.

The precise order in which you use the tools depends on the image you want to cut out, but you always start with the Foreground and Background Brushes, before moving on to fine tuning. Begin by choosing Magic Extractor from the Image menu.

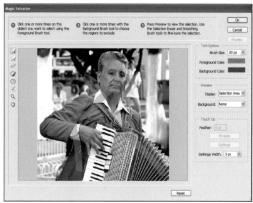

Use the Foreground Brush **(B)** to drag within the area you want to keep. Make sure the brush touches areas like the hair, which could be mistaken for background.

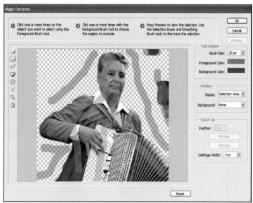

4 Use the Foreground Brush once more to drag a line over the keyboard, and the Background Brush to drag over those extra background elements.

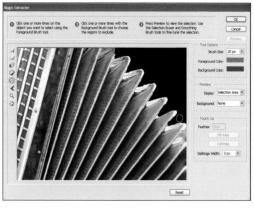

The Add To Selection tool (A) is used to paint missing parts back in. Use a very small brush for fiddly areas, such as the edge of the accordion's bellows.

2 Switch to the Background Brush P and drag in areas you want removed. This brush paints a blue stroke, in contrast with the red of the Foreground Brush.

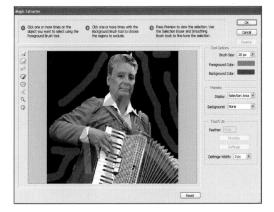

5 When we press Preview again, we can see a much better result. This is also a good time to change the preview background from None to Black, so we can see it clearly.

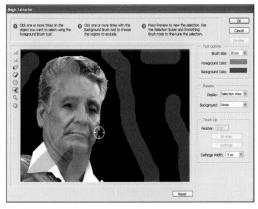

The extraction process does leave some ragged edges. Use the Smoothing Brush **J** to soften out the jaggies around the cutout; hit OK when you're done.

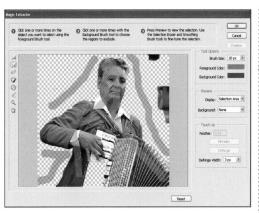

Now hit the Preview button to see how the extraction looks so far. There are some problems – pieces of stray background and the keyboard is missing – which we can fix.

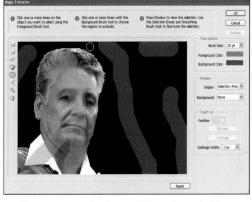

One or two stray background elements remain. We can remove these with the Remove From Selection tool **(D)**, which works like an eraser.

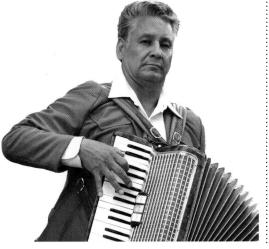

HOT TIP

You can view the entire photo at any point by choosing **Original Photo** from the Display pop-up. The Touch Up section of the dialog includes useful tools: Feather will soften the edge of the whole image; Fill Holes will make sure there are no stray pieces missing by accident; and Defringe will smudge the colors at the edges of the selection to make the cutout's edges crisper.

Selection techniques

Working with selections

We'll work mainly with circular selections here, for clarity – although any selection will work. To fill a selection with the current foreground color, press all sackspace; to fill it with the current background color, press are Backspace.

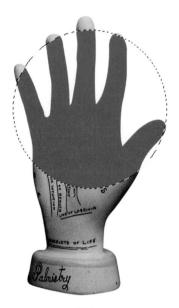

If you hold with either of these keys, it will fill with color but preserve the transparency of the current layer – as we can see here with this palmistry hand, which is on a layer of its own.

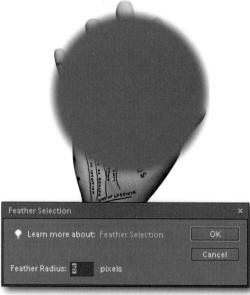

Once a selection has been made, we can press etall D # all D to open the Feather dialog. Feathering softens the edges of the selection: the higher the radius, the softer the edge will be. After feathering the selection, we've here filled it with our foreground color.

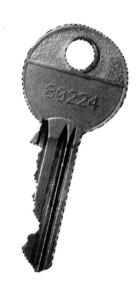

We can 'load up' the area taken up by a layer by holding ## ## and clicking on the layer's thumbnail in the Layers panel. We'll use this process many times in this book.

O FAR IN THIS CHAPTER

we've looked at how

variety of methods. Here, we'll

look at what we can do with those selections once we have

Selections can be filled in a variety of ways, both using dialogs and by pressing different key combinations. Selections can also be

modified to make them softedged, and to make them

larger and smaller.

created them.

to make selections using a

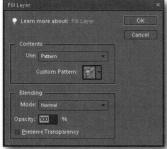

Pressing Shift and Backspace together will open the Fill dialog. There are several options: here, we're filling the circle with a pattern, as chosen from the Use pop-up menu. Press OK to complete the fill process.

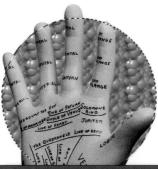

One of the more useful blending modes, as shown at the bottom of the dialog, is Behind. This fills the selected area behind the pixels already present on the current layer; the hand here remains fully visible.

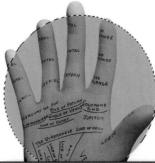

We can also vary the opacity or 5 We can also vary the opace, the strength of the fill. Here, we're filling with the current foreground color, but we're choosing to fill with an opacity of just 50% so we can still see the hand through the filled circle.

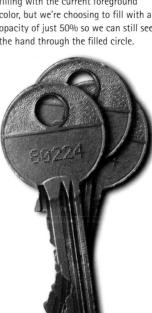

When we now duplicate the key layer a couple of times and move and rotate it, the shadow travels with it, so each shadow is seen on the key below.

HOT TIP

We can also expand and contract a selection by a set number of pixels, using Select > Modify > Expand or Contract. We're also able to smooth a selection here (useful for selections made with the Magic Wand, for example) and we can turn it into a border of the thickness we choose.

Note: The shortcut for invoking the Feather dialog on the Mac is also the system shortcut for toggling auto-hide for the dock. This would need to be changed in the system preferences before it could be used, as Elements shortcuts cannot be altered.

We can move the selection itself by dragging it (the cursor must be inside the selection) or nudging it with the cursor keys. Make sure a selection tool is active and not the Move tool.

Here, we've feathered the selection (see step 6) and used Fill Behind (see step 4) to make a black shadow behind the key. The shadow is on the same layer as the key.

Setting up Elements

WHEN YOU BUY MOST APPLICATIONS, you can just install them and run them straight out of the box. (Or out of the zip archive in which you downloaded them, if you prefer.) And so, to some extent, you can with Elements; but there are a few tricks you can do to make the experience more comfortable.

It isn't that Elements is a particularly awkward program, but that, since it involves working with images, it's memory hungry. It will happily gobble up all the RAM (memory) you allocate to it, and then sit panting for more. If it can't find any more real memory, it will settle for virtual memory, using vast chunks of your hard disk to store temporary files while you're working. These 'scratch' files, as they're called, are slotted in around the other files on your hard disk and are then deleted when you quit Elements. The more fragmented your hard disk, the more pieces these files will end up in, and the slower Elements will run. In the Interlude following Chapter 2, we'll look at the best way of coping with scratch files.

The Elements interface can be customized in a number of ways. Normally, you probably wouldn't bother to mess around with the interface of your applications – after all, the people who designed the program probably know it better than you do, so why not just trust their judgment and leave things as they are? Well, believe it or not, the people who designed Elements don't seem to spend that much time actually working in it. If they did, they wouldn't have the Project Bin turned on by default. Sure, it gives you access to all your currently open files, but it uses up an inch or more of valuable real estate. And that's an inch you could be using to view your pictures that much larger. Turn it off: you don't need to have it permanently on view. You can always pop it open when you need it.

The Palette Bin, down the right-hand side of the screen, contains your most frequently used panels. Store your favorites here, but collapse them to just their title bars when you're not using them: they take up a lot of space, and you want to give the maximum amount of space to the Layers panel. When you have a document with a lot of layers in it, consider reducing the size of the thumbnails (using the pop-up menu at the top of the panel) to fit more in.

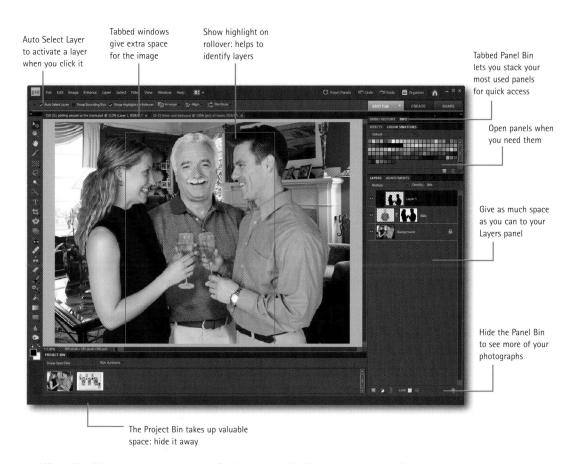

When the Move tool is active, the Options bar will display a number of choices. Checking Auto Select Layer will mean that a layer is activated when you click on it, but this can happen by accident; when this is unchecked, you need to hold the [18] key when clicking on a layer to select it. You can also check the Show Highlight on Rollover box, which will pop up a blue rectangle surrounding each layer as you roll over it. This can help to identify layers, but can quickly become irritating. If you don't find the feature useful, turn it off. Similarly, the Show Bounding Box option will place handles around each selected layer. Again, this prevents you from seeing the image clearly; don't use it unless you find it helpful.

Last but by no means least: Adobe listened when you, the collective users, complained about the new interface being too dark. There is a new addition to the General Preferences panel that gives you the ability to alter the brightness of both the Editor and Organizer interfaces!

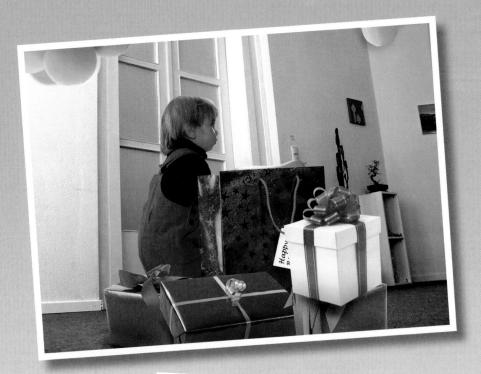

This little chap seems overwhelmed by all the gifts. If they had all been placed directly onto the photo, it would be stuck like that. Using layers in our image means we can freely move them around. Now we can clearly see that, like most children, he's not really interested in the gifts at all; he's perfectly happy playing with one of his balloons.

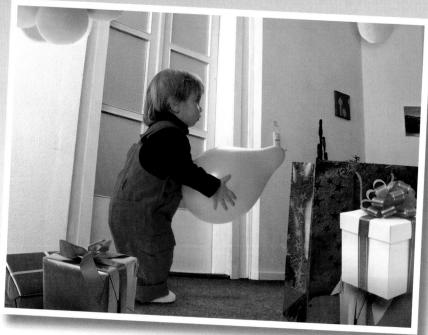

Montage essentials: layers

WHEN CREATING A MONTAGE, layers are probably the most important part of the process – aside from the design itself, of course. Without them, creating complex composite images would be a slow and difficult process. Think of layers as individual celluloid sheets: each one can be laid on top of (or beneath) another to build up the artwork. They can be manipulated independently without affecting the rest of the picture. There are many different types of layer, too, as we'll see.

We'll be exploring techniques that demonstrate the many functions and abilities of the main layer types. Beginning with the basics and moving on through to more advanced concepts, we'll see how layers are created and controlled and how they can be made to interact with each other in a variety of different ways.

Three card tricks

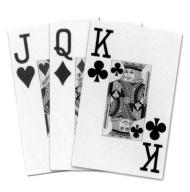

HEN YOU CREATE A NEW DOCUMENT, it consists of a single layer: the background. This is your blank canvas. You can paint on it, run most filters and perform many other operations. But working on a single layer is very limiting, and you'll probably find yourself continuously reaching for the Undo command. Although a painter creates his art directly on the canvas, we don't have to. Using layers allows us to add, remove and arrange pieces of our artwork, making as many changes along the way as we need.

The following example demonstrates the fundamentals of building a simple montage of playing cards using layers. We'll see how the layout of the artwork can be changed simply by altering the order in which the layers appear and by either adjusting their visibility or hiding them completely.

Opening the example image, we see that we have a document containing four separate layers – the background and three playing cards. In effect, we have four different images inside the same file. They can all be moved and edited independently of one another. We can

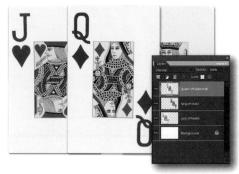

The order of the layers is not fixed, of course. Click and hold the queen layer's thumbnail in the Layers panel. Now drag it up above the king's layer. An indicator line will appear over its thumbnail. Release the mouse. The queen is now sitting on top of the other two cards.

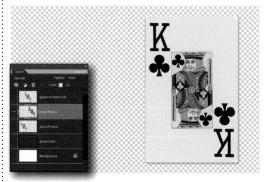

Layers can also be turned on and off. Click the eyeball next to the layer you wish to hide. If you hold all and click, all the other layers (including the background) will be hidden. This is particularly useful when you need to remove the clutter temporarily.

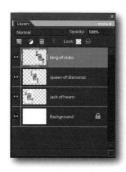

see the separate layers in the Layers panel. Each has its own thumbnail representation that shows a miniature version of the layer. We can customize the appearance of this thumbnail using the pop-up menu at the top of the Layers panel and choosing Panel Options.

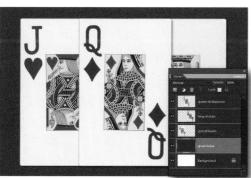

We can, of course, add blank layers. We've made the background layer active by clicking its thumbnail. A new layer is added by clicking the New Layer icon at the top of the Layers panel. Here it's been filled with color and some Gaussian Noise to represent the fabric of a card table.

For a more permanent solution, you can delete unwanted layers. This is done either by selecting the layer and clicking the Trash icon or by clicking and dragging the layer's thumbnail onto it. Here we've made all the layers visible again and disposed of the queen.

We can see here how the order of the layers affects the way they appear in the document. The Layers panel shows the structure: starting with the top layer (the king), is the foremost card in the image, followed by the queen and then the jack beneath.

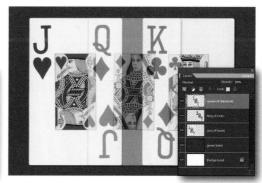

The transparency of a layer can be adjusted. This is achieved with the Opacity slider in the Layers panel, which ranges from invisible (0%) to completely solid (100%). The queen's opacity has been lowered to 50%. The rest of the image can now be seen through it.

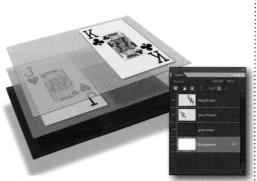

Here's our final image as it would look if you could view its component layers in three dimensions. Although the background layer appears as the same size as the other layers in the panel, it is represented here as an infinite base on which the rest of the images sit.

HOT TIP

Although it's easy to see which layers are which in a simple montage such as this, it's always good practice to give your layers meaningful names as they are added: Finding 'Jack of Hearts' will be far easier than 'Layer XX' when working on a complex piece of artwork with dozens of layers. Simply double-click the layer's label and replace it with your own.

2

Montage essentials: layers

Divide and multiply

N THE PREVIOUS PAGE, we created a piece of artwork by importing individual images as layers. The composition was altered simply by reordering the structure and changing the layers' visibility. In the following tutorial we'll go a stage further. Using the Move tool and a combination of keyboard shortcuts, we'll reposition and duplicate a single layer to quickly create multiple copies of the same object.

In the most recent versions of Elements, multiple layers can be selected to form a temporary group, allowing us to manipulate them as a single item. This is a much better way of working as there is no need to merge the layers into one before duplicating them, as was the case with earlier revisions of the program.

Here's our single plate. Its shadow has been created using a layer style; we'll be covering these later in the chapter. Notice how the shadow from the shelf falls across the plate. This is because both the shelves and their shadows are on a separate layer in front of the rest.

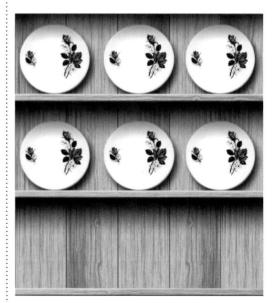

4 Go to the Layers panel. Hold **Shift** and click the first plate layer. This will highlight all three layers and, in doing so, temporarily group them together. Use the same keyboard shortcut as before; this time, drag the cursor straight down to create a copy of the entire row.

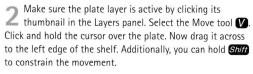

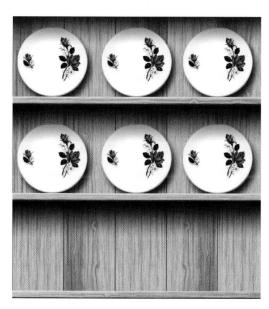

Leave the previous grouping enabled. Create a duplicate set for the final row. If you need to retain the group on a more permanent basis, click the chain icon at the top of the Layers panel. An icon will appear to the right of each layer denoting that it is part of a linked set.

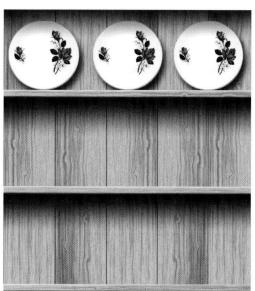

Holding all Shift Shift, click and drag the plate over to the right. Instead of simply moving it, this action has created a copy of the plate on a new layer. Release the mouse but keep the keys held. Now click on the new plate and drag once more to create a third.

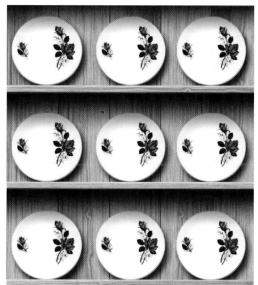

Currently there are nine separate plate layers. If you don't intend to make changes on an individual basis, you can flatten them into three rows or even one single layer. To do this, use the multiple select feature to group the layers together. Finally, press and E ** E** to merge them.

HOT TIP

Make sure the Move tool's Auto Select Layer option is disabled in the Options bar. Whilst this feature can be useful for finding a layer buried deep in your artwork, it can also cause chaos. You may find yourself moving or copying the wrong part of your image if you accidentally click another layer instead of your intended target. You can mimic this function at any time by holding ctrl H and clicking the layer in the document.

SHORTCUTS

MAC WIN BOTH

Importing layers

O FAR WE'VE SEEN HOW LAYERS can be duplicated, moved around, and placed over and under one another inside of a single image. These layers have all been included in the example files, however, so how do we go about getting them into the document in the first place?

As we'll discover here, there are several ways to do this. To demonstrate, we'll build up an image in six stages, each one using a different technique. You'll find the three .psd files used here in their own folder inside the Tutorial Files folder on the accompanying CD.

Begin by opening the Blank Background document. Now go to File > Place and choose the Board file. It opens as a new layer within the document. Notice how we also get a bounding box; at this point we could scale but we'll accept the default by pressing **Eniol**. Notice the small icon in the corner of the layer's thumbnail. This denotes that the layer is a Smart Object. We'll cover these later in the book.

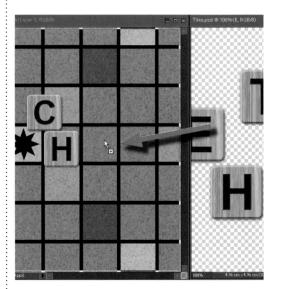

We can also drag layers between documents. There are three ways to do this: the first is directly from the document itself. Select the Move tool (M), click and hold on the layer, and drag it across to the other document. If, as with the example, we have many layers, holding (III) (38) when clicking the object will automatically select it.

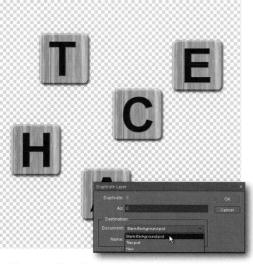

Now go to File > Open and choose the Tiles file. This contains five layers, each containing a letter. Click the top layer's thumbnail to make it active and go to Layer > Duplicate layer. Currently, the destination is set to the same document; we'll choose the Blank Background from the drop-down list. When we click OK, a copy of the tile will appear as a new layer in our other document.

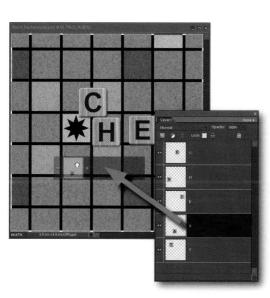

The second approach is similar to the last but, instead of dragging from the document, we'll copy the layer across from the Layers panel. With this and the previous method we also have control of where the object will be placed in the document. We can also force the layer to be placed in the center of the document by holding **Shill** as we drag.

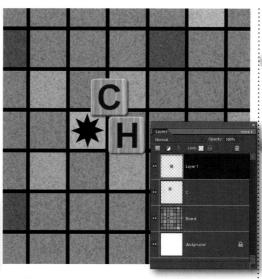

We can also copy and paste between documents. Make sure the H tile's layer is active, hold (#), and click its thumbnail to load its selection. Press (#) (#) (#) to store it in the clipboard. Now switch to the other document and press (#) (#) (#) to paste a copy. We'll need to rename the layer as it wasn't carried across. Remember to deselect (#) (#) (#) (#) (#) in the original document too.

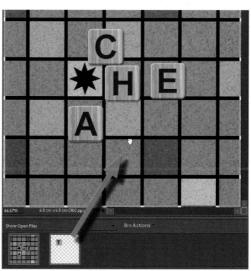

Lastly, we can drag the document in from the Project Bin. First, hold (a) and click the T layer's visibility icon to hide the other layers. If we didn't do this, we would end up with all the letters duplicated on the layer. Now drag the thumbnail from the Project bin onto our board to add the final layer to our image.

HOT TIP

Although we've used only a single layer to demonstrate each of the different ways of importing, we can - with the exception of the Place command and dragging from the Project Bin - just as easily perform the same tasks on multiple layers.

It's also important to note when importing with the Place command or from the Project Bin that multilayer files will be flattened, so make sure you have all the necessary elements of your document visible (or hidden) beforehand.

Think smart!

N THE PREVIOUS PAGE WE TOUCHED briefly on the subject of Smart Objects. So what do we mean by this term and what is the difference between them and regular layers?

Outwardly, aside from a small icon which sits in the bottom-right corner of their thumbnails, Smart Objects – or Blank Frame layers – to give them their correct title, appear to be no different to a standard layer. Behind the scenes, however, is a different story: they are resolution-independent, which means they can be scaled up and down, and, unlike their raster counterparts, they will never lose their original integrity.

This is incredibly useful when we're experimenting with different layouts in a montage, as we never have to be concerned about the degradation that occurs when continually scaling an object.

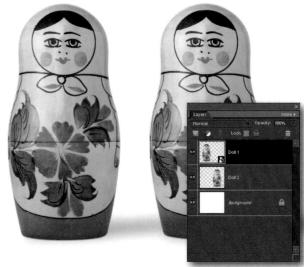

Here we have two seemingly identical Russian dolls. They're on separate layers but, looking at the left-hand doll's thumbnail in the Layers panel, we can see that it has the small icon in the corner which tells us that it's a Smart Object that has been created using the Place command. Over the next few steps we'll be able to see the advantages of this type of layer.

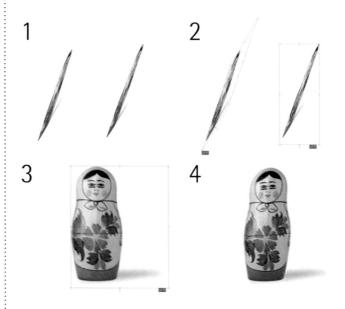

A Smart Objects also remember how they were previously distorted. Image 1 shows the two layers skewed drastically. Image 2 shows how the Smart Object's transform frame has kept its shape. Image 3 shows how simple it was to restore, and it will, of course, be perfectly smooth when we commit to the changes. Image 4 is the regular layer after a lot of battling; the result speaks for

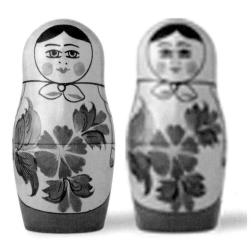

To demonstrate the way in which Smart Objects can be resized and then returned to their original size with no loss of quality, we've shrunk both layers down to 10% of their original size using the Scale command. Both objects still look good, just as we'd expect them to.

After scaling them back up to their original size, however, we can clearly see the difference. The Smart Object layer on the left is exactly as it was before we resized it. The standard layer, on the other hand, looks awful; its detail is blurred and the edges are horribly jagged.

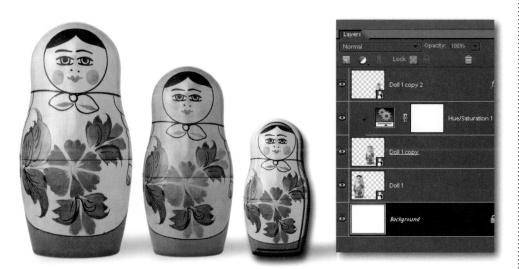

5 It's worth pointing out that Smart Objects are not without their drawbacks: they cannot be edited or added to once they have been imported into the document. They are also limited in how they can be transformed and can only be scaled, rotated, or skewed. This, however, is a

small price to pay when compared to the benefits. As we can see from the image and the Layers panel inset, we can duplicate the object and add layer styles and Adjustment Layers (we'll be covering these later in the chapter) to change its appearance; and this is all done non-destructively.

HOT TIP

Once you have the project you are working on looking right, you can, of course, convert the Smart Object back to a regular layer using the Simplify Layer command, which will allow you to edit and apply filters directly to it. It may be worthwhile making copies first though, just in case you need to alter something at a later stage.

Staying in shape

O FAR, WE'VE LOOKED AT RASTER LAYERS. These are the most common types but do have one major downfall: resizing causes permanent image quality loss. There is, of course, no compromise when working with photographs but, if you use a lot of graphic objects in your artwork, shape layers are the perfect solution. Instead of being built up from individual static pixels, vector shapes are defined by anchor points; when scaled up or down, the computer redraws the lines and curves between the points — a digital 'join the dots' image. No matter how many times the graphic is scaled, there is never any degradation.

In the following example we'll use some of the basic shape tools to create a film negative. This could be used as a custom frame for your photos or as a banner or header on a web page. We'll see how areas can be added and subtracted to alter the shape in a similar way to the selection techniques covered in the first chapter. You can, of course, perform all the same functions as regular layers, too.

Select the Rectangular Shape tool . Choose a suitable color from the palette in the Options bar; the dark red orange preset works well. Click and drag out the base shape for the frame. Deceptively, individual negative frames are almost square, being only a little wider than they are tall.

Repeat the last step six times to finish the row; you should have eight holes. Grab the Shape Selection tool. Click one of the hole shapes. Holding Shift, click each of the other shapes to select them all. Hold All Shift Shift Shift and click and drag down to duplicate the row on the bottom.

Photoshop Elements 8

Press and hold **all \simes**. The cursor will show a minus sign next to the crosshair, indicating subtract mode. This will remove the marked area. Draw another rectangle. This time make it wider: photo-shaped, as it were. Press the Spacebar whilst dragging to position the frame centrally.

Select the Rounded Rectangular Shape tool. Hold [all] again. Draw a small rectangle. Now hold ctrl # alt . Click and drag the new shape to create a copy. Hold Shift to constrain the movement. Make the distance between them slightly larger than the size of the hole.

At present all the shapes are separate entities. It's At present all the snapes are separate summitted unlikely that we'll need to alter them. Click and drag a bounding box around the entire object. Now click the Combine button in the Options bar. This creates a single shape from its component parts.

We've used the Custom Shape tool to add an arrow. This is created on a separate layer which, along with the text, is grouped and linked to the film strip. Whilst it may not be the most tidy of solutions, you still benefit from the ability to scale the artwork image without loss of quality.

HOT TIP

Once you've completed your artwork, save it as a Photoshop document. This way, you can be sure the layer information is retained correctly. You can then open and import the layer(s) into vour artwork as and when you need it. Once you have it in place, you can alter the blend mode and opacity to suit. The frames can also be tiled seamlessly to create a strip.

MAC WIN BOTH

Montage essentials: layers

Adding a little style

STYLE

This styles can be added by double-clicking their thumbnail, highlighting, and clicking the Apply button at the base of the Artwork and Effects panel; or by dragging and dropping onto the target layer. In the example, we've applied the Low Drop Shadow preset.

AYER STYLES ARE VERSATILE, REUSABLE effects. With them you can quickly place shadows under objects, create metal textures, add embossing, and much more. Unlike filters, however, they are non-destructive; once applied, they can be altered, added to, or removed without the need to undo previous changes or recreate parts of the artwork. Styles are not limited to regular image layers either; in fact, they show their worth far better when applied to objects which themselves are changeable such as shape or text layers.

In version's 6 and later the program comes with a much better Settings dialog with which to fine tune the styles. Previous editions did give you control over the attributes, but these controls were fairly rudimentary in comparison. You will, of course, still be able to follow the majority of this tutorial if you have an older version.

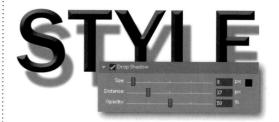

4 We'll adjust the shadow next. Start by lowering the Size. This makes it sharper, as though the light source were closer to the text. Increasing the Distance value gives the appearance of the text being further from the background. You can also lower the Opacity if required.

STYLE VOGUE

Because the style affects the layer as a whole, you have the ability to change the content of the layer without the need to apply the style again. In the example, the color and wording of the text have been changed; the style is added as we type. This even works when painting on a layer.

The default settings of the styles may not always be right for the image you are working on. Double-click the star (f on earlier versions) icon to the right of the layer thumbnail to open the Settings dialog. Here you'll see the adjustments that can be made to the style's attributes.

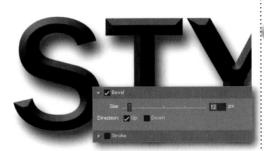

We'll start by making the bevel a little smaller to fit the text better. Use the slider to lower the value; you'll see the effect change as you do so. Bring it down enough to make the bevel's ridges straight with a slight flatness on top. Here a value of around 12 pixels is sufficient.

HOT TIP

Although styles are normally cumulative, you can force the current effect to be replaced outright by holding Shift when applying the new style. Be aware that many of the more complex builtin presets will override your effects as they already contain compound settings. It's also worth noting that patterned styles on surfaces in perspective may not look right, particularly those which contain strong horizontal or vertical lines. Such effects are generally designed to be applied to flat objects. You'll need to simplify (flatten) the style, then create the distortion on the object.

STYLE

5 The Lighting Angle controls the highlight and shadow of the bevel effects as well as the direction of the drop shadow. The default is top-left. This can be changed within the dialog. You can also click and drag within the document itself, which allows you to set the angle visually.

STYLE GRACE

We can also copy styles: right-click the layer style icon and select Copy Style. Now when we right-click on another layer's label we can paste a copy. The text adopts the exact same effect. This is useful when you have customized the style and want to match it across the artwork.

VOGUE STYLE

The effects also operate independently to the layer. Here both layers have been flipped vertically. You'd expect the bevels and shadows to follow suit. Instead, they retain their original direction. One more thing to note: altering the Lighting Angle will affect all layers with a style applied.

VOGUE STYLE

Now you've set up your styles, what if you want to remove them? You can hide/show all styles from the layer styles sub-menu under the main Layer menu. You can also clear them from there (the same as deleting). This is also available from the More fly-out in the Layers panel.

Protect your work

F YOU'RE PLANNING on putting your images up for sale online or sending them somewhere for evaluation, the last thing you want is for some unscrupulous person to stroll in and steal them for themselves.

One of the most common ways to prevent this is to add a watermark to the image; this will often be your website address or logo because they also serve as good advertising. The problem we can have is knowing where to place it: if we put it along the edges, it could easily be cropped or cloned away, and having something that covers up too much of the image defeats the purpose.

There is a compromise, of course: We'll be using a shape layer and layer styles to create a way of protecting the image quickly and effectively by filling the document whilst leaving it almost completely visible beneath.

First of all, we need to decide what to use as our watermark: for simplicity, we'll use the copyright symbol. Select the Custom Shape tool **()**. From the Options toolbar open the Shape Picker; our shape isn't in the default set so go to the fly-out menu and choose Symbols from the list.

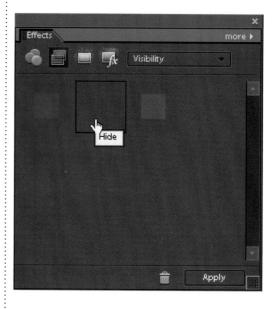

We can't use the opacity control to remove the color as we'd have to drop it to 0%, which would also remove the bevel. Instead, go back to the Styles panel and choose Visibility from the layer styles menu. From the three available options, double-click Hide.

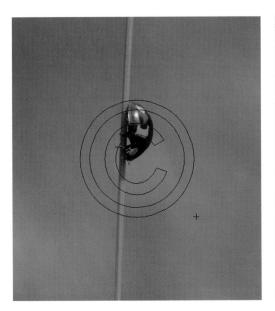

Holding Shift to retain the shape's proportions, click and drag out the shape. Make sure as much of the important detail is covered by the symbol as possible; if we also hold the spacebar, we can move the symbol into the correct position.

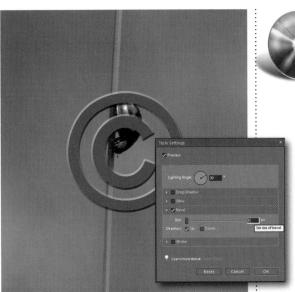

The color is immaterial as it will be removed later. We'll give the symbol some styling: from the Effects panel, select layer styles and choose Bevels. Double-click Simple Sharp Outer. It's too large so we'll double-click the layer style icon to open the settings and reduce the size slightly.

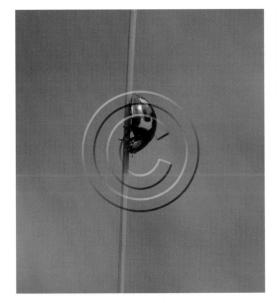

We've removed all the color but kept the layer style. This lets us see the image without too much obstruction but also makes sure we protect it from being used without our consent. It would be difficult and time-consuming to restore the image convincingly, and more-so on a complex image.

We're not restricted to simple shapes, of course. We can also use text: here we've used a company name and its website address; now watermark becomes a passive advertisement as well as preventing theft. As it's using live text and styles, it can easily be altered, too.

HOT TIP

Once we've set up our watermark we can save a file containing just its layer, or perhaps a whole range of versions for different situations. When we want to add it to another image we can simply open it up and drag it into the document.

2

The power of adjustment

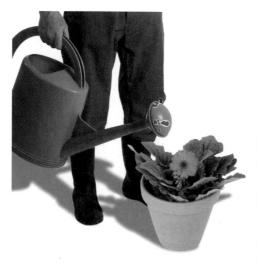

HEN YOU APPLY AN ADJUSTMENT such as Levels to an image, the affected pixels are permanently altered. If at a later stage you decide you no longer want that effect, unless you made a backup, you have a problem. It would, of course, be really helpful if you could create the same effect but have the ability to turn it on and off, alter its settings, have it apply to only certain areas of the image, and, most importantly, be able to return to the image at any stage to do so. With Adjustment Layers you can do just that. Anything beneath them in the layer stack will be affected unless, of course, you don't want it to be. They are just like regular layers. You can alter their opacity and change the blend mode. Most importantly, however, they can be toggled on and off, disabling the effect.

In the following tutorial we'll use a Hue/ Saturation Adjustment Layer to remove the color from a selected part of our image. This is done using the layer's built in mask. We'll see how it can be edited, inverted and even exchanged for a completely different effect.

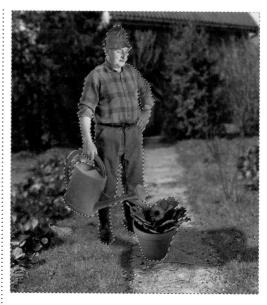

Our image comprises two layers, the garden background and the man watering the plant. Hold ## ## and click the gardener's layer thumbnail to load its selection. Now press ## Shift ## ## To inverse it. When we create our Adjustment Layer it will only affect the background.

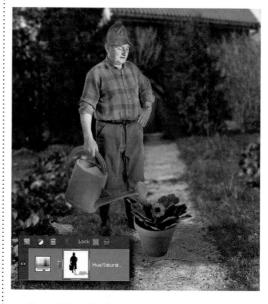

4 You might decide that you want the flowerpot in gray, too. Click the mask thumbnail to make it active. Grab the Brush tool. Set the foreground color to white. Now carefully paint over the pot to remove its color. You're really just reducing the mask's protection over the layers.

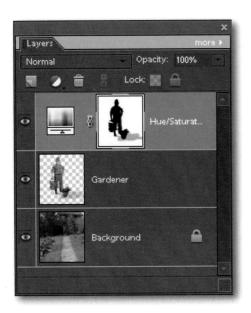

2 Create a Hue/Saturation Adjustment Layer from the split circle icon at the top of the Layers panel. Notice how the selection has been used to isolate the man in the layer mask. The black areas will not be affected by the changes we are going to make with the Adjustment Layer.

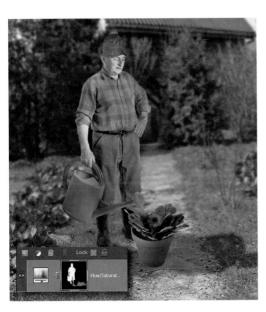

We can also swap the effect around, giving the background its color back and removing it from the man. Press (m) ** D. This inverts the layer mask; everything that was white is now black and vice versa. This acts like a toggle: inverting the mask again will revert it.

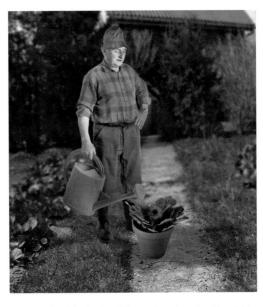

Use the slider in the dialog to drop the saturation right down. The background will become black and white; the man remains untouched. Notice how some color is still showing through the shadow. The gray tones act like an opacity filter. This will be explained later in the book.

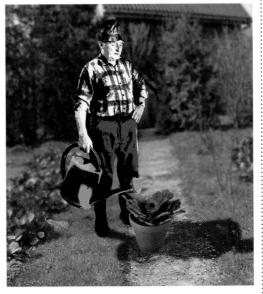

Another feature is the ability to change the type of Adjustment Layer to use without losing the mask and any changes. Select Change Layer Content from the Layer menu. You can choose one of the ten remaining types to apply to the image; Posterize is used in the example.

HOTTIP

You can use adjustment I ayers to make temporary alterations to an image. For example, you may be having difficulty selecting and separating your subject from its background because there are areas of low contrast or because it's simply too dark in places. Create a Brightness/ Contrast Adjustment Layer above your subject. You can take the values to their extremes for the duration of the task. Afterwards, you can simply turn the layer off or discard it completely.

Montage essentials: layers

Exploring blend modes

VEN IF YOU'VE NEVER USED THEM you will no doubt be familiar with the term 'blend modes'. These determine how layers interact with the other layers in the artwork. In our example, we'll change the graffiti layer's mode, which will affect the way it blends with the wall: our background layer. There isn't space to show every mode but the examples should serve as a guide; the results you get will vary greatly depending on the colors and tones of the component layers in your image.

The default is Normal. Technically this isn't really a blend mode at all as the top layer does not interact with the base layer. Almost all layer types can use blend modes. Individual tools such as the paint brush and gradients use them as well.

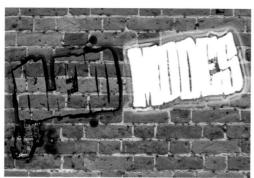

Here we have Multiply on the left and Screen on the right. Multiply produces rich, darker tones. Again, white has no effect and is cancelled out. The opposite, Screen, produces a much brighter blend. White is completely opaque. Any black in the image has no effect and is not displayed.

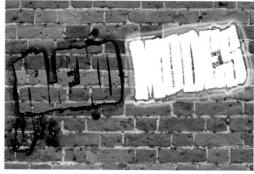

5 Color Burn (left) and Color Dodge (right) produce similar results to Multiply and Screen. The colors, however, appear far more exaggerated using these modes. Following on from these are Linear Burn and Linear Dodge (not shown). These produce slightly stronger results.

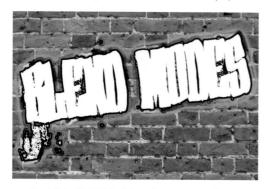

Hard Light, Vivid Light (shown here on the left), and Linear Light all produce strong color tones, Linear being the deepest. Pin Light (right) uses the tones of the base image to shift the color of the top layer, depending on lightness. 50% gray is invisible in all of these modes.

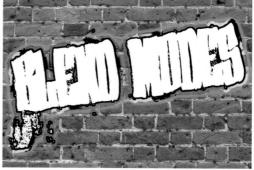

Hard Mix limits the blending image to eight colors – white, black, red, green, blue, yellow, cyan, and magenta; the mix depends on the blending colors of both layers. This produces a result similar to that of Posterize. It is a brash, aliased effect and therefore has limited use.

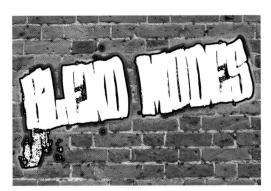

2 This is Dissolve. On a crisp, fully opaque image this mode has no effect. However, when you add some blur or start to lower the opacity, random pixels will start to disappear. The more the image is blurred, the stronger the effect becomes. You can see this on the sprayed green edge.

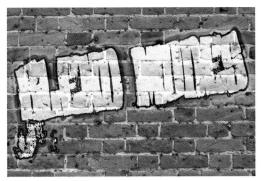

This is Overlay. It's a combination of Multiply and Screen. It darkens lighter pixels and vice versa. In areas of midtones there is little or no effect, 50% gray being completely invisible. The highlight and shadows are retained, giving it a slightly blown out appearance.

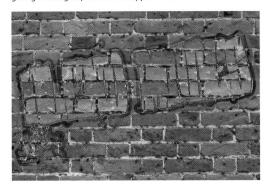

10 In Difference mode, color is subtracted from either the base layer or the blend layer, depending on brightness. Pure white inverts the blending colors; black has no effect. This can be used for comparing images for slight changes. Exclusion (not shown) gives a less contrasted effect.

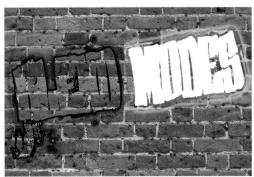

On the left we have Darken. This blends any pixels that are lighter than the wall; white becomes transparent. There's little change in the color. On the right is Darken's counterpart, Lighten. It has the opposite effect, blending where the wall is darker. The color is a little washed out.

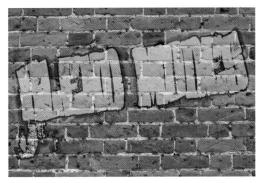

Soft Light operates in a similar way to Overlay, the difference being that it combines Darken and Lighten. As we can see, this produces a somewhat muted blend. This mode is often used for creating reflections because of its already slightly translucent qualities.

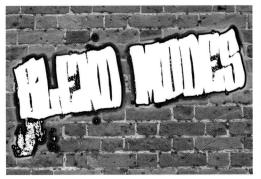

The four remaining modes, Hue, Saturation, Color and Luminosity, work by combining the named attribute of the top layer with the remaining two (Color is not included) from the base. The example is Luminosity, which leaves only the grafitti's brightness values.

HOT TIP

Because using blend modes can produce very different results depending on the number of blended layers, their tonal values and many other factors, it's often easier to cycle through the individual modes until vou find one that fits the effect you're looking for. There's a keyboard shortcut for this: press Shift + to drill down the list and Shift - to drill up. Make sure you're not in one of the painting modes as that will result in changing the mode for that tool, rather than the layer.

Montage essentials: layers

Banqueting arrangements

FEATURE INTRODUCED in Elements 5 was the ability to automatically align and distribute layers within the document. In earlier versions, this would have needed to be done by hand, either by sight alone or by setting up and aligning to a grid - a somewhat messy business. Now you can accurately space out and arrange components evenly across your artwork with just a few clicks of the mouse. This is great for making precise designs such as navigation bars on web pages or for laying out and ordering text and images for scrapbook pages.

Here we have the all the pieces of our place setting on separate layers. We could, of course, select and position each individual layer manually, but this is time consuming and not altogether accurate. Instead, let's make use of

Elements' ability to select and work with multiple layers simultaneously. By grouping the sets of cutlery together we can then use the new Align/ Distribute feature of the Move tool to space them out neatly either side of the plate.

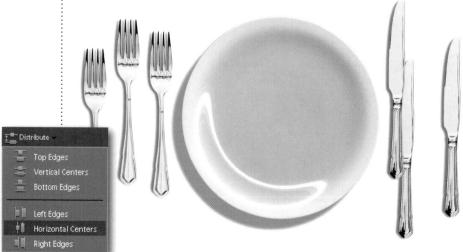

Now we can space the cutlery out. The Distribute function works by spacing the central layer(s) evenly between the two outer ones. Start by arranging the knives and forks into two rough groups. The forks have already been

tidied in the example. Multi-select the inner and outer knives by again holding (III) (#) and clicking their name labels. Now use the Horizontal Centers option from the Distribution menu. They will now be evenly spaced.

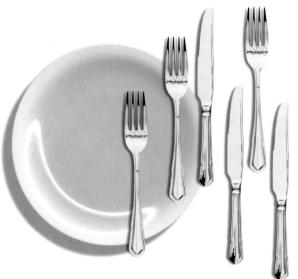

The first task is to bring the plate into the center of the canvas. Select the Move tool

Click the background layer in the Layers panel to make it active. Now hold

B. Click on the plate layer's name (not the thumbnail) to

group the two layers. Start by selecting Horizontal Centers from the Align menu in the Options toolbar. This will shift the plate across to the middle. Now use the Vertical Centers option to move it down.

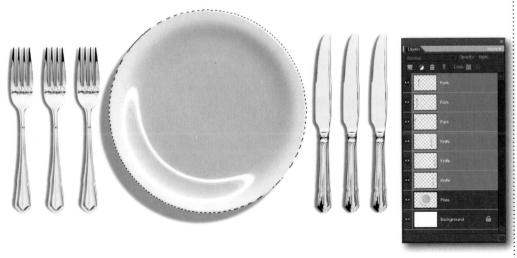

Press (#) # and click the plate layer's thumbnail to load its selection. Now group all the cutlery layers together. You can do this by holding (#) # and dragging a bounding box across the document to encompass the knives.

You'll see the layers highlighted in the panel. Release the mouse and do the same for the forks. Go back to the Align menu. This time select Bottom Edges. All the cutlery will move down to align with the bottom of the plate.

HOT TIP

You can align layers to selections as well. We've used this method in the final step to match the cutlery to the baseline of the plate. If we had only used a layer group, everything would have been aligned to the base of the entire document.

SHORTCUTS
MAC WIN BOTH

Montage essentials: layers

Cut-up collage

E CAN USE LAYERS to create interesting image effects too. The British artist, David Hockney, creates artworks by taking photos of his subject in sections and then reassembling them in a slightly offset arrangement. The result is a slightly abstract version of the original scene.

We can recreate this effect from a single image by slicing it into several layered sections that we can rotate and reposition. To make sure our sections are of equal sizes, we'll use one of the less prominent new features of Elements 8, user-defined guides. We can specify the exact position of the guides as units of measurement (inches, picas, etc.) or as a percentage of the document's dimensions - which we'll be using in this project. Once defined, we can use the snap-to feature to create perfect selections to slice up our photo.

If you're using an earlier version, you can still create the guides using a different method: see pages 224-225.

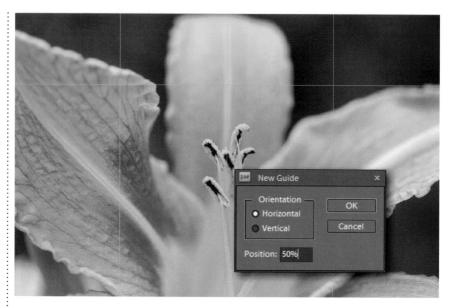

We'll begin by creating our guides. For this project we'll divide it up into a 4x4 grid. Go to View > New Guide. We'll leave the orientation on Vertical to start with. Type 25% (one quarter of the image) in the Position box and click OK.

Create another new guide, this time setting the Position to 50%. Add a final vertical guide at 75% to give us four columns. Repeat the process in 25% increments; this time set the orientation to horizontal to create the four rows.

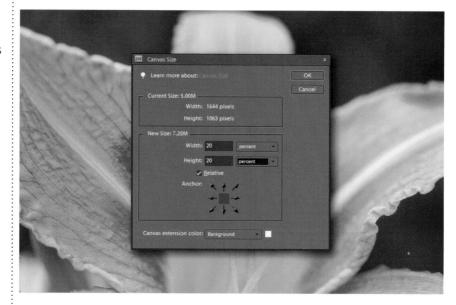

We've finished with the guides now so we can remove them. Go to View > Clear Guides. We also need to add some extra working space to the document to enable us to rotate and move the pieces around. Go to Image > Resize > Canvas

Size. Make sure Relative is checked. Set both the width and height to 20% and click OK. Now select the Move tool **W**. Make sure Auto Select Layer and Show Bounding Box are enabled in the Options toolbar.

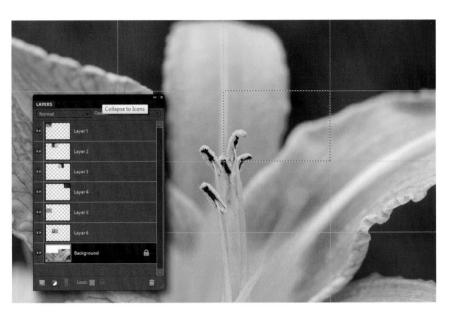

Make sure Snap To > Guides is set in the View menu. Grab the Rectangular Marquee tool M. Click and drag the selection out in the top-left corner of the image. It will snap to the guides and document edges. Press @TP Shift J

Eshift J to cut the selection to a new layer. Click the background layer to make it active again. Make a selection in the next section and cut it. Repeat this for each piece, remembering to switch back to the background each time.

Click to select one of the layers. Move the cursor outside of the bounding box until it becomes a curved arrow. Click and drag to rotate it. Press **Enter** to accept the change. Move to another section, click again to select the layer,

and rotate it. Repeat this for the whole image. We can also go back and move the pieces around to fill some of the gaps. Finally we can add a small Drop Shadow layer style to each of the pieces to make them appear more three-dimensional.

HOT TIP

Instead of having to specify that the value is a percentage each time you create a new quide, you can change the default unit of measurement by opening the Info panel (Window > Info) and clicking the little disclosure arrow next to the crosshair icon. You'll get a menu showing all the available units. Select percent and you'll now only have to type the value in the box, without the percentage sign. This works for most tools and also the Status Bar at the bottom of the document window.

Keep up, no slacking

THERE'S ONLY ONE THING FASTER than the speed of light: the computer industry. It seems that no sooner do you remove the shrink-wrap from your software or prize the new PC from its snug Styrofoam packaging than you expect to see a little fortune cookie-style note congratulating you on your purchase being out of date. That groaning, creaking sound you hear becoming progressively louder is not your antiquated computer about to keel over in a spectacular shower of sparks, but the heavy cogs of the corporate machine trundling toward you, decimating all but the newest of technologies in its path.

As with the fashion industry, it seems you're nobody unless you're first in line for this season's must have accessory. As the glossy adverts in magazines will imply and the even glossier sales people in computer stores will tell you (the prospect of a sales commission instantly makes you an expert, of course), your current system is already half way to the scrap heap and not fit for anything other than being the basis for a retro art statement.

You should not be too despairing of the seemingly decrepit piece of hardware chugging away beneath your desk, or that your copy of Whizz-Bang 3000 Professional Gold Edition SP5 is now 'so last Tuesday'. Before you rush out to part with a month's salary, you have to ask yourself: *is it good enough for my purposes and, if it lacks a certain area of functionality, can I achieve the same thing in a different way?* Unless the latest hardware or software is offering something completely revolutionary, the answer will almost certainly be yes.

There will, of course, come the time where an upgrade is necessary. Perhaps support for your current operating system is being dropped and its replacement will not run efficiently on your computer. It may also be that certain components, such as graphics cards, need replacing. This doesn't involve replacing the whole system.

Ask anybody in the world of digital imaging – unless they're trying to sell you a completely new computer – what, above all, are the most important system components and you'll generally get the same answer: memory and hard disk space. Even if you have the latest AMTEL liquid-cooled, 50 megagiga-googleplex processor,

it is still very much at the mercy of these two commodities. The computer needs memory to run the graphics program itself and store the image(s) you are currently working on, not to mention everything else that's going on in the background. Adobe recommends between 512Mb-1Gb for the current version of Elements to run smoothly. The more complex the document becomes, however, the more memory it needs to use to hold that information. Images can often bloat out to hundreds of megabytes in size, especially when you start creating multiple layers. Add to that the history (undo) states and the space used by copying and pasting to the clipboard and you'll soon be pushing the resources to their limits.

There's no way to second-guess how much memory you will need. Presently the average PC comes with around 1-2Gb, which is ample for most tasks. When the system starts running low on physical memory, it starts to free it up by using virtual memory, referred to as 'scratch' space in Elements. This is a temporary area on the hard disk set aside for storing the overflow. Think of it as writing things down on a scrap of paper when you begin to become overwhelmed with information. This is where you need to make sure you have a large enough hard disk. Remember, the operating system, programs, and your data all share this space. If it's full to bursting, trying to cram in this transient file will at best slow things down to a crawl; at worst it can cause the program (or the entire system) to crash, taking whatever you are working on with it.

Enhancing your system needn't be expensive. A large external hard drive will set you back around \$100-200; you just plug it in and it's ready to go with no fuss. An internal drive could be half that amount. You can add an extra gigabyte of memory for less than \$50. If you're not technically minded and unwilling to delve into the arcane world that is the inside of your computer, there will usually be someone you know who can help. If not, there will be no shortage of people advertising in the classified section of the newspaper who will be able to do the work – usually for a reasonable price, too. If it keeps you up and running for a year or two more, it's certainly money well spent.

■ This photograph of a man rowing has been removed from its original background and placed into a tranquil river setting. It looks far more part of the scene when it's partially hidden behind the foliage; that, and the reflection in the water, really bring the scene to life.

Hiding and showing

CREATING EFFECTIVE PHOTOMONTAGES is all about making layers interact with each other. And, more often than not, this entails making layers partially hidden behind existing objects in the scene.

The standard way to do this is to erase the parts you don't want. But this is an irrevocable step; instead, we'll look at a cheat that gives Elements users some of the power of Photoshop CS4, with the ability to selectively hide and show regions of layers.

We'll also see how to blend layers together in a convincing manner, and how to arrange our montages so that they look that bit more convincing.

Cheating with layer masks 1

NE OF THE MAJOR FEATURES present in the full version of Photoshop – but not found in Elements – is Layer Masks. These are a method of hiding, rather than deleting, parts of a layer in such a way that we can reveal them later if we need to.

It's a hugely powerful technique, as it means you never have to commit yourself to removing parts of a layer that you might want to get back. It's just a pity this technology isn't included in Elements as well.

Or is it? Well, in a way, yes it is. We can use the fact that, in Elements, although layers themselves might not have masks, Adjustment Layers still do, which means that with a clever workaround, we can harness that power and put it to good use. Here, we'll use it to stick a boy down a drain.

Here's Steve's son in front of a drain. The first thing we're going to do is to make a new Brightness & Contrast Adjustment Layer using the pop-up menu at the bottom of the Layers panel; use the default settings and press OK.

A Now for the clever part. If we change the foreground color from black to white, we can paint the layer in again. Now that we can see the edge of the hole, it's easy to paint it back in accurately, and the layer is revealed again.

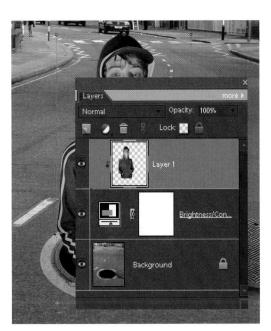

We want to group Joe with the Adjustment Layer, so switch to his layer and press (F) (B) (G). Now click on the white rectangle to the right of the mask's icon in the Layers panel, because that's where we'll paint.

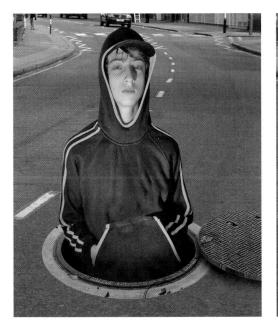

5 To give the effect of shading, switch to a large softedged brush at an opacity of 50% and paint in black at the front of the hole. This partially hides the layer, making Joe look shaded as he disappears into the drain.

When we paint on this mask in black, we hide the Adjustment Layer. Because Joe is grouped with it, we hide him as well. Using a hard-edged brush, paint him out roughly around the edge of the drain and below it.

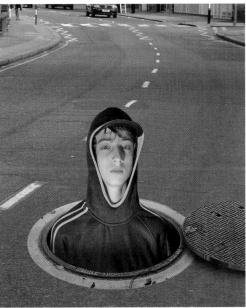

6 Now for the *really* clever part. Because Joe's layer is separate from the Adjustment Layer, we can move it independently. Here, we can drag Joe down and the mask stays in place, so it appears that he's going down the drain.

HOT TIP

As well as painting in black and white, you can paint on the Adjustment Layer's mask in shades of gray: the darker the shade, the more the layer grouped with it will be hidden.

When painting on masks, you'll frequently want to switch between black and white. Press ** to do this.

In step 6, you might find that some of Joe is visible at the bottom of the image. If so, just paint him out in black on the Adjustment Layer's mask.

3 Hiding and showing

Cheating with layer masks 2

N THE PREVIOUS PAGES we looked at how to fool Elements into thinking it could work with layer masks, by grouping a layer with an Adjustment Layer beneath it.

It's a neat solution and it makes it easy for anyone to use layer masks in Elements. But it's slightly clumsy having to manipulate two separate layers, when all you really want is to have a layer mask on one.

So here's another workaround. As we said earlier, Elements may not have layer masks built in, but Photoshop does. So what? Well, it turns out that Elements is capable of opening all Photoshop documents – including those with layer masks. And, surprise surprise, the layer masks come in to Elements intact, and we can use them as we wish.

On the CD you'll find a file called Layer masks PS.psd. It's an empty Photoshop layer with a mask attached. Here's how to use it in your own artwork.

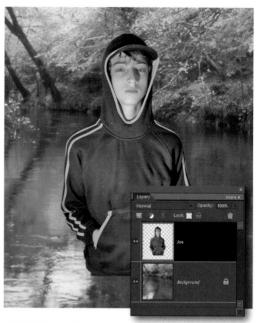

We'll begin with our image of Joe in the river, or rather, hovering above it, as he is at present. He's already on a separate layer and that's what we'll be attaching our imported layer mask to.

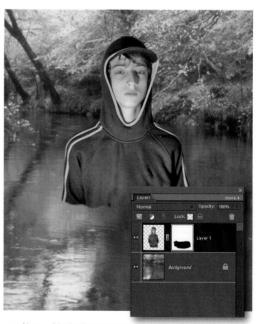

4 Now, with the layer mask selected by clicking its thumbnail, we can use a fairly hard black brush to paint away the area where we want Joe to be beneath the water, making the edge slightly uneven to mimic the ripples.

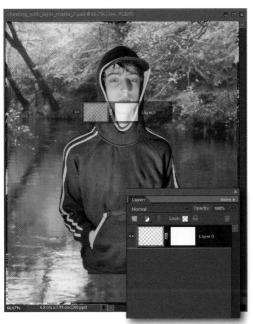

2 Make the background layer active as this will ensure the mask layer will be in the correct place when we import it. Open the layer mask file, then drag its thumbnail from the Layers panel and drop it onto the scene.

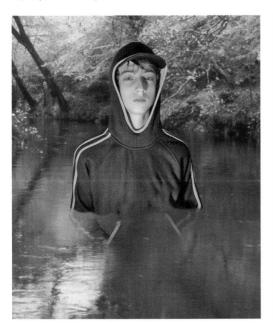

5 We should be able to see some of Joe's body beneath the water. Set the brush to white and lower the opacity; around 20% is fine. Begin to paint back the area where he meets the water and he'll become slightly visible.

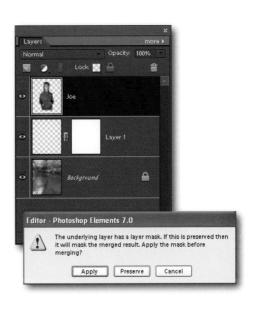

Making sure Joe's layer is selected, we can merge it into the mask layer by pressing **(M)** (E) (E). A dialog will appear giving you the option to either apply or preserve the mask. We need to click Preserve.

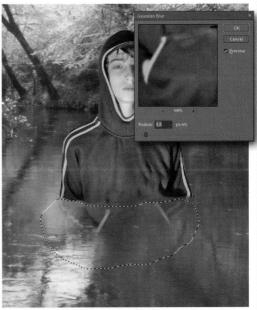

Finally, we'll make the submerged part of Joe a little more hazy. Click the image part of Joe's layer and use the Freehand Lasso (a) to select the area beneath the water. Add a small amount of Gaussian Blur to complete the effect.

HOT TIP

When we used the Merge Layers command, we were asked if we wanted to apply or preserve the mask. We used preserve because we wanted to keep it. If we'd clicked apply, the mask would be merged as well. We would only use this when we were happy with the adjustments and wanted to convert the layer to a regular one.

If you ever want to see how a layer looks without its mask, hold Shift and click on the layer mask's thumbnail. This will temporarily disable it, placing a red X across the thumbnail. Use Shift click to enable the mask once more.

Smudge masking

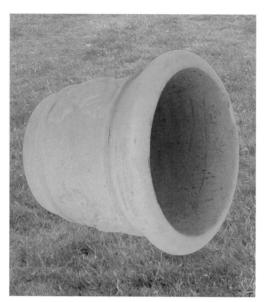

O FAR, WE'VE LOOKED AT CREATING layer masks by painting on them with the Brush tool. It works well: we can paint on an Adjustment Layer's mask beneath our target object to hide and show the object that's grouped with it.

But we can use any of the painting tools, not just the brush. Here, we'll look at how we can use the Smudge tool to create a convincing grass effect, using a technique that's far easier than painting each blade.

First, create a new Adjustment Layer beneath the pot. Hold ctr. ** and click on the pot's thumbnail to load it up. Inverse the selection using ctr. Shift ** ** Shift ** Shift

Here's how the finished Adjustment Layer's mask looks on its own. Smudging the mask in from the edges in this way is very much easier than painting the mask, as the smudging creates a natural, fading look that matches the growth style of the grass.

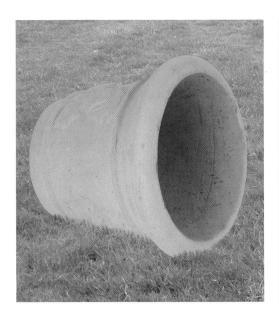

2 The Adjustment Layer now has a mask that exactly matches the area outside the pot – so far, we see no difference. But, when we switch to the Smudge tool, we can brush in the mask beneath the pot so that it hides the pot, giving the impression of grass growing up in front of it.

5 We now need to add some shading, both to the pot and the background. Make a new layer above the pot, grouped with it; set the mode of this layer to Multiply. Now sample a dark color from inside the pot and use a soft-edged brush to paint shadows on the lower edges.

Finally, make a new layer above the grass. This is where we'll paint the shadows cast by the pot. Use a soft-edged brush again, with black as the foreground color. Set the brush to a low opacity and build up the shadow in small stages until it looks convincing.

HOT TIP

The technique here works well for grass but, if we want to bury our object in a different surface, such as sand or snow, we'll need a slightly different technique. Rather than using the Smudge tool, use a soft-edged brush, but set the mode of the brush to Dissolve: this will create a granulated, speckled effect. To soften the effect, apply a little Gaussian Blur after painting the mask.

SHORTCUTS

MAC WIN BOTH

On golden pond

B LENDING TWO IMAGES TOGETHER is a technique that has many uses. Here, we'll look at a specialized use: making a composite of a man with his favorite hobby.

It's a technique that's reminiscent of the poster for the Henry Fonda movie, *On Golden Pond* – and that's why we've chosen this particular subject.

Blending the portrait into the background is straightforward enough, using the techniques outlined earlier in this chapter. But what makes this image work is blending the color as well, rather than simply relying on the colors in the original pictures. This is the secret to creating a montage that looks unified, rather than two disparate elements.

Having chosen our background, the next step is to place our figure in front of it. Since he's the main figure in our composition, make him as large as possible within the frame, while leaving space top right for a caption.

4 By default, a Solid Color Adjustment Layer comes out as black. Changing this to a warm orange better suits the background. As we can see, because the Adjustment Layer is grouped with the figure, it only shows up where it overlaps the man.

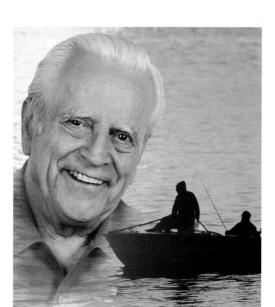

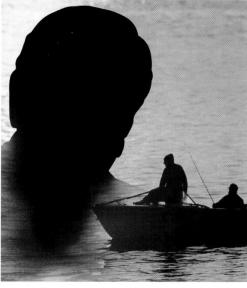

2 To fade him out, use the layer mask technique described earlier in this chapter: make a new Brightness/Contrast Adjustment Layer behind the man and group him with it; then paint in black on the mask to hide the layer and paint in white to reveal it again.

5 In order to be able to see the man through the Solid Color we need to change the layer's mode from Normal to Multiply. Now we can see the man clearly, and the color is having its effect. But it's much too strong: we need to lower the opacity of the layer.

Taking the opacity of the Solid Color layer down to 50% gives us the effect we want. The man now has a coloring that matches the background far more closely: the two separate images are now unified into a single montage that works as a whole.

HOT TIP

By creating a layer mask in step 2, rather than simply erasing the figure around the boat, we have the flexibility we need to move him around and adjust the mask as required. It's important that the man doesn't hide the prow of the boat, for example, but the man needs to wrap around it smoothly. This would be hard to achieve by simply erasing parts of the layer.

Part of the scene

BIG KIDS, LITTLE KIDS – how about giant kids? It's easy to turn a straightforward photograph into a King Kong creation by simply changing the background and adding a plane or two.

But we can go further than this. Placing a child in front of a scene may be the first step, but it's a long way from the finished montage. The trick is to bring picture elements from the background in front of any people or objects we've placed in the scene. By doing this, we're integrating our placed items in such a way as to make them appear to be genuinely part of the background, rather than merely floating on top. It makes all the difference between a straightforward montage and a truly compelling scene.

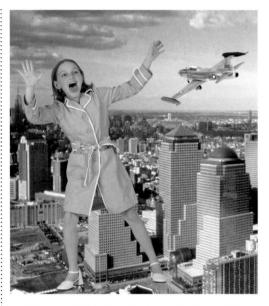

We've placed the girl on the view of New York and her feet fit neatly into the space in front of the buildings; the toy plane has been added to give her something to look at. But we can integrate her into the scene better than this.

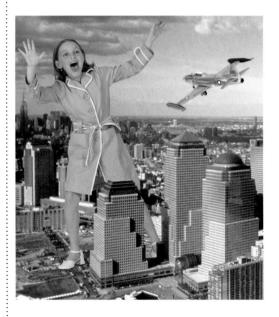

4 In the last step, we left part of the girl's shoe showing beneath the new buildings layer, so we need to move her up. Judge where she fits best within this scene, positioning her so that her feet seem to be firmly planted behind the buildings.

Hide the girl's layer and make a selection of the two buildings in the middle. With straight edges such as this, the Polygonal Lasso tool works best; you can also hold all with the regular Lasso to trace straight lines.

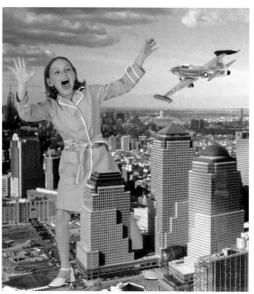

Make the buildings into a new layer using etril and move this layer above the girl's layer so that she appears behind the buildings. She now looks like she's in the middle of the buildings.

HOT TIP

This trick of moving background elements to the front will help in just about any kind of montage. If there aren't any suitable background objects that can be 'promoted' in this way, create your own: an out-offocus bush, for example, can help an outdoor montage to look that much more realistic.

5 To integrate her further, we need to add some shadows. First, on a new layer, paint shadows beneath her foot on the ground below. Then make another layer just above the girl, grouped with her layer; paint shadows here on her leg, as if the building is adding shading to it.

6 Finally, we can move the plane so it's right in her line of sight. Also, by positioning it slightly in front of her hand, we further help to create the illusion that she's really standing in the middle of downtown New York, batting away an attacking air force.

Polaroid-style photos

POLAROID INSTANT CAMERAS may be somewhat out of favor since digital photography became so accessible, but the familiar shape of the photos they produce remains a popular way of framing images, particularly if you're looking to create a retro theme.

The following tutorial serves not only to explain the steps to create a great Polaroid effect, but also to demonstrate the use of clipping groups to crop a photo down to fit the frame; this gives us the freedom to position, scale, and rotate the image within the window before committing to any permanent changes.

Begin by creating a new layer. Use the Rectangular Marquee M to mark out the shape of the frame. Fill the selection with white. This, of course, makes it difficult to see so we've colored the background. You could also turn the background layer off. Press D 30 D to deselect.

5 Polaroid photos are thicker than normal prints so we need to give ours a bit of substance: click the Frame layer's thumbnail to make it active and apply the Simple Inner Bevel. The default is far too large so double-click the Style indicator and adjust the bevel's size.

Bring in your photo either by dragging the image into the document with the Move tool or by copying and pasting it. Make sure it's between the two sections of the frame. Press (A) (B) (C) to group the photo layer with the window backing; the remainder of the image is hidden.

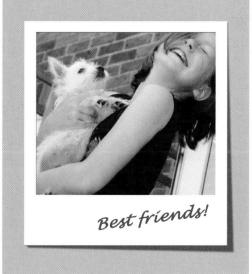

To finish off the effect some texture has been applied to the frame using the Texturizer filter. Setting the texture to canvas with a very low relief gives us a rough but subtle effect, breaking up the solid white. A text layer has also been added; that's why the extra space is there, after all.

HOT TIP

You don't, of course, have to leave the Polaroid image square on the page once it's complete: multi-select the component layers (or link them if you have an older version of the program) and use Free Transform to make further changes. This way, you still have the option to edit the text or adjust the photo a little. We've also placed a shadow beneath to add a sense of depth; see Chapter 5 for more on creating shadows.

SHORTCUTS

MAC WIN BOTH

Spectacular fireworks

IREWORK DISPLAYS ARE FANTASTIC to watch but notoriously difficult to photograph, especially when there are other elements in the scene to consider; the camera has to be perfectly steady to prevent the foreground from becoming horribly blurred – not to mention the problem of timing the shot to capture the moment at its best.

With Elements, of course, we can add our own pyrotechnic delights. Although merging something as complex as fireworks into a photo might seem like an arduous task, it's made surprisingly simple by using a blend mode to knock out the dark areas, allowing the background to show through, which enables us to place the fireworks into the scene precisely where we want them.

We've placed our first firework into the scene which has, of course, hidden most of the background. There's far too much going on to be able to select it or mask it out, and lowering the opacity would cause it to become washed out.

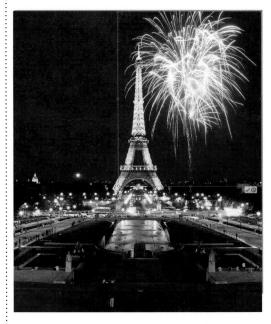

The firework is too large so press (IT) (IT) to invoke Free Transform; now you can position and scale the firework down so it fits into the scene – remember to hold (Spitt) to ensure the image remains in proportion.

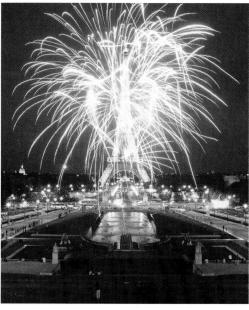

The layer's background is almost black so we can use the Screen blend mode to filter it out, leaving just the bright areas of the firework visible. This gives us an almost perfect result with no harsh contrasting edges.

We can see the background is still visible against the and drag the Shadow slider in from the left a little; you'll see the light area at the bottom begin to disappear.

HOT TIP

If you're creating your firework display over a scene with an expanse of water or another shiny surface, you'll need to remember to add a suitable reflection for the fireworks as well. See Chapter 10 for more details.

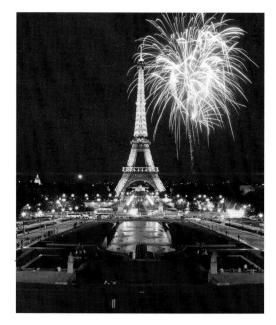

We still have a problem: parts of the firework are in 5 We still have a proofern, parts of the front of the tower when they should, of course, be behind. This is easily resolved by erasing or, better still, masking out the unwanted areas.

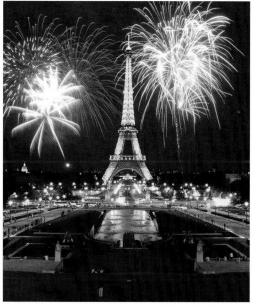

We've placed some additional fireworks to balance the image. Whilst we could have filled more of the sky, in this instance we want to complement the scene rather than totally drawing focus from it.

3 Hiding and showing

Fairy gets her wings

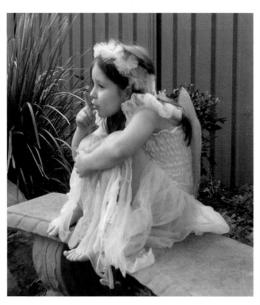

HILDREN LOVE DRESSING UP: either to mimic the latest movie or television characters or just to play a part in their own imagination-fuelled fantasies. With Elements at our disposal, however, we can take things a stage further and turn their fantasy into something more realistic; albeit pictorially, of course.

The following project is split into two sections: in this first part, we'll be concentrating on creating her wings. For this we'll use a layer mask to make the wings transparent. As we'll see, this gives us far more control as we are able to change the opacity selectively, rather than acting on the whole image as we would with layer opacity or blend modes.

1 Open the Butterfly Wing psd file from the CD. There's already an in-line layer mask in place. It's important to have the mask as part of the image like this, rather than using the Adjustment Layer method, as that would make manipulating it too difficult later on.

Keeping the mask active, open the Levels dialog (M) We'll begin by dragging the Highlights slider in from the right. This increases the brighter areas of the mask which makes the black of the wings more solid but leaves the colored areas almost unaltered.

Select the entire image using ctrl A # A. Press hold alt and click the mask's thumbnail. We're now working on the mask itself. Press ctrl V # V to paste the image in. Now deselect ctrl D # D.

We can't see any change, of course, because we're looking at the mask. Click the image thumbnail again; we can see that most of the image is hidden. Click the mask thumbnail again and press ctrl 1 # 1 to invert it. Now most of the mask is lighter and we can see the wing again.

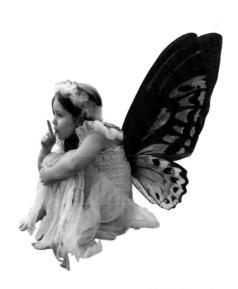

Now we can add the wings to our fairy. We've cut her away from the background and added some space so we can fit the wings in. The wing layer has been duplicated then distorted to fit with Free Transform. One layer is in front of the girl with a small part erased to fit her body.

HOT TIP

A really good way of seeing how changes to the mask affect the image is to open a new viewing window: From the View menu, select 'New Window for filename'. When you set one of the windows to edit the mask, you can keep the second window as a standard image view. As you adjust the levels of the mask you can see the transparency changing

3 Hiding and showing

Extending the scene

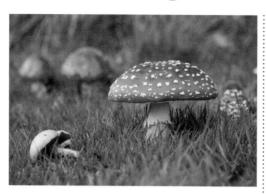

INDING THE PERFECT IMAGE for a montage isn't always easy and you can waste many hours trying. Unless you go out to take your own, specifically with the idea in mind, there will doubtless be something that means it doesn't fit exactly as you intended.

Our project image is a case in point: it's a wonderful image of some toadstools, ideal for our fairy image. The trouble is there isn't enough space to comfortably fit the fairy on the main toadstool. We need to increase the height of the photo – for this we'll use the much overlooked ability of the Crop tool to expand the area of a photo . We will, of course, need to fill in the additional space we have created; we could use the Clone Stamp but there is not much to work with in the background and the result would look messy. Instead, we'll bring another photo into the image and blend it in with a layer mask.

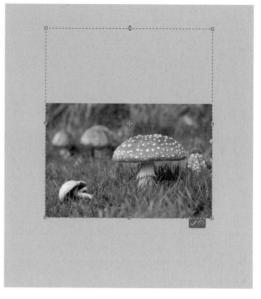

Grab the Crop tool . Zoom the image out so we have some space around the photo. Click and drag the crop boundary around the entire image. Now drag the top-center handle up to mark out the additional space. Once applied, the area is filled with the background color.

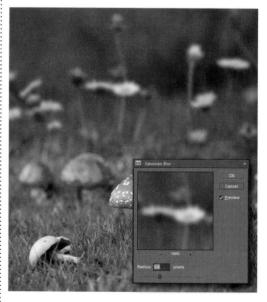

We need to match the focus of the original image.

Make sure we're working on the image by clicking its layer thumbnail. Open the Gaussian Blur filter and check that Preview is enabled. Now start to move the slider to the right visually comparing the two photos until it looks realistic.

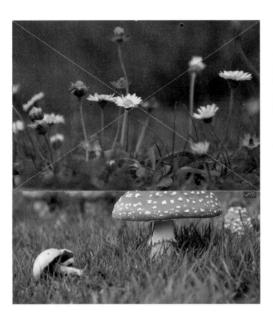

Prom the File menu, select Place and locate the file Daisies.jpg on the CD. The image is automatically scaled to fit. Click and drag the new image to the top of the document. Press Intel to set it down then select Simplify Layer from the Layers menu to convert it to a regular layer.

Now we need to create a mask. This can be done in any of the ways shown at the beginning of the chapter. Once the mask is in place we can start to paint away the area where the two images overlap. Paint in black using a large, soft brush so we get a good blend.

idea to turn
off the option
of resizing
windows when
you zoom in and
out as it saves
you having to
manually drag
the window in
order to see the
space around
the image.
Press and K

K to enter
the General

Preferences then uncheck Zoom Resizes Windows.

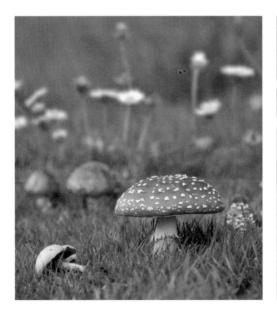

The color of the two images doesn't quite match.

This can be fixed simply by using the Auto Smart Fix command civial M ** SM*. Although these 'magic' options don't always give the best results, it's certainly worth trying them first as they can save a lot of time.

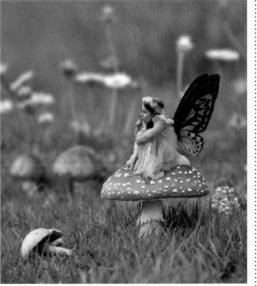

All that remains now is to add our fairy. We've imported the saved file from the previous project and scaled it to fit. We've used Levels to adjust her color and contrast slightly and added a shadow to fix her into the scene. All the techniques for doing this are here in the book, of course.

Reusable images

PEOPLE ENJOY GETTING PERSONALIZED items and Elements is a great way of doing this. It can, however, be a very time-consuming job to create an image from scratch each time. This is where working with layers and masks comes into its own. We can create and save image templates that can be used over and over again. These can be used for almost anything: wedding album covers, birthday cards, invitations; the list goes on.

The trick is to make sure the subject image is quick and easy to replace. In this instance we'll add a photograph to our example image so it appears under all the components of the scene. Initially this takes quite a bit of time for the selection work, but once this has been done all we ever need to do is change the photo; a task which takes seconds to complete.

First we need to make a selection of the box, glass and flowers. A combination of the Quick Selection tool and the Selection Brush works well. We'll ignore the shadows and we only need to include enough in the selection to be able to slot a variety of photo sizes under the objects.

4 Create a new layer below the cutaway layer. Set the blend mode to Multiply. Select a soft brush. Set the foreground color to black. Now begin to paint in some shadows around the box, glass and flowers. lower the opacity to match the existing shadows on the rest of the image.

We have a problem with the glass: we should be able to see through it. Make the cutaway layer active and add a layer mask using the technique on page 52. Grab the Brush tool **3** and select mid-gray for the foreground color. Paint over the base and stem of the glass to make it translucent.

To add to the effect, create a new layer above the photo layer. Now hold **#** and click the photo layer's thumbnail to load its selection. Select Edit > Stroke (outline) Selection. Set the width to about 10 pixels. Set white as the color. Make sure Location is Inside and click OK.

Finally, we've added a small drop shadow to the photo to add a little more depth. We can now save the image as a .psd file, which keeps the layers intact. To reuse the template we simply open it and place a new photo using the existing one as a guide, as we have in the intro image.

HOT TIP

Our example image is fairly complex and selections won't always be as tricky as they are here. It is, however, worth spending the time making the cutout as perfect as possible as it only needs to be done the once. To make the file a little more lean, we can merge the cutout and shadow layers together ctrl E # E

The opacity and translucency are retained in the single layer.

SHORTCUTS

MAC WIN BOTH

Panorama power

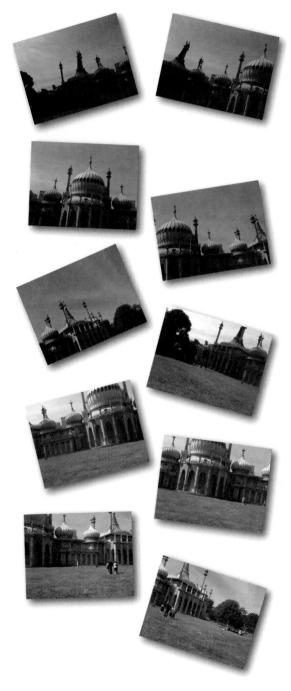

O MANY OF OUR GADGETS now either come with, or can be fitted with, a digital camera. No matter where we are, we will almost always have a way of taking photos. This is great, of course, but there is a downside. Devices such as cell phones have limited space in which to place the camera lens, so they are generally fairly small and rarely have a zoom facility - some have digital zoom but the less said about that the better. This makes taking pictures of buildings or other large landmarks difficult because you have to be at a fair distance to capture the whole thing. This is often impractical or, if it is possible, the results lack clarity and the resulting prints may not be as detailed as they could have been, even with today's high megapixel camera phones.

There is a solution, of course. Elements has an incredible panoramic stitching feature. All we need do is move closer to our subject and take several photos in overlapping sections. Here we took shots across the top half of the building first, then moved back along the bottom. This way, we were able to keep the images fairly level. We feed these into Elements which then goes off and does its magic, producing one complete image at the other end. Fantastic!

The final image has a length of just over 11 inches at 300 dpi. This could probably be blown up two or three times without loss of quality. That's nearly three feet long from a 2 megapixel camera phone. Imagine the size you could achieve if you did the same with a high-resolution DSLR!

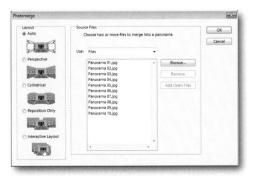

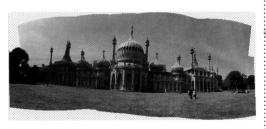

We'll begin by opening the panorama dialog: File > New > Photomerge Panorama. Click Browse and find the Panorama Power folder on the CD. Select all the images by clicking the first file and holding while clicking the last file. They'll appear in the dialog window.

We'll leave the Layout option set to Auto. This will arrange, distort and blend all of the pieces together. Click OK and it will begin to perform its magic. It can take some time, depending on the number of images and the speed of your PC. The result is good but still a little rough.

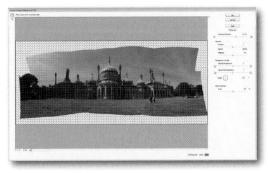

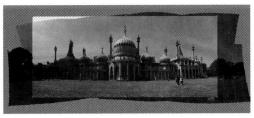

Press crif Shift & Shift to merge the layers into one. Open the Correct Camera Distortion Filter. We can now visually adjust the angle of the building – 2.9 degrees is about right. We can also remove some of the curvature by dragging the Remove Distortion adjustment to the right.

A Select the Crop tool ②. Drag out the bounding box to select the building and some of its surrounding area. We want to cut away as much of the ragged edge as we can. It's not always possible, of course, and we are left with a part of the sky missing. This is easily fixed with the Clone Stamp.

5 Here's our finished image. We've patched the sky in the top-left corner with the Clone Stamp S. We've also used it to remove an unfortunate chap from the bottom left

whose head was removed during the blending process. This often happens if there are people in the scene, as they move between shots. Overall, it's an astonishingly good result.

HOT TIP

images for this composite were all taken by pivoting round from a central viewpoint. This resulted in a slightly curved result as the far extremes are at a slight perspective angle. We could have avoided this to a degree by moving the length of the building, taking photos with a more straighton position as we went. This isn't always practical, of course, and our single point method still gives us a completely acceptable end result.

SHORTCUTS

MAC WIN BOTH

Digital cameras

BEING AN ELEMENTS USER, it's likely that you'll already have a camera of some type, even if it's not digital. You may, however, be looking to buy your first, or upgrade from your current model, and, with so many different cameras on the market, choosing the right one can be a difficult decision. There are many factors to take into consideration and they are largely based on how much you intend to use it and for what purpose; you don't really want to be carrying huge amounts of equipment around with you if you're only interested in taking the occasional snapshot, and similarly, if you're a keen photographer you might be disappointed with the lack of features on a smaller model.

There are three main types of digital camera: let's begin with the compact models. Firstly, small is not necessarily a sacrifice in quality or features. Even at entry level, most start at 3 megapixels (Mp) which will give you a perfect quality 7" x 5" print and a reasonable one at letter or A4 size. Some have a fixed lens whilst others offer a moderate amount of optical zoom – don't fall for the digital zoom gimmick, though; the results are often lower quality because the image is enlarged by the software in the camera and not by the lens. The features vary from set point-and-shoot modes to a reasonable amount of manual control, depending on the model.

Next in line are the mid-range cameras, sometimes referred to as prosumer (from professional-consumer). These are bulkier than the compacts but are generally higher quality, having larger image sensors and more manual control of the settings. The lenses are larger with a good zoom factor; again, many still include the digital zoom feature in an attempt to make the package more attractive to the buyer.

Finally, we have the DSLR (digital single lens reflex) cameras: these are the most expensive and largest, but do give the best image definition, most producing photos that can be printed at A3 with no degradation. They have the same control features as their film-based brethren and their lenses are interchangeable. Many share the same mounts as their analog predecessors, giving you the option of using your existing ones if you choose the same manufacturer.

It's worth noting that, when it comes to the resolution of a camera, bigger isn't necessarily better, especially on the compact cameras which use a smaller sensor;

the receptors need to be more tightly packed and the definition of the image can suffer as a result. For most purposes anything between 3 and 7Mp is sufficient. Professional DSLRs tend to start at 6Mp and can go as high as 20Mp or more but you'll be paying out serious money at that level.

Once you've decided on the type of camera, you need to choose the specific make and model: this can be another minefield, of course, and it's certainly a good idea to read reviews, both in magazines and online. There are two websites well worth visiting: www.dpreview.com and www.stevesdigicams.com; both offer highly in-depth information about almost every camera currently available — and sometimes advanced previews of the latest technology, as well as archives of the older models too.

From a photomontage perspective, having a good camera certainly helps when it comes to sourcing images for your artwork. We'll talk about stock libraries elsewhere in the book and, whilst you're almost certain to find the image you need on at least one of the sites, there's still no substitute for taking your own; you are in full control of the pictures and can get just the right angle and distance to suit your needs. You can create your own library of images, especially if you have a camera that you can carry with you easily at all times; that way, you'll always be ready to capture those interesting scenes and textures. You can also set up a small home-studio for photographing smaller objects, either by buying a dedicated light box and lamps or, if you're feeling particularly adventurous, building your own – there are numerous websites with instructions on how to do this.

You might even consider uploading your own images to one of the many free stock libraries and adding to the constantly growing resources. You may think that your contributions will be just a drop in a very large ocean but you may just provide someone with a picture of something nobody else has. If your pictures are of high enough quality you could subscribe to one of the micro-stock websites such as www.istockphoto.com or www.shutterstock.com. You never know, you may start earning some extra money from it, especially if you sign up with a lot of different ones. There's always the excitement of seeing one or more of your pictures in use on someone's website or in a book such as this, perhaps.

■ The Palace of Westminster is one of London's best-loved and most-photographed attractions. But the dull gray sky that's almost as much a London landmark makes the whole image look dreary. How much better it is when we substitute a blue sky with fluffy clouds. It isn't hard to do, even though that tree may look fiddly.

Image adjustments

THE DIGITAL CAMERA is the best gadget the Elements user can own. But even the best camera can't produce sunny skies on an overcast day, make snow from thin air, or change the color of a car. Fortunately, we have a solution.

Elements allows us to make any changes we like to an image; literally anything we can imagine can be changed within a single image. We can turn silver into gold, alter the time of day, and give the impression of speed.

But we can also enhance our images without adding anything new. Got a dull, lifeless photograph? We'll see how to liven it up in just a few steps – and how to recover apparently lost information from shadows and burnt-out highlights.

Image adjustments

Adjusting images with Levels

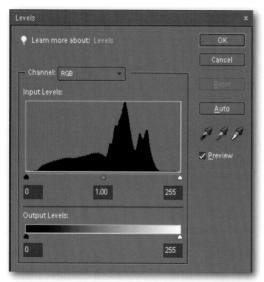

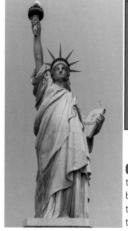

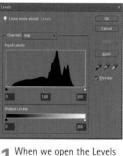

When we open the Levels dialog using arr L

L, all the sliders are in their starting position: the black and white triangles to the extreme left and right and the gray triangle in the middle.

LEMENTS INCLUDES SEVERAL METHODS for adjusting the brightness, contrast and tonal range in images. By far the most powerful – and the most versatile – is Levels, which gives a large degree of control over your pictures. Getting to grips with Levels will mean you're able to fine tune your images to get perfect results.

The Levels dialog is in three parts: the histogram, the graph which shows the spread of tones in the image; the Input Levels, which allows you to adjust highlights, shadows and midtones; and the Output Levels, which controls the final brightness and contrast of the finished image.

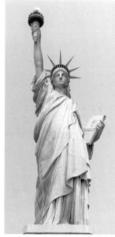

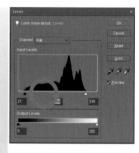

4 Dragging the center gray slider will affect the midtone values. Here, dragging the slider to the left brightens the image without changing the brightest and darkest areas.

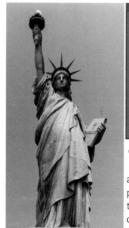

T Levels also gives access to the individual red, green and blue channels, using the pop-up menu. Here, dragging the midtone on the red channel to the right reduces the total amount of red.

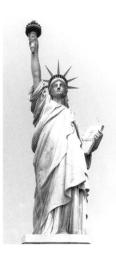

2 Dragging the small white triangle in the Input section to the left will brighten the image overall. Similarly, dragging the black triangle to the right will darken it.

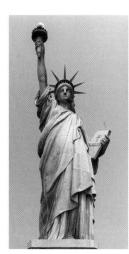

3 A good way to balance an image is to drag the black and white triangles so they touch the extreme edges of the histogram. This gives the image the full tonal range and makes it much crisper.

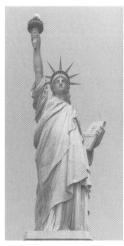

5 Dragging the black Output triangle to the right makes the image brighter; dragging the white triangle to the left would make the whole thing darker. Moving either will reduce image contrast.

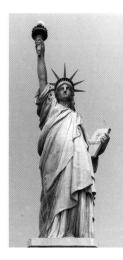

button can produce a marked

improvement at a stroke.

HOT TIP

If you make a mistake and feel everything has gone horribly wrong, don't panic: press the Reset button to return the dialog to its original state.

You can use the three eyedropper tools to adjust the image automatically. With the black (left) dropper, click in the darkest part of the image; click the brightest part with the white (right) dropper. Use the gray (center) dropper to click on a neutral gray in your image (if there is one), to color balance the image.

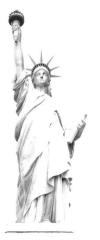

When we drag either the black or the white Input triangles, the middle gray triangle moves with them to remain spaced half way between light and dark.

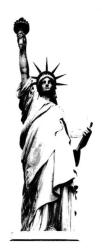

9 By dragging this midtone gray marker towards the light end, we can produce a strong, graphic effect.

SHORTCUTS

MAC WIN BOTH

Shadows and highlights

XPOSURE IS THE
ONE factor that
photographers worry about
more than any other.
Professional photographers
will always 'bracket' their
exposures – that is, they'll
take a range of exposures of
the same image to make sure
they've got the right one.

The real difficulty comes when we're faced with an image like this: a view through a window. In the image captured by the camera, above, we can see that the room itself is too dark (we can barely make out the blind texture among those deep shadows), while the view is so bleached out as to be wholly indistinct.

We can fix both of these problems in one go, with the Shadows/Highlights adjustment. It's a hugely powerful tool which can rescue even the most poorly exposed photographs.

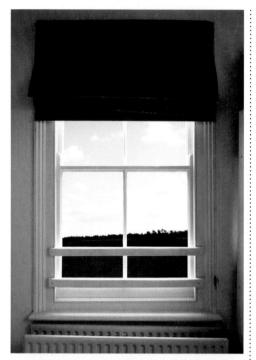

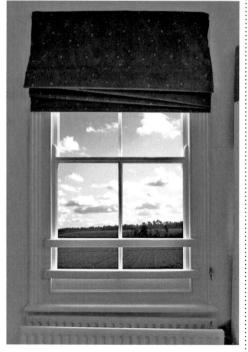

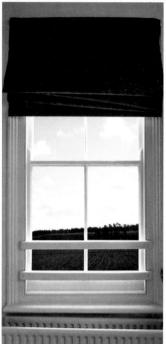

After opening the image, go to Enhance > Lighting > Shadows/ Highlights, and the dialog above will appear. As long as the Preview button is checked, any changes you make here will be visible immediately in the image. The default setting for this adjustment is to Lighten Shadows by a value of 25% and, as we can see here, this setting manages to rescue some of the darker areas of the image. We can already see that there's a yellow pattern in the blind, for example.

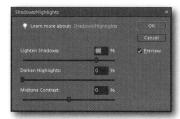

2 That's not enough for our purposes. Let's increase the value significantly – here, we've dragged the slider to raise it to 80%. Now, the pattern and texture in the blind can be clearly seen. In addition, we can see that the dark field outside the window has now acquired some definition: the trees on the hill are now distinct from the plowed field in front of them.

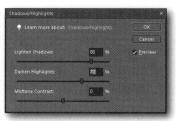

Now let's turn our attention to the Highlights. As the image stands, the sky is greatly over-exposed. Dragging the Darken Highlights slider addresses this problem: the further to the right we drag it, the more detail we're able to see in the sky. We've dragged it here to a value of 70% and this means that the clouds now stand out from the sky behind them.

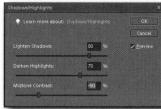

Although we could stop there, it's worth looking at the final slider – Midtone Contrast. Generally, we'd welcome contrast, as it provides definition within the image. Here, though, the result of tweaking both the shadows and the highlights has resulted in a window frame that's so well defined that it overpowers the view through it. By lowering the Midtone Contrast we take out a little of that over-defined molding, drawing the eye through the window to the view instead.

HOT TIP

Not all cases are as extreme as this one. The adjustment is also useful when a person has been photographed with side lighting: by lightening the shadows and darkening the highlights, we're able to give the impression that the lighting came directly from the front.

Bee flat to bee sharp

E ALWAYS STRIVE to get the best possible images but sometimes, even with the best equipment, we can end up with an image that is slightly soft.

In our example the combination of the extreme close-up and the bee's movement has resulted in a less defined photo. There is, of course, no way to get a clearer image once it's been taken but we can enhance it to give the impression of it being a lot sharper. We'll have a look at two different sharpening methods here, each of which provides a slightly different effect.

Rather than working directly on the image, however, we'll use a grayscale copy and blend it with the original; this way, we have far greater control over the final effect.

These effects can, of course, be applied to any image, regardless of its original clarity; by reducing the amount of adjustment we can give a photo some added pop.

Here's our slightly soft photo in need of a little attention. We're not going to work on the image directly so the first step is to duplicate the background layer. Both techniques require a grayscale layer so we need to desaturate the layer by pressing our Shift U \(\mathbb{H} \) Shift U.

4 With our adjustment applied we can overlay it onto our original image. Set the blend mode to Soft Light. Our image is looking a lot sharper whilst retaining much of its tonal qualities and color balance, something that could be affected if we'd applied the effect directly to the original.

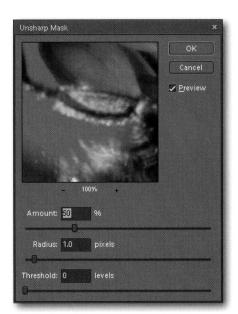

2 For the first technique we'll use the Unsharp Mask adjustment. This can be found at the bottom of the Enhance menu – in previous versions it can be found in the Filter menu under Sharpen. The dialog may look a little daunting but it's surprisingly straightforward.

5 The second technique makes use of a little-known filter called High Pass; this resides in the Filter menu under Other. There is only one slider and, unlike Unsharp Mask, we only need to make a small adjustment to achieve good results – we've used a setting of 3 pixels here.

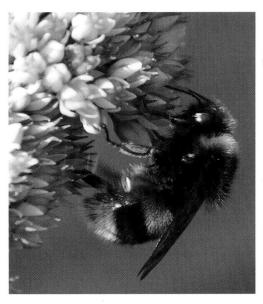

The default settings are fairly tame and have little effect on our image. Drag the Amount slider to the right; don't be afraid to increase it more than you would normally; it won't look as severe when we blend it with the original. In this case we raised it to 350%.

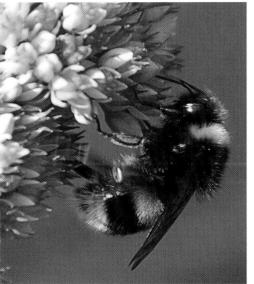

6 As before, we need to change the blend mode; this time, set it to Hard Light. This is a more subtle effect than the Unsharp Mask version, concentrating more on the edges than the entire image, but still gives superb results and leaves the original color almost unchanged.

HOT TIP

There is no right or wrong way of sharpening; the method used depends greatly on the image itself. Some photos may require an all-over effect, whereas others may just need their edges enhanced. Because we're applying the adjustment to a layer, we can experiment with different blend modes and opacities and even combine the techniques. At worst, all we would need to do is to create a new effect layer and reapply the adjustment.

4

RAW adjustment

OU WOULD BE FORGIVEN for thinking that RAW is something that should be left in the realm of the professional photographer. This is not the case, however: more and more compact and so-called 'prosumer' (the not-quite-DSLR type) cameras are now able to record their images in RAW.

So what is so special about this format? When you take a photo the camera records the data its sensor sees into memory. Normally this would then be converted to a JPEG by the camera and stored on its memory card. Various enhancements are carried out during this process, making sometimes irreversible changes, and as the image is compressed, there is already a slight degradation in quality. RAW images are not processed by the camera. The recorded image is saved unaltered (more or less) to the memory card. The data is instead decoded by the software on the computer. This gives us far more editing power as we can work on the separate color channels to make more precise corrections. The main benefit, however, is RAW's non-destructive editing. Whenever a change is made, the original image remains untouched. The alterations are written to a control file which in turn tells the software how to display it. These changes can be output to a separate version of the image, either by opening it in Elements or saving as a .dng (digital negative) file directly from the Camera Raw dialog.

¶ Go to the File menu and open RAW adjustment.crw from the CD. Before we start working on our image, make sure you are working in full screen mode. This can be done by pressing ♠ or by clicking the button just to the left of the histogram window.

A Now we can start color correcting and enhancing the image. Firstly we'll set the white balance; this generally defaults to As Shot. The image was taken in sunny conditions so set it to Daylight. This gives a slight blue hue and brings out the color of the sky and water.

Blacks is the opposite to Recovery, dealing with the heavy shadow areas. Again, there aren't too many in this image. Press to display them; they show up in blue. There's a very small area on the hull of the boat. This time drag to the left to tone them down.

2 One of the first things we notice is that the image is crooked. Select the Straighten tool from the toolbar (or by pressing (a)). Find a suitable guideline – the opposite ends of the bridge work well. A boundary appears showing the change in angle. Pressing (Enter) sets the changes.

5 It's worth trying the Auto Correction option. Even if it's not perfect, it serves as a good baseline. It's done a pretty good job here. If we weren't happy with the changes, we could select Reset Camera Raw Defaults from the fly-out menu on the tab bar to return it to its initial state.

The previous adjustments have left the image slightly washed out. Grab the Clarity slider and drag it to the right. This acts as a subtle form of sharpening by boosting the midtones of the image. A value of 60% works well here and takes away the haziness.

We can also crop the image down a little. Select the Crop tool . The skew-adjusted boundary appears again. We want to keep the same image aspect: hold . And drag the bottom-right corner in – enough to remove the cut-off ship and its mooring. Press . Enter again to set it.

6 We'll concentrate on the lighting adjustments first. Recovery deals with blown highlights. There are very few in this image. Press **o** to turn on the highlight clipping warning. A small red area appears on the boat on the right. Drag the slider to the right until most of the red area is gone.

9 The last adjustment we'll use is Vibrance. This boosts the less saturated colors whilst leaving more saturated ones untouched. It really deepens the sky and the softer colors of the buildings. Finally, we can save all our changes by clicking Done. They will be there next time we open this image.

HOT TIP

The standard tool cursors can get in the way, particularly if you are zoomed right out of the image. You can temporarily switch to precise crosshairs by pressing the Caps Lock key. This is especially useful for the Straighten Tool, where you often need to pinpoint a particular area of the picture. To return to normal cursors, simply press Caps Lock again. This shortcut also works for most tools within Elements' Editor workspace.

Photomerge: exposure

NE OF THE DIFFICULTIES with photography is the inability to capture both bright and dark areas of the scene at the same time. Unlike our eyes, which can create a happy medium between the two extremes, the camera falters, leaving us with horribly blown out highlights when we try to capture shaded areas and disappointingly dreary shadows if we expose for the bright areas.

Fortunately, with Elements 8 we have a solution. The new Photomerge: Exposure command basically compares the differences between two or more photographs at different exposure levels to blend and output one composite image comprising the best of the batch. The photos can either be shot separately at the same time, exposing for light, shadow and midtone – the filter will also realign the images if necessary – or, as we will see here, they can be created them using the Camera Raw dialog. Here we can save different exposures of the exact same image, so they will be perfectly aligned from the outset.

There are two modes, automatic and manual; the former is the default and will often do the job without any need for alteration. It's not perfect, however, so we can also get our hands dirty and define the regions of the image ourselves to perfect the result.

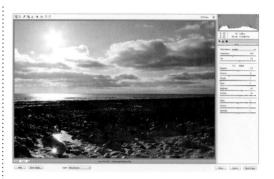

1 Open Photomerge exposure.dng from the CD. The photo will appear in the Camera Raw dialog. The image has already been straightened and auto-adjusted. We can see that the image has been exposed for the sea; the foreground is dark and the sun and sky are a little too bright.

4 Open the original image one last time. Increase the Exposure to brighten up the rocks in the foreground. Save the file, appending the filename with Light. Now make sure the Project Bin is visible; if it's not, you can make it do so by clicking its entry in the Window menu.

Now click the Light image and paint over the rocks in the same way. We now have a much more evenly balanced image. If we click the Show Regions box, we can see where the image has been blended. It's an even split but more complex images would have many blending areas.

2 We'll use the starting image as our base. Click the Open Image button to open the photo in Elements. We have to save the file as we cannot open more than one version of the same file. We'll add the word Mid to the end of the original filename as it's a midtone equivalent.

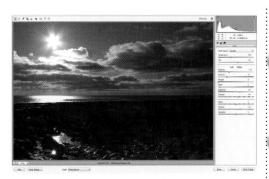

3 Open the original dng file again. Drag the Exposure slider to the left. We want to tone down the blown highlights. We can also add a little Vibrance to bring out the blue sky. Open the image in Elements. Save it as before but this time append the filename with Dark.

HOT TIP On complex

images with finer detail, you may find yourself accidentally spilling over into the wrong area of the image when working with the Selection tool in manual mode. We can still undo the last few actions but, if we've gone too far to do this, there is the Eraser tool. We can erase the section definitions which remove that area from the background image. Remember to make the relevant photo active first by clicking its thumbnail in the Project Bin.

5 Go to File > New > Photomerge Exposure. Elements will start to process the files. When it's finished we have our merged photo. It's done a reasonable job but the colors are a little strange. We have a limited amount of adjustment control here but not enough to make a difference.

6 Click the Manual tab. Click and drag the Mid file from the Project bin to the right-hand (background) window. Now click the Dark file's thumbnail to make it the active foreground. Make sure the Selection tool is enabled. Paint a zig-zag line over the sky to replicate it to the background.

The sky is a little too intense. Click the Dark thumbnail to make it active. Now drag the Transparency slider to the right. This works like opacity, allowing the background image to become more visible. It's always best to make the middle exposure image the background for this reason.

9 When we're happy with the effect, we click Done to return to the Editor window. A new document will be created containing both the original mid-exposure image and the merged image as a layer. We can now save it as a Photoshop file to keep the layers or as a single JPEG image.

All that glitters...

HANGING A SILVER OBJECT to gold is not a difficult task. The two metals are very similar. They have the same specular properties (the way light is reflected back from their surfaces – once polished, of course). Silver has a high content of blue, giving it its colder appearance. Gold, on the other hand, is predominantly red and green. It's simply a matter of adjusting the hues to give us the familiar warm color. Although you might be tempted to use a Hue/Saturation adjustment, we'll use the Levels dialog. By working with the color channels individually, we have far greater control.

Here's our silver watch. The face has been cut away from the rest of the image and placed on a separate layer. We only want to color the body, after all.

Because of its slight angle, we used the shape selection technique from Chapter 6.

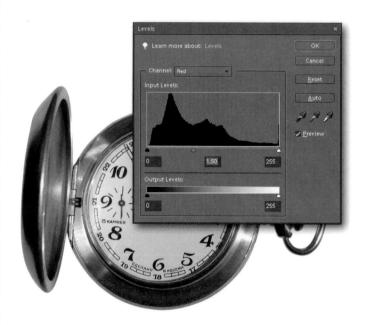

3 Now switch to the red channel. This time increase the amount by moving the Midtone slider across to the left. As you can see, our watch is now looking much more valuable. It's still a little dull, though.

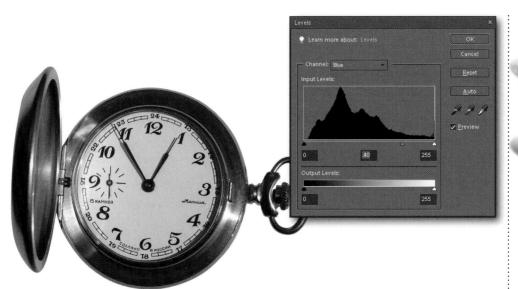

the drop-down menu. Move the Midtone slider towards the right. As the blue is subtracted from the image, the color becomes noticeably greener and much closer to gold.

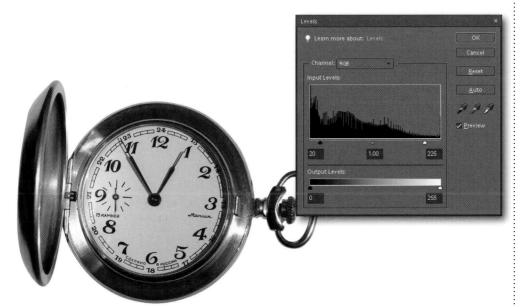

4 Switch back to the composite RGB view. Drag the Highlight and Shadow sliders a little way toward the

middle. This gives us a richer tone to the color as well as giving the impression that the metal is much shinier.

HOT TIP You can also

select the individual channel views from the keyboard. Holding ctrl 第 and 11, 22, or 3 will switch between the red, green and blue channels respectively. Press ctrl 第 and the ~ (tilde) key to return to the composite RGB view - not the more logical 0, as you might think. This, of course, is the reserved shortcut for the Fit on Screen view mode.

SHORTCUTS

MAC WIN BOTH

Image adjustments

The perfect respray

HERE ARE NUMEROUS WAYS to change the color of an object. Most, however, are designed to affect the entire image. We could, of course, use the selection tools to isolate the parts we need to work on. This is a timeconsuming practice and often more trouble than it's worth.

For tricky jobs, such as this car with all that complex trim, by far the best method is to use the Replace Color tool. With this we can selectively alter the hue, saturation and lightness of an area without the need to separate it from the rest of the image.

Press ctrl J # J to duplicate the background layer. Open the dialog by going to Enhance > Adjust Color > Replace Color. The white area in the preview shows the selected area after clicking a section of the car's body. We've set the Fuzziness to its maximum and will adjust it later.

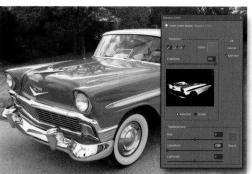

Instead of applying the new color straight away, we've lowered the Saturation completely; this shows up the more subtle shades of red not included initially. We can add these areas to the selection by holding Shift and clicking them with the eyedropper.

HOT TIP

The Fuzziness setting of the dialog works in a similar way to the tolerance feature of tools such as the Magic Wand. By increasing the value, Elements will select a greater tonal range of the chosen color. This can be used to avoid harsh lines where two hues meet. It's rarely possible to achieve a perfect result with no excess areas affected; if we keep refining the balance by adjusting the fuzziness and adding in small amounts to the selection we can keep problems to a minimum.

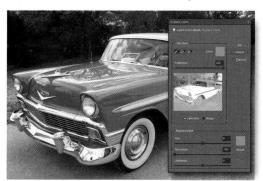

We've isolated all of the car's color but we now have a problem: looking at the preview, a large number of unwanted areas have been included from the rest of the image. This is where we'll use the Fuzziness setting to finetune the result.

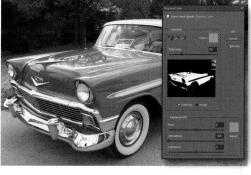

By gradually lowering the Fuzziness value we can see the selection start to tighten up in the preview. Some of the previously selected color will begin to reappear. Zoom in a little and start to add these back in. If necessary, adjust the Fuzziness a little more until you have a good balance.

Now we can add the new color by raising the Saturation 5 and altering the Hue to the desired shade. As we began by duplicating the image, we can simply erase the unwanted areas, such as the 'for sale' sign in the window and the trees in the background, to let the original show through.

You may notice, there are still places where the original 6 hue remains. Often this will be noticeable in the highlights and reflections. As a final touch, grab a soft brush. Set its blend mode to Color. Now you can carefully paint over these areas with the target color.

4

Shifting seasons

E CAN'T ALWAYS BE THERE to capture a scene at a particular time of year. Our example image was taken during the summer and, whilst it's already a very picturesque scene, it would look particularly beautiful in the fall, with the reds and browns of the leaves framing the chapel nestled within.

There's no need to hang around, of course; we can speed up the seasonal change with Elements. In the previous project we changed the color of the car with Replace Color. We'll use it here as well but we'll need to take a slightly different approach as we want to make the shades of the leaves different. We can't do this in a single action, so we'll change portions of the image individually to build up the effect.

Duplicate the background layer and May Now use the Quick Selection tool to make a selection around the chapel. Soften the selection slightly with Refine Edge or Feather. Press and Shift May Shift to inverse it. Now only the trees will be affected.

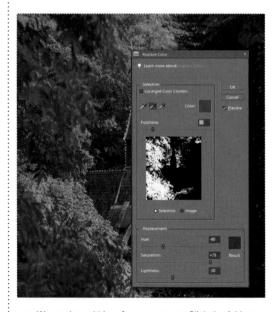

We need to add in a few more tones. Click the Add to Sample (middle) icon in the Selection area. Click a few of the areas next to the reds to add them in – not too much as we don't want to include too many shades. Now use the Fuzziness slider to fine tune the selection. Click OK to apply.

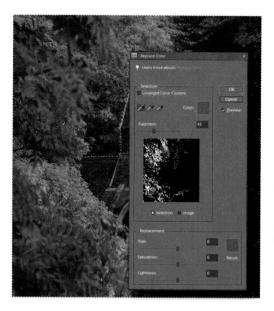

2 Open the Replace Color dialog from the Enhance menu. Click the Selection button so we can see the area of the effect. Choose a suitable starting point such as the large leaves on the left. Click the eye-drop cursor on one of the leaves. The area shows up as white in the preview.

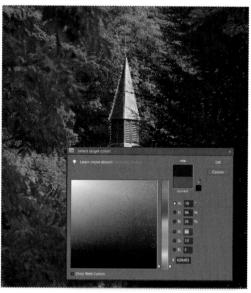

Rather than trying to get the right color using the Hue slider, we're going to be a bit bolder. Click the color chip in the Replacement area. Select a fairly deep red/brown hue. We've picked up a little of the green here. Click OK to accept the color change.

6 With our new colors, the chapel looks a little stark. Inverse the selection again. Now create a Photo Filter Adjustment Layer. The chapel will be masked from the selection. Select the Warming (85) preset and increase the density to give the impression of a warm fall glow.

HOT TIP

Try not to encompass vast areas of different colors. This can result in some bizarre shades which are difficult to control. Working with many smaller, more focused areas gives far better results. In Elements 8 we have the Localized Color Clusters feature. This works like the Contiguous setting on the Magic Wand, attempting to keep the color selection to a smaller area of the image.

If the colors look too bright when the image is complete, we can always create a Hue/Saturation Adjustment Layer to mute them a little.

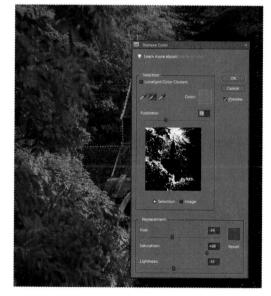

5 Open the Replace Color dialog again. Select a different range of greens and adjust them as before. This time, use a slightly more orange tint in the Color Picker. Try not to make the colors too bold as they can end up looking unrealistic. Repeat the technique for the rest of the image.

SHORTCUTS

MAC WIN BOTH

A splash of color

EAVING LARGE AREAS of prominent color in an otherwise monotone image to make it leap out at you is by no means a new idea, although it was used to great effect in the recent movie *Sin City*, which we'll be paying homage to in this project. It has always been possible to create this effect in Elements, of course, but with version 7 came a new tool which makes the whole thing much easier.

The Smart Brush is a combination of the Quick Selection tool and Adjustment Layers: as you click or paint, the selected area dynamically builds a mask, so only that part of the layer's effect is visible. The great thing is that, because they are Adjustment Layers, we can change the look of the image in an instant by simply choosing another preset or by altering the opacity or blend mode.

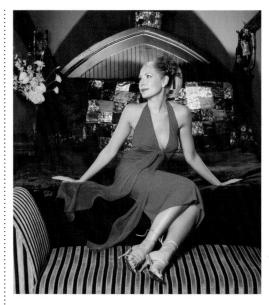

Here's our starting image. It's fairly striking to begin with but we can make it really stand out with just a few simple steps. Begin by grabbing the Smart Brush tool ; go to the Preset Picker, select Photographic from the drop-down list and choose Natural Tone BW.

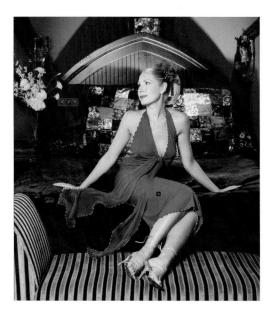

Continue clicking around the dress, varying the brush size accordingly. The tool is good but not infallible and some areas have spilled onto the bed and parts of the skin. We can remove these by holding at to temporarily switch to subtract mode and clicking/painting over them.

5 We've added as much as is possible with the Smart Brush. Pressing again gives us the Detail Smart Brush. Using this, only the immediate area is affected so we can resize the brush and paint the rest of the areas in. We can also use it to touch up any other areas around the dress.

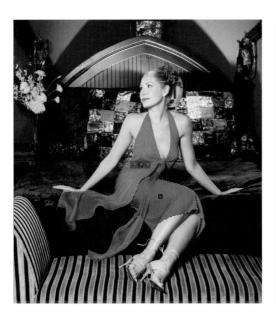

2 It makes more sense to work on the areas we want left intact and switch them later, than to spend time on the background. We'll start with the lower part of the dress. Using a fairly large brush, but making sure it stays within the confines of the dress, click once to begin the selection.

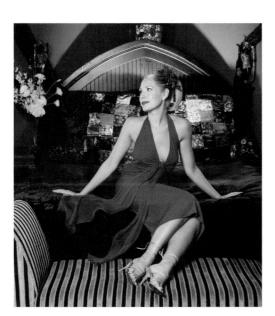

6 Here's our image with all the areas painted in. We're almost ready to reveal the final effect but as a last piece of tidying we can use Refine Edge (see Chapter 1 for more detail) to clean up the fringing that's been left around some of the dress.

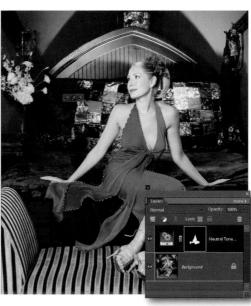

The small square that appears marks the starting point of the selection and is color coded for when there is more than one effect layer applied. Add some more areas in by clicking once each time. If we look at the Layers panel we can see how the effect is starting to build up.

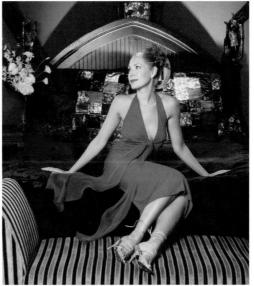

Clicking Inverse in the Options bar swaps the areas around and gives us a stunning result. We found the black and white to be a little too bright so we've changed the Adjustment Layer's blend mode to Color, as this gives us a slightly more even contrast.

HOT TIP

By default, whenever we select the Smart **Brush or Detail** Smart Brush, the Preset Picker appears. This can be very off-putting, especially when switching between the two as we have done in this project. Fortunately, we can turn this off: open the Picker window and open its fly-out menu. Click Show on **Tool Select to** uncheck and disable it.

Image adjustments

Smart bling

HE PREVIOUS PROJECT introduced us to the power and ease of use of the new Smart Brush. We only used a single layer for the effect but, as we'll see, you can apply as many as you need. Each can be a stand-alone effect or one that enhances the rest of the artwork.

There is a whole host of preset styles available by default and more can also be installed. Because they are standard Adjustment Layers, we have hundreds of possible effects at our disposal: we can even import Photoshop-only layers, which gives us extra scope.

The custom presets and installation instructions can be found in the Goodies folder on the CD.

Our starting image is just a simple embossed image created using a similar technique to the wax seal in Chapter 7. It's a bit dull and looks like pressed plastic at present – not very exciting at all. This is all about to change, of course: select the Smart Brush and choose the Gold preset from the Picker window.

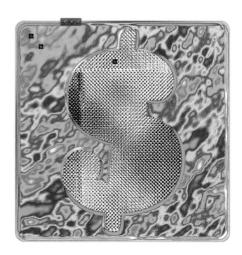

4 Let's really add some value with some diamond encrusting. Deselect again and choose the Diamond preset. Decrease the brush size so it fits comfortably within the dollar emblem and start to paint. We have a bit of a problem, though: because some of the edges are low contrast, the texture has spilled out. We'll deal with this next.

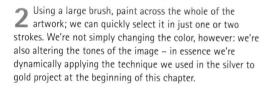

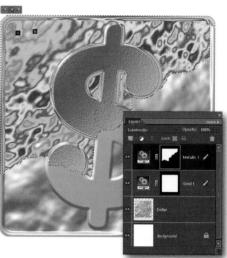

Now to create the impression that the surface is polished: Firstly, deselect oth D # D, to force the tool to add a new effect layer. Go back to the Preset Picker and select Metallic. As we can see in the inset, painting over the object again applies a new texture on top of the gold layer and they interact to create the shiny surface.

HOT TIP The colored

icons that appear on the document are visual links to the individual effect layers. Left-clicking on one takes us straight to the corresponding layer - very useful when we have many different effects. Rightclicking gives the option of editing the settings (unless it's not a native function of Elements). We can also opt to delete the current effect or select another layer by name.

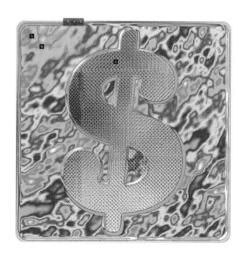

We'll use the Detail Smart Brush 🗗 to clean up the problem areas, as we can work much more accurately with it. Remember to switch to Subtract mode, either by holding all or by clicking the icon in the toolbar. As the texture has covered up the shape, we can lower the opacity of the Adjustment Layer to enable us to see more clearly.

Here's our completed artwork: not bad for only a few 6 minutes' work. Once we have our effects in place we can easily alter them too: we could, for example, swap the gold for silver and the diamonds for gold. This is done simply by selecting the relevant layer and choosing another style from the picker.

Changing skies

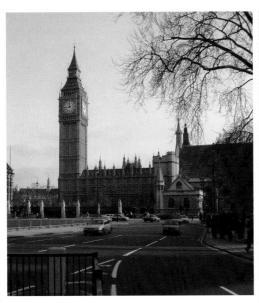

HE BACKGROUND ERASER is a fantastic tool for removing areas of similar color. It's the second of the Eraser tools and it works by sampling the color beneath the crosshair and deleting all the pixels of that color within the radius of the brush. Here, we're going to use it to erase all of the sky from this photograph of London's Houses of Parliament and replace it with a more dramatic sky.

Although we could select and delete much of the background using the Magic Wand tool, that won't select inside fiddly areas such as around the tree: this is where the Discontiguous setting of the Background Eraser comes in handy, as we'll see in this example.

Before we start with this tool, it's important to duplicate the layer you're going to work on, hiding the original so there's always a copy we can return to later.

Select the Background Eraser tool and change its limits from Contiguous to Discontiguous. A Tolerance setting of around 40% works well for this plain sky. Click and drag around the tower to delete the background, but be sure not to let the crosshair stray onto the building.

Continue erasing all of the sky within the image, varying the size of the brush as you need to. Don't worry if some areas of the picture are erased that shouldn't be; we can get those back later. For now, concentrate on getting rid of all that sky.

2 When we move into the tree area, we have a problem. Once the crosshair touches the branches, that's the color that's sampled – and so that's the area that is deleted. We need to find another way to remove the sky in there. Undo that step and we'll try again.

5 When we now bring in a new sky layer behind the buildings, we can see a few mistakes: the clock face has been erased and we can see the new sky through it, and the same applies to one or two parts of the buildings. Just as well we were working on a copy of the layer!

Make the Eraser brush size much larger – we've used a 175 pixel brush here. Click on a clear area of blue sky within the tree branches and all of the sky within the radius of the brush will be deleted. Make sure you don't click on the branches by accident.

6 Make selections around the missing building parts, using the Lasso tool. Now return to the original (hidden) layer and press and \$\mathbb{H}\$ \$\mathbb{H}\$ to make a new layer from the selection. Move this layer above the clouds layer and the image is complete.

HOT TIP

There are several settings for this tool. The first is choosing between Contiguous and Discontiguous: the former will find edges and the latter will look inside bounded regions such as the branches of the tree.

The Tolerance setting depends on how uniform the background is. The higher the Tolerance, the wider the range of deleted colors will be. It's a matter of judgment for each image individually; start with a setting of around 50%, and increase or decrease it as needed.

Image adjustments

Making rainbows

HETHER IT'S THE PROSPECT of finding the fabled pot of gold or simply its beautiful colors, a rainbow can really lift your spirits on an otherwise dreary gray day. The problem is that the conditions have to be just right for us to see one. The sun has to be low and behind us and it has to be raining, of course. This is not a common combination.

We don't have to rely on science and nature to call the shots, however. We can make our own rainbows in dry comfort. In just a few steps we can not only paint a spectrum across the sky but conjure our own rain as well.

As well as using the technique for photographic effects, we could just as easily use it to create bolder graphic objects to highlight stationery or brighten up collages and album pages.

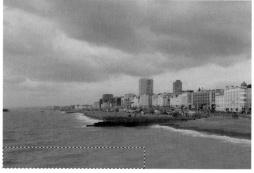

Start by creating a new layer. Grab the Rectangular Marquee tool M and draw out a selection from the bottom-left corner to around half way across the document. The height determines the rainbow's width; we don't want it too wide to begin with as we'll be scaling it up later.

Enter Free Transform (III) and scale the rainbow up proportionally; it will help to zoom out (III) so we can see outside of the image bounds. We can also stretch it horizontally to gain more of an arc. Press (Enter) to commit the changes.

Now open the Motion Blur filter. There are no definite settings for this; it's just a case of experimenting with the angle and distance until we get a reasonable rain effect. Click OK to apply the filter. Use Free Transform to scale the layer up slightly to lose the harsh edges the filter has left.

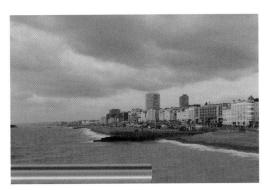

2 Select the Gradient tool **G** and pick the Transparent Rainbow preset from the Options bar. Make sure Linear Gradient is selected and, holding **Shill**, drag just inside the boundaries of the selection from the bottom to the top. Release the mouse and deselect **Chill B D**.

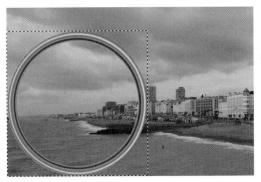

3 Grab the Rectangular Marquee again, hold Mill to keep it square, and click and drag from the bottom-left corner of the image to the far right of the gradient. Select the Polar Co-ordinates filter (under Distort), choose Rectangular to Polar, and click OK and deselect.

HOT TIP

You may find that when you run the Polar Co-ordinates filter you get a colored haze around the circle. This is because part of the object gets caught on the edges of the filter. To avoid this, select the Move tool and nudge the gradient up from the bottom by a couple of pixels to leave a gap before making the square selection.

Similarly, if you find you have a gap in the circle, it's because there was a gap between the end of the gradient and the selection.

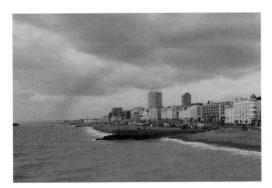

5 We don't want the bottom part of the arc so use a soft-edged Eraser (a) to remove the excess. Now apply some Gaussian Blur to make it more hazy; the exact amount will vary depending on the image size. Finally, we'll lower the layer's opacity to fade it out a little.

We couldn't have our rainbow without rain, of course. Create a new layer above the rainbow, then fill it with 50% gray using the Fill Layer dialog Shift Backspace. Now add some noise: check the Gaussian and Monochromatic boxes and push the amount up to around 100%.

Holding (a) So, create a Levels Adjustment Layer. Check Group With Previous Layer and click OK. Now we can adjust the strength of the effect: bring the Shadows up to the edge of the histogram then adjust the midtones and highlights to produce a lighter amount of rain.

9 Click the rain layer's thumbnail to make it active again and set its blend mode to Screen. This hides the black, leaving us with just the rain. Using an Adjustment Layer means we can go back at any time and edit the settings to increase or decrease the amount as we see fit.

Catching the drops

E CAN'T ALWAYS CHOOSE our backgrounds and, whether we just want a better looking photo or need the subject to be placed in a different image entirely, we need to be able to make a good selection, and one that comprises all the required details. Our standard tools do a great job in most cases but, as ever, there will always be something that eludes even the most powerful of them.

In our example, the fountain's background is hardly inspiring, so we'd like to cut it away and replace it with something more fitting. The problem we have is all the little splashes of water: we need to keep them because the image would look static and unrealistic without them, but it's too much for the Magic Wand to cope with. Zooming in and selecting each one by hand would be far too time-consuming.

As we'll see, though, by applying a little lateral thought, we can achieve our goal quickly and very effectively.

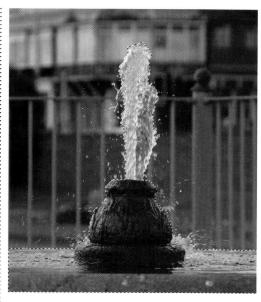

1 We'll begin by selecting as much of the fountain and water as possible. The Quick Selection tool is perfect and makes short work of this. For earlier versions of Elements, we could use the Magic Selection Brush or a combination of the Magic Wand and the normal Selection Brush.

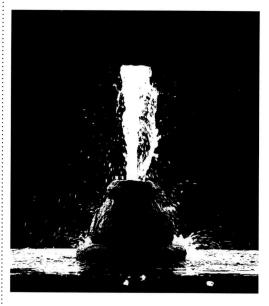

4 There are a lot of areas that we don't want: we can paint these out using a hard-edged black brush. The fountain is saved so we don't have to be too careful around it, as long as we leave the splashes intact. We can erase the area at the top where it meets the windows, for example.

With the basis of our selection complete, we'll store it for later: go to the Select menu, choose Save Selection and give it a name, and click OK. Now deselect [21] D. In preparation for the next part of the technique, we'll duplicate the background layer [21]]

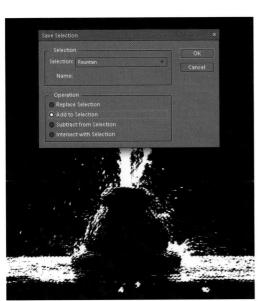

5 Grab the Magic Wand **₩** and uncheck Contiguous in the Options bar. Clicking in one area of white will select them all. Open the Save Selection dialog. Choose our previously saved one from the list and click Add to Selection. Finally, click OK. We can hide or discard this layer now.

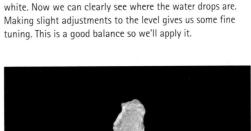

Select the Threshold adjustment from the Filters menu.

This converts the light and dark areas to pure black or

Make the background layer active and load the saved selection. Apply a 1 pixel Feather to soften the edges then press (III) ** To make a copy. Shown against black, we can see how good the result is. We can add a more suitable background, of course, as our intro image shows.

HOT TIP

As an additional step, we could separate the main water spurt from the rest of the image by selecting with the Rectangular Marquee and cutting it to a new layer ctrl Shift J 策 Shift J. We can desaturate it to remove any unwanted color casts and also lower its opacity a little to make it slightly translucent.

0-60 in ten minutes

F YOU'VE EVER TRIED TO PHOTOGRAPH a moving object such as a car, you may have found the results disappointing. When cameras are set to automatic mode they have a nasty habit of removing the action from the image by freezing the motion.

Fortunately for us it's not difficult to put the drama back, or, as we'll be doing with the image above, to create movement from a stationary image. We'll see two different ways of doing this: the first mimics the use of a slow shutter speed by blurring the object in front of a static background. The second method is the opposite effect: the car remains still whilst the background is blurred. This would be the result of panning – following the subject's movement with the camera whilst taking the shot.

The first task is to isolate the car from its background. A combination of the Magnetic Lasso and the Selection Brush is best for doing this, the latter being used to tidy up the tricky areas of low contrast. Copy the car to its own layer by pressing (17) 3 J.

4 You'll notice there's some blurring in front of the car as well as behind, most prominently around the tires and far right of the bodywork. This, of course, wouldn't happen unless it was being vigorously shaken. Select a large, soft eraser. Use the edge to carefully remove the unwanted areas.

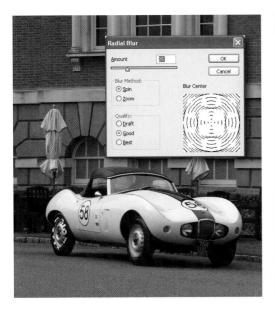

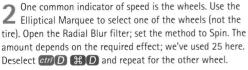

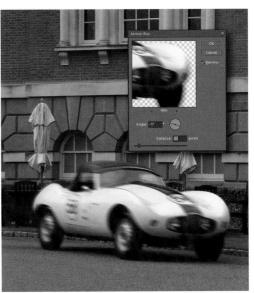

3 First we'll create the effect of the car zooming past. Open the Motion Blur filter – make sure Preview is enabled. Start by setting the Distance. Keep this subtle to avoid it looking too much like a cartoon. Now adjust the Angle to suit the direction of the car's movement.

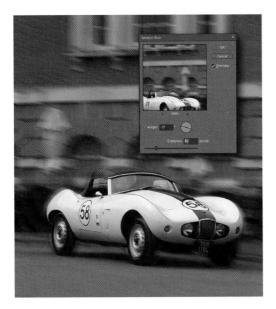

5 Here's a different approach. Make the background layer active. Apply the Motion Blur filter; as before, set the Distance and Angle. You can add a slightly heavier effect this time. Once again there are some unwanted areas. We'll deal with those next.

6 Select the Clone Stamp. Using a small soft tip, go around the car painting over the sections where the overspill is most pronounced. Finally, switch back to the car layer. Use a small eraser to remove the windows to reveal the blurred background of the original image.

HOT TIP

When you're cloning in parts of a blurred image you can often afford to be a little less precise than you would be where the detail is visible. As long as there are no obvious areas where there's a repeating pattern or misalignment, a little artistic license will most likely go unnoticed.

SHORTCUTS

MAC WIN BOTH

Real world modeling

HIS TECHNIQUE IS STYLED AROUND an effect known as 'tilt-shift', which is derived from a specialist camera lens of the same name. Its main purpose is to prevent perspective convergence when photographing subjects such as tall buildings. When using this equipment to capture normal scenes, however, it was discovered that the results could end up looking like scale models, due to the extremely shallow depth of field produced. We are used to seeing larger areas in full focus and small objects with heavily blurred backgrounds; when this is swapped around, our brains can be confused.

The best images to use with this technique are ones that are taken from above the scene – although different views, such as our example can work. It's also good to keep the subject area fairly tight in the frame as we are less likely to be fooled by an image that extends for miles into the distance, as models generally don't have that degree of detail as it would take too long to construct.

Here we have our starting image: a picturesque fishing village. It almost looks like a model to begin with so our technique is going to work really well. The first thing we need to do is duplicate the background layer as we'll be working exclusively with the copy.

4 Ensure you have the mask selected. Pick the Gradient tool, choose the Black, White preset, and set the type to Reflected. Holding (SMI), click and drag up from the middle of the image to where the trees meet the sky. We now have a narrow area in sharp focus which softly fades to a blur.

2 Now we'll apply some Gaussian Blur. We don't want to completely obliterate the scene, just knock out the detail. A radius of around 6 pixels works well in the example; the amount will vary for different images, of course, depending on their size.

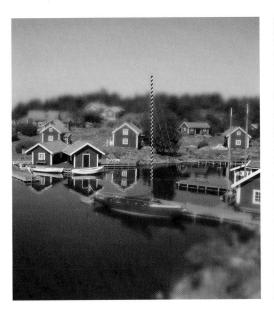

5 It's beginning to look good but there are still a few adjustments to be made. Because we're looking straight at the scene, the masts of the boats should still be in focus. Still working on the mask, use the Polygonal Lasso to outline them and then fill the selection with black to hide the blur.

The next stage is to add a mask to the image. We'll use the Adjustment Layer method from the 'hiding and showing' chapter. Click the background layer then add a Levels Adjustment Layer. Click the blurred layer's thumbnail and group it with the Adjustment Layer and \$\mathbb{G}\$ \$\mathbb{G}\$ \$\mathbb{G}\$\$.

6 We can use a soft black brush to paint away additional areas, such as the tops of the trees behind the mast, or blur more of the background by painting in white. Finally, we'll add a Hue/Saturation adjustment above the blur layer and raise the saturation to enhance the illusion.

HOT TIP Remember, we

can hide the blur layer to make accurate selections using the original as we're always working on the mask layer. Any changes will show up when we make it visible again. With very fine detail such as we have with the boat's rigging, editing the mask with a brush is much too difficult. Instead, we can use the Polygonal Lasso to follow the lines to the top of the mast and back down the other side then connect them up at the bottom. Now we can use the Stroke command set to black, at around 2 pixels, applied centrally to accurately bring the rigging back into the scene.

SHORTCUTS

MAC WIN BOTH

Sunset silhouette

ARLIER IN THIS CHAPTER we looked at replacing a washed out sky with a more impressive one. Simply changing the existing sky isn't always enough, however: depending on the type of scene we want to produce, we will often need to adjust the foreground to match. We'll demonstrate this by transforming our uninspiring photo of a windmill into a lovely evening silhouette.

As the sun sets its light changes, becoming a richer, more orange tone which, in turn, affects the scene's colors. We can mimic this by adjusting the levels of the image. It's important not to darken the subject too far; we still want to be able to see some detail.

Producing images in this way not only lets us rescue dull photos; it also allows us to create difficult to capture or sometimes impossible views: with Elements, the sun will always be just where we want it.

Here we've duplicated the background layer and removed the sky: the Magic Wand in discontiguous mode made easy work of the fiddly areas of the sail frames. Our sunset image is then placed on a layer behind. It's not looking particularly convincing at this stage, though.

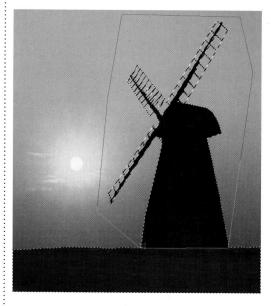

We'll add a shadow to complete the scene: load the windmill layer's selection. Only the outline is needed so grab the Polygonal Lasso tool, hold **Shift all Shift** to switch to intersect mode, and draw across the windmill's base. Follow on with a loose selection around the rest.

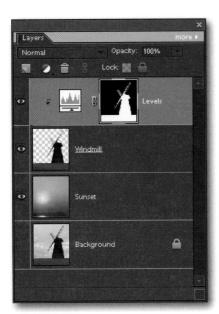

Make the windmill layer active and load its selection by A holding and Standard and clicking its thumbnail in the Layers panel. Create a Levels Adjustment Layer; the selected area becomes a mask so the changes we make will only affect the foreground image.

Tones richer and darker. Increase the Shadows slightly Drag the Midtone slider across to the right to make the and bring the Highlights up a little by dragging the slider to the left. Select the red channel ctrl 1 # 1. Drag the midtones a little to the left to deepen the red hue.

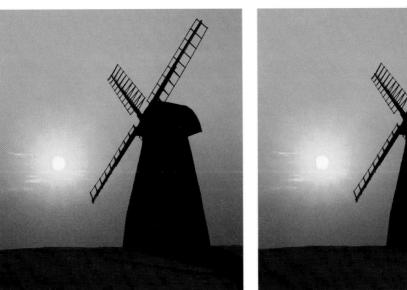

5 Create a new layer above the Adjustment Layer and fill the selection with black. Deselect and enter Free Transform mode ctrl T # T. Distort the shadow into position by holding ctrl \(\mathbb{H} \) and dragging the corner handles - you'll need to zoom out to stretch it past the bottom edge.

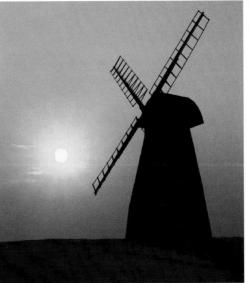

The shadow is too harsh so we'll use a small amount of Gaussian Blur to soften the edges and lower the opacity a little so it's not completely black against the background. As a final step, we've used the Ripple filter to add the effect of the shadow falling across the uneven grass.

HOT TIP It's often not

possible to remove all traces of the background, particularly in small, intricate areas of the photo. When placed against a darker image these lighter areas can show up as a halo around the isolated object. We could zoom in with a smaller eraser to tidy it up but this is fiddly and we could end up removing parts of the image we meant to keep. Instead, use the Burn tool to darken and blend in the offending areas: this can also be used to paint over any brighter elements in the scene that the Levels adjustment doesn't affect.

That's snow business

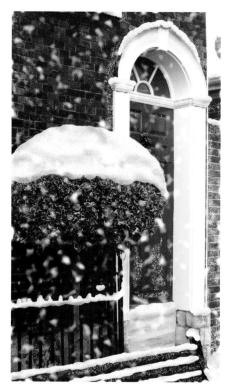

E DON'T SEEM TO GET THE SAME amount of snow as we did in years gone by; whilst some people would say this is a good thing, it is a shame not to see the stunning white backdrop blanketing the streets and countryside. It does make a particularly great photo opportunity, after all.

This is not a problem for the montage artist, however. With a little effort we can take almost any scene and add a little wintry magic; what's more is we will never have to worry about the fresh snowfall being disturbed before we get our shot.

This technique can be used to make great seasonal greetings cards or calendars, or just to create a scene you may never see — snow in Egypt, perhaps?

Here's our charming Dickensian scene ready for a fresh snowfall.

We'll begin by creating a new layer ctr) all Shift N # Shift N, which will be where we'll add the areas of built up snow.

6 Switch back to the main snow layer. Add a small amount of monochromatic Gaussian Noise to give it some texture. Around 7% is enough; we don't want it too grainy.

2 Set the foreground color to white and grab the Brush tool **B**. Select a small, hard tip and start to paint where the snow would lay: on the arch over the door, and so on. Remember to leave a slight overhang.

7 Grab the Burn tool **(a)** and use a small soft tip set to a low exposure to paint in some random shading on the snow, particularly the underside to give it some thickness.

3 Carry on adding in areas of snow: on the railings – create small peaks around the spikes – and on top of the tree, of course. As the tree is rounded, you should paint it to around a third of the way down.

Create a layer at the top of the stack. Fill this with black and add a large amount of noise; around 100 pixels. Apply some Gaussian Blur; we want to achieve a soft, mottled effect.

4 Create a new layer above the snow layer. Set the Brush's blend mode to Dissolve and lower the opacity to around 20%. Paint in some small areas of powdery snow on the walls, the bench, the tree and on the door.

9 Open the Levels adjustment and bring the white point up to the base of the peak on the right-hand side. Drag the black point up toward it; this creates our falling snow effect.

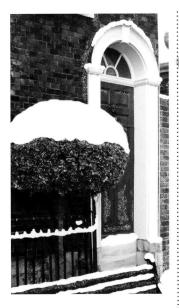

Set the brush mode back to Normal and raise the opacity back to 100%. Paint in the small area of ground by the door. Now add a tiny amount of Gaussian Blur to soften it, giving the effect of a light dusting.

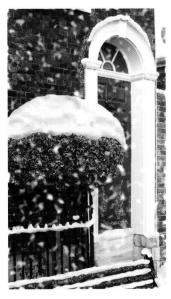

10 Set the blend mode to Screen to hide the black, leaving just the flakes visible. Lower the saturation of the background layer; snowy days tend to wash out the color of a scene.

HOT TIP

For this image, one falling snow layer is enough as we are quite close to the buildings. If we could see further into the distance, we could add the illusion of depth to the scene by duplicating the layer, scaling it down and tiling it. By doing this several times it would appear that the snow is getting smaller as it extends away from us.

But is it art?

THE ART WORLD CAN BE A FICKLE and sometimes intimidating place. Whilst the majority of its denizens are more than happy to welcome new concepts such as digital art with open arms, there will doubtless be the old-school stalwarts who balk at the very notion of something as utilitarian as a computer being capable of being the medium for any kind of creative expression. This is nothing new, of course: photography also received the same amount of steely repudiation when people started using it as anything other than a functional method of preserving images of people and places. It took the work of the late, great photographer Ansel Adams and others like him to prove that the photograph could have just as much visual impact and provide the same aesthetic pleasure as paintings by the old masters.

Unfortunately, as with many things, there can be a degree of fighting within the ranks as well. There are those who frown upon certain aspects of digital art, such as photomontage and three-dimensional imagery, seeing it as compensation for lack of talent because it's not created from scratch and often uses other people's work as a constituent. This is, of course, a ludicrous way of thinking. Nobody thinks to question the validity of art-forms such as decorative floristry, which quite obviously doesn't necessarily require the flowers to be grown by the artist beforehand; it is, after all, the end result that matters, and not how it was achieved.

Squabbling aside, one of the main accomplishments of the digital age is its ability to unlock and uncover artistic flair. We may shy away from trying out our ideas, often because we lack confidence in our abilities, believing that we'll make irreversible or costly mistakes. Another reason might be one of space and time, or the lack thereof: a studio requires a fair amount of working space and it's not always practical to set one up permanently; it can take a while to ready the materials and pack them away after a session, all of which does nothing to aid the creative process.

This is where computers come into their own. In general they're fairly self-contained, taking up only a small proportion of space, and they can be ready for action in just a few minutes. What really sets them apart, however, is their forgiving nature: make a mistake on canvas and you've got a fair amount of tidying up ahead

of you – at worst you'll have to paint over it and start afresh, which is demoralizing to say the least. Working digitally is a different matter entirely. With technologies such as layers, non-destructive adjustments and styles, and not forgetting the trusty Undo function, you can afford to think more freely in the knowledge that you have these safety-nets to catch you, should you falter and lose your artistic balance.

It's not all plain sailing, of course. The standard equipment that comes with a PC, usually a mouse, is great for moving the cursor around the screen to point at links in web pages and menus, and to highlight passages of text in a word-processor, but not so good for creating a masterpiece. Imagine trying to draw with a pencil shaped like a soap bar: it's not impossible, but it can be awkward and become uncomfortable after a while. If you're considering any kind of digital art as a serious hobby or even as a profession then a graphics tablet is an essential purchase. They can take a while to get used to, however; there's often a period where hand-eye coordination causes problems - we are usually more accustomed to looking directly at what we're drawing, rather than away at a screen. Once you have overcome this, it's unlikely you'll want to stop using your tablet: outlining and selections can be achieved in half the time and you can really see the difference with the painting tools. Using a pressure-sensitive device makes shading an absolute delight, rather than the constant size and opacity-changing nightmare it once was. Many tablets have configurable buttons on the stylus which can be set to emulate key-presses; for example, you could set one up as the spacebar, allowing you to pan around the image whilst zoomed in for close-up work. Some also have an eraser function when the stylus is flipped over, which also saves time.

There are, of course, some things that even the most powerful computer technology can't provide you with: imagination and determination. You're on your own there, but, without the constraints that may have been holding you back before, you're free to express yourself in whatever way you see fit. There is no rule book to abide by here; just do what seems good at the time.

Who knows, those images you had locked away in your head might be just what the art editor of a magazine is looking for, so get creating!

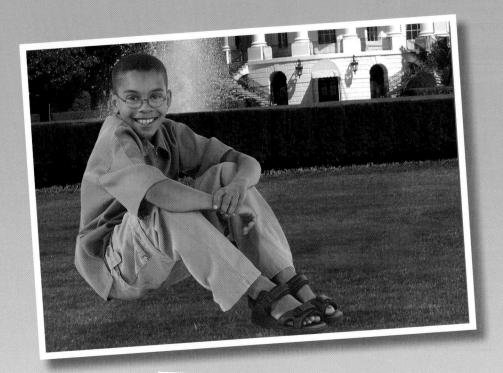

It's not difficult to create a simple montage like this one – a boy sitting on the White House lawn. But while he may be in the correct place, the image above looks unconvincing. By adding shadows, both on the boy and beneath him, we greatly increase the sense of realism, making it appear as if he was really photographed in this location.

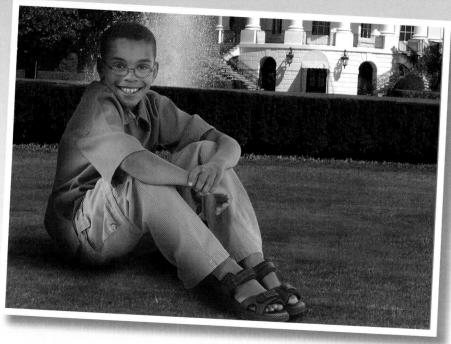

Light and shade

WHEN WE COMBINE IMAGES from several different sources, we can scale them, rotate them, and distort them to fit the space – but they still won't look quite right. In order to achieve a true, realistic appearance, we need to add shadows. Whether they're cast on the ground, the wall, or other objects, it's shadows that will help your montages to work as complete images and to look less like obvious compositions.

Of course, there's a lot more to light and shade than just adding shadows. In this chapter we'll also look at how to make fire from scratch, how to add a spotlight effect to a stage curtain, and how to turn day into night.

Shadows on ground and wall

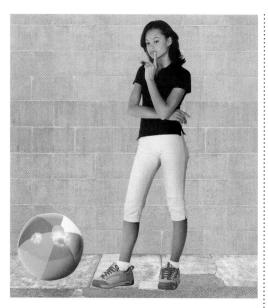

HADOWS CAN MAKE THE DIFFERENCE between a convincing montage and one that looks like several images placed together, and yet shadows are often overlooked in the rush to get things done.

It's easy to make shadows on the wall and on the ground – easier still if the base of the wall is at right angles to the viewer, as it is here. The ball, the girl and the background are three separate layers, which makes it easy for us to place shadows between them.

We'll look at two different methods for creating shadows: the girl and the ball require different treatments to produce their effects.

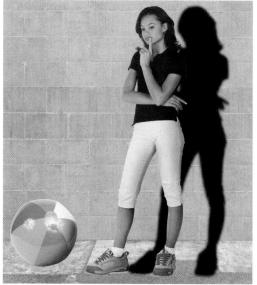

Begin by loading up the girl as a selection by holding and clicking on her thumbnail in the Layers panel. Make a new layer, feather the selection using and D ** D**, and fill with black. Deselect, move this layer behind the girl, and drag it out to the side.

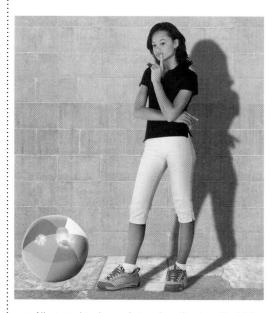

4 All we need to do now is to reduce the strength of this layer so we can see through it. We can change the opacity by dragging the slider at the top of the Layers panel; a simpler way is to use the number keys – 3 for 30%, 4 for 40%, and so on. We've used a 50% opacity.

Now make a rectangular selection of the shadow at about knee height. Enter Free Transform with curl T and drag the top center handle down to meet the bottom of the wall. Then hold ctrl ## as you drag the bottom center handle to meet her feet.

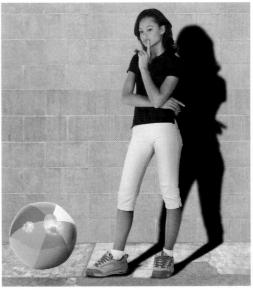

move on to the wall part. Select the remaining piece of shadow with the Marquee tool and simply drag it down until it meets the ground. Stretch it vertically slightly if you need to.

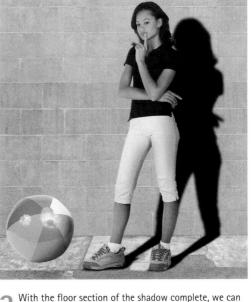

Not all objects on the ground are as obliging more complex shapes, paint

the closer her

shadow will be.

The distance of the shadow from the girl is determined by her distance from the wall: the closer she is to the wall,

as this ball: for the shadow on a new layer with a soft-edged brush, working at a low opacity to build it up.

If you're working with a wall that isn't parallel to the bottom of the picture, you'll need a slightly different technique. In step 2, cut the bottom half of the shadow to a new layer, distort both parts, and erase any overlap.

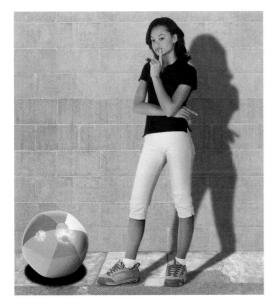

The ball's shadow requires a different treatment. As it's a spherical object, it will cast an elliptical shadow, so use the Elliptical Marquee tool, on a new layer, to make a selection. Feather it as before, and fill with black. Make sure it's behind the ball layer.

Lower the opacity of the ball shadow to match that of the girl, and then move it so that its position corresponds with the angle set by the girl's shadow. As it's a separate layer, it's easy to move and transform it until it looks exactly right.

Painting soft shadows

N THE PREVIOUS PAGES we looked at how to create shadows cast on a wall and on the ground, by duplicating the figure and filling with black. But some kinds of shadow can't be created this easily: seated figures, such as this one, need shadows to be painted by hand.

As well as adding shadows beneath the figure, we need to add some shading to the figure itself in order for the effect to work properly. The technique we'll use here is more efficient than painting directly onto the figure and gives us greater flexibility and accuracy.

When we place our figure of a seated girl onto this beach background, she looks as if she's hovering above the surface: we need to add shadows to place her more firmly on the ground.

We also need shadows on the girl herself, to make sense of those cast beneath her. Although we could paint directly onto her layer, here's a better method. First, hold and click on the thumbnail of the girl's layer in the Layers panel to load this area up as a selection.

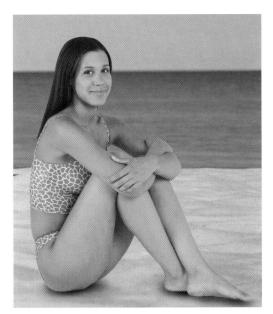

2 Begin by making a new layer between the girl and the background. Using a soft-edged brush set to an opacity of around 40%, paint the shadows beneath the places where she's touching the surface. By working at a low opacity, we can build the shadow up in stages.

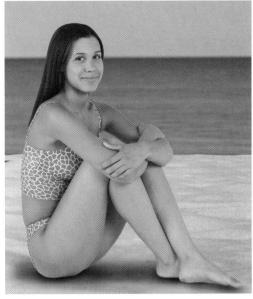

Now switch to a larger, soft-edged brush and reduce the opacity of the brush still further. We can now paint the shadows cast by her body and her legs: they're fainter than those directly beneath the points of contact and the lower opacity will help us to achieve this effect.

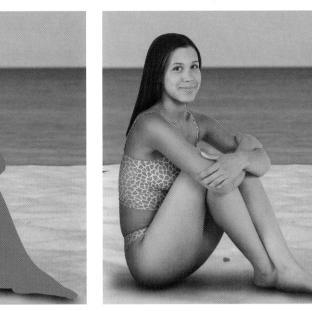

When set to Hard Light, the gray is invisible. But when we use the Burn tool, set to a soft-edged brush, to paint on this layer, we can darken it up. Add shading to her undersides, beneath her legs and bottom, to link her shadow into the shadows we've already painted beneath her.

HOT TIP

The best way to paint shadows is to use a pressuresensitive graphics tablet. If you don't have one, use a low opacity and build the shadow up in small stages. If the finished shadow looks too dark, remember you can always lower the opacity of the shadow layer to reduce the effect.

Light and shade

Turning day into night

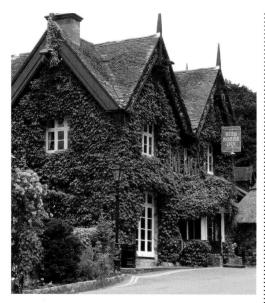

AKING PHOTOS AT NIGHT generally requires the use of a tripod to avoid shaky or fuzzy images. You won't always have one with you, especially if you're just out for the day and happen to spot a scenic view such as the quaint English pub in the above photo. Whilst it's a great scene in its own right, it probably looks equally as good after dark.

In the following tutorial we'll fast-forward to a night view, almost exclusively using Adjustment Layers to create the effect. This way we can have total control over the look and feel of the final image and take it back to daylight whenever we wish.

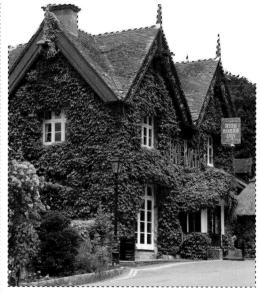

A Now we'll create the lit areas. Click the Color layer's mask thumbnail. Now select a soft brush set to a low opacity and begin to paint in black over the areas where light would fall: around the lamp and windows. This hides the color layer to reveal the original daylight image beneath.

The next stage is to isolate the glass of the street lamp and the windows that will be lit. The Polygonal Lasso is best for this job: hold and so to switch to the Freehand Lasso to select the tricky areas around the leaves. Add a light feather to the selection and copy to a new layer.

Create a Levels Adjustment Layer between the building and the layer you just created; accept the defaults for now. Add a Solid Color layer above that. Select a midnight blue color; this will create the night effect. Set its blend mode to Multiply and drop the opacity to around 80%.

5 We need to adjust the lighting a little. It's too harsh for our image. Double-click the Levels Adjustment Layer to bring up its settings. Darken the shadows by dragging the left slider toward the middle. Add some warmth by raising the red channel's midtones and lowering the blue.

HOT TIP

When creating the lit areas of a scene you need to be aware of the areas that would be affected in real life. In this image, for example, the lamp lights the wall behind it and some of the foreground but the area of the bush which is facing us remains in shadow.

The photo you use also needs to be carefully chosen: our picture was taken on an overcast day so the lighting is flat. Images taken in bright sunlight may have strong shadows which will need to be cloned out first - it's far easier to add them than it is to remove them.

Making fire

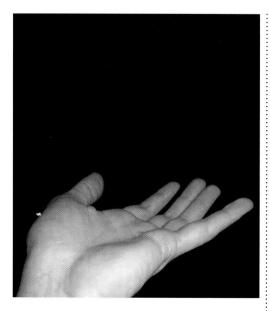

CCORDING TO LEGEND, it was
Prometheus who brought fire to mankind
– and suffered a particularly grisly fate as
reward for his efforts.

Here's a method of creating fire that doesn't end up with us being chained to a rock and having our livers repeatedly pecked out by eagles. (Strange storytellers, the ancient Greeks.)

We'll create our fire from scratch, the only photograph being the hand we choose to place it on. Of course, you could set fire to anything – a house, a car, a landscape; whatever you choose, bear in mind that the effect will work very much better if you start with a black or very dark background. Flames rarely have the same impact on a bright summer's day.

This is the kind of image you can keep working at until the result looks exactly as you want it: there's a lot of fun to be had from continuously tweaking those flames.

Begin by painting a blob, using a soft-edged brush, on a new layer. The shape and size don't matter that much at this stage, as we'll transform both later in the process; this is just the starting point.

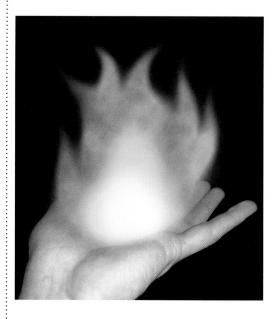

We need a bright heart at the center of this flame.

Using a soft-edged brush, paint a yellow glow covering about a third of the flame area, then switch to white and paint a much smaller blob of color right at the bottom. It's already starting to look quite flame-like.

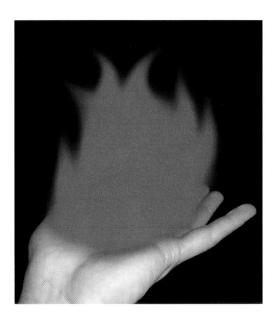

2 Use the Smudge tool, set to a strength of around 70% to 80%, to smudge that red blob into the beginnings of flame-like structures. Make sure the tool is not set to Sample All Layers or you'll end up smudging the hand as well.

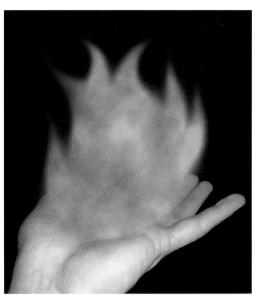

To make the basic texture, first lock the layer's transparency by clicking the Lock icon at the top of the Layers panel (or press). Set the foreground and background colors to red and yellow and apply Filter > Render > Clouds.

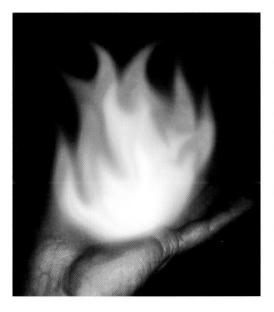

5 Using the Smudge tool once more, tweak up that yellow and white into fire-like shapes, reaching up into the body of the flame. This is also a good time to darken the hand: open the Levels dialog and drag the middle gray triangle to the right, about 80% of the way along.

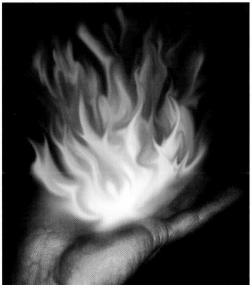

Now unlock the transparency on the layer and work on the flames with the Smudge tool once more. Switch between large and small brush sizes to work on large areas and details; remember, you can smudge down from outside the flame area as well as up from the middle of it.

HOT TIP

Locking the transparency in step 3 allows us to apply the Clouds filter just to the flame area otherwise, it would fill the whole canvas. We need to unlock it again in step 6 so that we can distort the flame layer. Getting from step 5 to step 6 took longer than the whole of the rest of the process: it's a slow and painstaking procedure to get this to look right. Don't rush it, and you'll be rewarded for your efforts.

Instant candlelight

VEN THOUGH CANDLES have long been obsolete as a source of lighting, we still rely on them for the atmosphere they bring and for the sense of occasion they lend to any event.

On the previous pages, we looked at how to create a fireball. Making a single candle flame is a slightly different process in that it's painted entirely 'by hand', using no filters.

This isn't a difficult procedure, but it can result in a spectacular image: the trick is to paint each stage slowly, building up the effect as we go along.

If you want to take it a step further and add smoke to your flame, you can see how it's done in 'Smoke without fire', in Chapter 6.

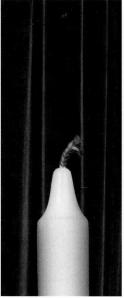

1 Start by placing your candle on a dark background so the flames show up well. We've used a deep red curtain.

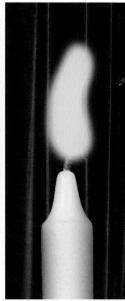

2 On a new layer, paint a rough shape in pale orange, using a soft-edged brush. Don't worry too much about the exact shape yet.

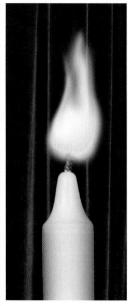

Continue smudging the top of the flame, perhaps with a smaller brush, until you're happy with the shape.

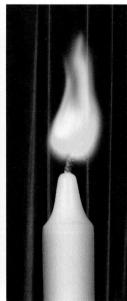

Changing the mode of the flame layer from Normal to Hard Light gives it added impact.

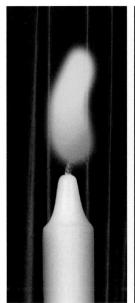

3 set to Midtones, and darken the bottom of the flame around the wick to give the flame depth.

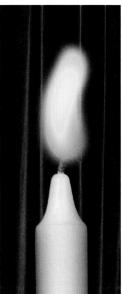

4 Switch to the Dodge tool, set to Highlights, and use it to brighten the center of the flame, turning it from orange to yellow.

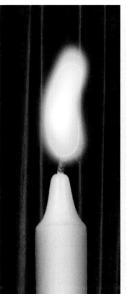

5 Continue painting the flame in with the Dodge tool until the center is a brilliant, glowing white (but don't overdo it).

Now use the Smudge tool (A), with a large brush size, to twist the candle flame into a more appropriate shape.

HOT TIP

When we started to brighten the flame in step 4, we brought the yellow down into the orange a little way. Continuing with the Dodge tool in step 5 hardens the edge between the yellow and the orange, automatically producing the subtle glow effect we see at the base.

9 It's possible to create a huge variety of flame shapes by distorting the original painting with the Smudge tool – particularly handy when you want to make a row of candles. No need to paint each flame; just duplicate and smudge it.

10 For a stronger result, try painting a soft glow on a new layer behind the flame, using the same orange we started with (but at a low opacity). Darkening the background also draws attention to the flame itself.

Stage lighting

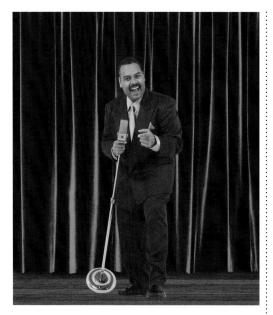

E ALL WANT TO BE ON THE STAGE; now, thanks to Elements, we can easily achieve this ambition.

The trick to creating stage lighting is to think in reverse. You might imagine that the way to add a spotlight effect would be to place a bright disk over the affected area, but you'd be wrong. Rather than adding light to the spotlit region, we'll subtract it elsewhere – in the form of a shadow with a circular hole in it.

And just for good measure, let's add a glow from the spotlight just out of shot and a shadow cast on the curtain behind.

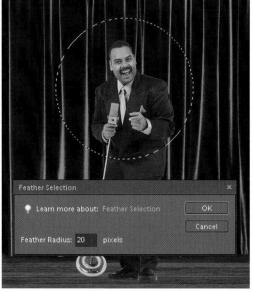

Begin by making a circular selection: hold **Shift** as you trace with the Elliptical Marquee tool to make a perfect circle. Now use **cirl all F B F** to bring up the Feather dialog and add a large feather radius – about 20 pixels is sufficient for this task.

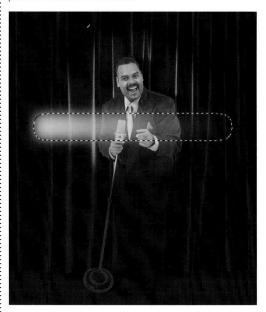

A Now for the visible light. Make a rectangular selection and feather it as before, with a feather radius of 20 pixels. Choose a very pale yellow color and, on a new layer, use the Gradient tool set to Foreground to Transparent to drag from left to right, making a faded glow.

Make a new layer and inverse the selection by pressing curl Shift 1. Now, everything except the feathered circle is selected. Press D to make the foreground color black, then all Backspace B Backspace to fill the selection with the foreground color.

Use Free Transform (ctr) ** T) to rotate and distort the glow so that it comes in from the top left of the picture. Holding ctr) all Shift ** Shift while you drag one of the corner points produces a perspective distortion, giving the impression of the beam getting larger.

3 At the end of the previous step, the shadow was so strong that we were unable to see anything through it. Lower the opacity of the shadow layer, either by dragging the slider at the top of the Layers panel or by pressing a number key: pressing 7 gives an opacity of 70%.

Finally, add the shadow behind the man. Load his selection by holding (11) (12) as you click on his thumbnail in the Layers panel; use the technique described earlier in this chapter to make a shadow that sits on the curtain behind him and runs along the ground to his feet.

HOT TIP

You can add more than one spotlight glow if you like: simply duplicate the glow and flip it to come in from the opposite side of the image. If you do this, be sure to add an additional shadow behind the man, cast by that light.

Light and shade

Divine light

OMETIMES IT'S NECESSARY to exaggerate an effect – for the purpose of illustration, for instance – and, as long as we don't overdo it, a little hyper-reality can really make an image stand out.

We'll demonstrate this by creating the impression of light beaming through a stained-glass window and projecting its image on to the floor of the church. Whilst this is not an unnatural occurrence, it's unusual to see it in such bold effect.

We don't have to use stained glass, of course; we could just as easily apply the technique to a normal window, projecting the shadows of the frame instead of the colors of the glass.

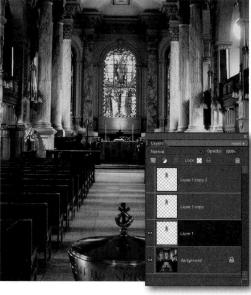

Begin by making a selection of the window. The Magnetic Lasso or Quick Selection tool work well here. Now press 如力 我力 three times to make as many copies. Turn the last two layers off by clicking their visibility icons in the Layers panel.

4 Enter Free Transform (III) T (III) Now, holding (III) S, click and drag the bottom corner points out to distort and elongate the rays down the aisle and extend them a little more at the top. Press (Enter) to commit the changes. Finally, set the layer's blend mode to Screen.

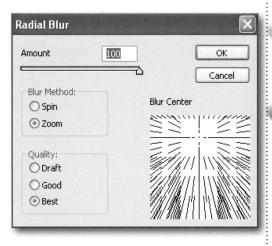

We'll start off the effect by brightening up the window as though the sun is behind it. Make the first copy's layer active by clicking its thumbnail in the Layers panel. Add a Simple Outer Glow layer style; we can leave it at its default settings. Now set its blend mode to Color Dodge.

Now for the light rays: make the second copy active and visible again. Open the Radial Blur filter, set the Method to Zoom, raise the Amount to maximum, and select Best for the Quality. Now click and drag the Blur Center so the majority of the lines are pointing down. Click OK to apply.

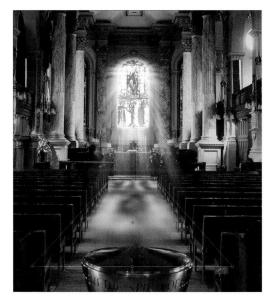

5 Switch to the top layer and make it visible. Open the Gaussian Blur filter and set a moderate amount of blur: enough to soften the window's detail. Flip the layer vertically via Image > Rotate and now use Free Transform as before to move and distort the layer so it lays along the floor.

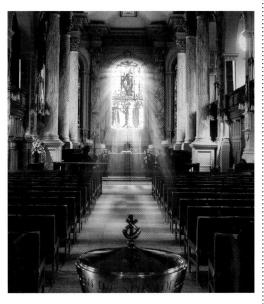

Change the blend mode to Hard Light – or Vivid Light for a more intense effect – and lower the opacity to fade the colors slightly. Finally, use a small, soft Eraser to tidy up unwanted areas such as the ornament in the foreground and the front edges of the steps.

HOT TIP

The Radial Blur filter works really well here as we are viewing the window headon. If, however, the picture was taken at an angle, we would need a slightly different technique: we would need to duplicate the blurred layers and flip one horizontally so we could have the rays emanating in different directions.

SHORTCUTS

MAC WIN BOTH

Light and shade

Shading using Hard Light

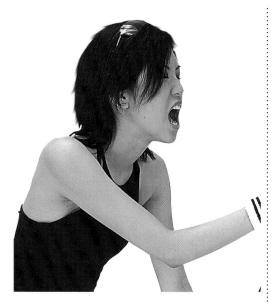

HEN WE LOOKED AT SHADOWS earlier in this chapter, we were always painting with dark colors. But in this scene, set in a nightclub, we want to add the impression of the singer being lit by multicolored stage lighting from different angles.

Rather than painting directly onto the girl's layer, we'll create a new layer in Hard Light mode. By painting on this, we can add the effects we want without damaging the original layer; we can also edit the effects later, to produce exactly the overall effect we want.

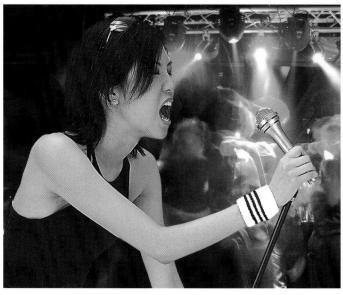

When we place the girl on the nightclub background, she looks quite artificially placed in the scene: her coloring in no way matches the tones of the background image. To begin, hold ** 33* and click on the girl's thumbnail in the Layers panel to load it up as a selection. Make a new layer and, in the dialog, set the mode to Hard Light, filled with Hard Light neutral color.

4 Let's add some Lens Flare to make the scene more impressive. We could add this filter directly to the background or to the girl – but we get far more control if we first make a new layer, filled with black. Then choose Filter > Render > Lens Flare and position the flare in the preview window so that it's pointing down from the left.

2 Group this new Hard Light layer with the girl's layer, so it only shows up where the two overlap. Using a soft-edged brush, sample some of the pink color from the background and paint it on the girl's shoulder to look like light reflecting off her.

3 Continue sampling colors from the background, painting them on the Hard Light layer as appropriate. You'll need to choose fairly dark colors to paint with: too bright, and the effect will look artificial. As it's a separate layer, if we make a mistake we can easily paint over it.

5 When we change the mode of this Lens Flare layer from Normal to Screen, all the black disappears so we can see through it to the scene beneath and move it into place.

6 In the previous step, the Lens Flare layer appeared where we created it – right at the top of the layer stack. But, if we move it beneath the Hard Light layer, it appears to originate from behind the girl's head. We can still see an outline of the ring it created in front of the girl, but the dazzling white center is hidden by the Hard Light layer.

HOT TIP

Although we've used a Hard Light layer to paint in color, we could also use the technique for painting in black to create traditional shadows - or, for a more subtle look, paint them in dark brown or dark blue instead, depending on the lighting of the scene. By painting shadows on a separate layer, we keep the original intact.

SHORTCUTS

MAC WIN BOTH

Deceiving the eye

OW WE PERCEIVE THE SURFACE of an object visually is largely due to how light falls across it. Everything from the waves of the ocean to the contours of someone's face are defined by the variance in the tones.

In this project we have a wild-west style wanted poster. This has been created from scratch - using techniques in the book, of course. In its current state, it looks two-dimensional and lifeless, especially when set against a real background.

We can enhance the image immensely simply by adding a shadow but we can take it further still. Folding over a corner instantly portrays depth and by painting in areas of highlight and shadow using the Dodge and Burn tools we can create the impression that the poster has been wrinkled, as though dried in the high-noon sun. An interesting thing to notice here is how the artwork appears to be distorted, even though we don't actually alter it. Clever stuff!

We'll start by adding a drop shadow layer style to the poster layer using the Low preset. It needs adjusting slightly so select Layer > Layer Style > Style Settings. Set the angle to 90° to match the background's shadows. Drop the opacity to 50% and lower the Size and Distance a little.

4 Set the shading layer's blend mode to Hard Light. Grab the Burn tool ②. Choose a medium sized soft brush. Set the Mode to Highlights in the Options toolbar. Set the Exposure to around 40-50%. We'll begin by following one of the edges of the fence to make a crease.

2 Grab the Polygonal Lasso . Mark out one of the corners of the poster. Press . Mark out one of the cut the area to a new layer. The shadow style will be applied to the new layer. Now use Free Transform . The state and distort the folded corner into position.

Add some random wrinkles at different angles and sizes across the poster to break up the linearity. If we swap the highlights and shadows, we get a dent, rather than a bulge. We can also add some shading to the folded corner to give the impression it's slightly rounded.

HOT TIP

Drawing the creases is made much easier if you're using a pressuresensitive tablet, as you can control the amount of effect as you paint. If you don't have one, you may want to lower the **Exposure setting** a little more and make several sweeps for each crease to build up the effect. If the final result seems too strong, we can always lower the opacity of the shading layer.

Hold are to temporarily switch to the Dodge tool. Now add a highlight just above the shadow you just painted. Continue to add horizontal creases – remembering not to go over the top of the corner fold, of course. Try to vary the tones to give a more uneven effect.

Flashlight illumination

ARKNESS CAN PROVIDE AN IMAGE with a much needed change in mood. This technique is frequently used in horror or thriller movies – the lurking terror is very rarely in a well lit, designer basement, after all.

Our starting image is a bit dull and lacks any sense of purpose: it's just a flashlight in a light room that may be in the process of being renovated. Its owner's probably gone off to find his sandwich. By turning out the lights and switching on the flashlight, however, we instantly add an air of mystery to the scene: where is this place, and why has the flashlight been left lying on the ground in what appears to be a derelict house? Suddenly thoughts of jolly decorators on their lunchbreak are replaced by ones of deserted buildings and lurking fiends in hockey masks – or perhaps not.

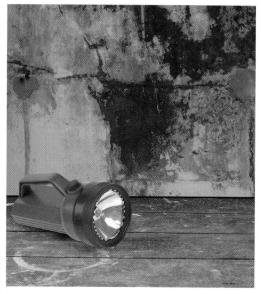

Make sure the flashlight layer is active by clicking its thumbnail. Now make a selection around the lens. This is quite tricky because of the angle; see the sidebar for a tip on how best to achieve this. Once done press ciril 3 ** I twice to create two new copies.

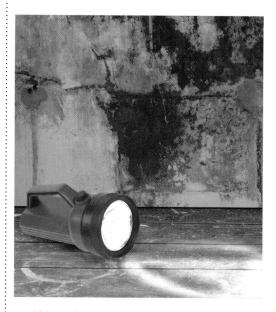

4 It's beginning to shape up but something's not right: the flashlight needs to be switched on to cast its light, of course. Make the second lens copy active and set its blend mode to Linear Dodge. This has the effect of making the already light areas much brighter.

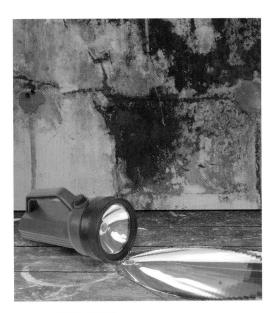

Press IT to enter Free Transform. Now stretch out one of the lens copies to create the shape of the beam area on the floor in front of the flashlight. You'll need to zoom out to see the handles as they will be outside of the canvas area. Press Enter to apply the transformation.

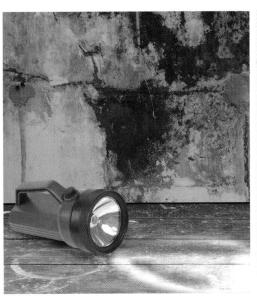

HOT TIP

We can't use the Elliptical Marquee to select the lens of the torch because of its odd angle. Instead, we can use the Shape tool method of selecting irregular areas which is described in the next Chapter.

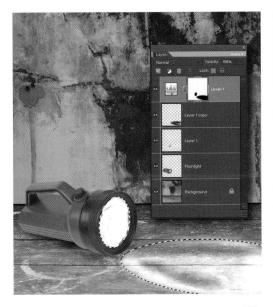

Load up the light beam layer's selection by holding and clicking its thumbnail; add the lens layer's selection by holding and clicking its thumbnail. Now create a Levels Adjustment Layer at the top of the stack. The selection automatically creates a mask.

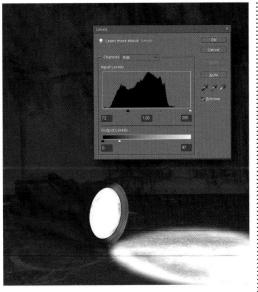

Drag the right-hand Output Levels slider across to the left to lower the overall brightness. Now push the Shadows value to the right to give a richer effect. Finally, load up the flashlight's selection and use a soft black brush to paint out the mask inside the bezel to lighten it up.

Cooking up a storm

IGHTNING IS NOT THE EASIEST OF phenomena to photograph. Firstly, electrical storms are not as common in some parts of the world as they are in others and, secondly, there's the problem of braving the weather – not the best of environments for a camera. There's the issue of getting a good image as well; the best we can hope for is one or two lucky shots, let alone getting a picture of the lightning striking just where we need it! Even if it does, the chance of being ready to capture it is not very likely, and lightning never strikes the same place twice, of course.

In this project we'll find out that it's not at all difficult to create a stormy scene and place a realistic lightning strike just where we want it.

This picture of an isolated castle on the coast will make an ideal starting image. We have everything here: it's dark and mysterious and we already have some menacing-looking clouds as a backdrop. All we need now is to add some raging, untamed weather.

Change the layer's blend mode to Screen to filter out the black areas. Now open the Levels dialog and drag the Shadows and Midtones sliders to the right until most of the cloud texture has disappeared. The rest can be removed with the Eraser tool .

Instead of scaling the lightning, we can just choose a suitable portion and erase the rest, then move it into position. Open Hue/Saturation (M) (#), check the Colorize box, and drag the Hue slider to the right to add a tinge of blue; we can also increase the saturation if needed.

Create a new layer ctrl Shift N \ Shift N and fill it with white. Now take a soft black brush and paint a slightly jagged line down from the top of the document to the bottom. This will become our bolt of lightning. Finally, use a larger brush to fill one side of the canvas with black.

Make sure the default colors are set by pressing **D**. Make sure the delault colors are seen.

Now apply the Difference Clouds filter. This gives to inverse the image and we can see our lightning bolt beginning to take shape.

us a narrow and more defined line. Press ctrl 11 # 11

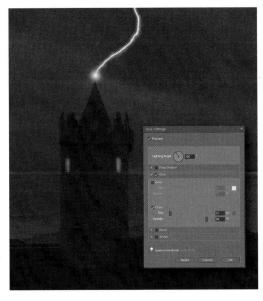

Create a new layer above the lightning. Use a soft, low-opacity brush to build up a small glow where the lightning hits the tower. Now add a Simple Outer Glow layer style; double-click the Style icon in the Layers panel to change its color to the same sort of hue as the bolt.

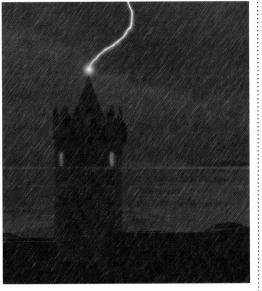

Finally, our image wouldn't be complete without a heavy downpour. We've used the technique from the rainbow project in the previous chapter and used much stronger settings to give the impression that our tower is in the midst of a truly ferocious storm.

HOT TIP

We've created a simple example of the effect here but we could just as easily add more layers to build up a really tropical or magical storm. We could also use a very low opacity brush to paint in brighter areas on the clouds to give the effect of them being lit up by the lightning as they extend off into the distance.

MAC WIN BOTH

Can I get a job doing this?

THE SHORT ANSWER IS: YES. The longer answer is: Well, yes – if you have the skill, determination, and free time available, and if you happen to bump into the right people.

The question of whether it's possible to make a career out of doing photomontage work occurs, at some stage, to just about everyone who's ever dabbled in Photoshop or Elements. It's an appealing proposition: the idea of spending one's days tinkering with images for profit sounds like a great way of occupying oneself.

The trouble is, the world just isn't crying out for more photomontage artists. It's not like studying to become a dentist or a plumber. There's no standard course, no regular qualification, and absolutely no guarantee of a career of any sort at the end of the line. This, coupled with the fact that you're not alone in wanting to pursue this path, means that there are far more people out there capable of manipulating images than there is demand for such services.

But if you're really determined, then there are several steps you could take to make the dream a possibility. It all depends on whether you have the free time to develop your skills without being paid to do so.

The first, and most important, step is to get your work published. Art editors are notoriously busy and preoccupied people who are driven by deadlines and the need to fill the space between the text and the advertisements in their publications. What matters to them are four main factors: Can you interpret a brief? Do you have the skill needed to turn in a good job? Do you have an interesting or unique style? And, above all: Can you be sure to meet a deadline? For, ultimately, it doesn't matter how good or inspired your work is if you're unable to turn it in on time. If you don't meet the deadline, you'll never hear from them again.

Art editors are far more likely to take a chance on commissioning work from an unknown artist (you) if you can demonstrate that others have already placed their faith in you. Of course, it's something of a catch-22 situation: you can't get the work unless you've already had work published, and you can't get work published unless someone gives you the work.

One solution is to begin by offering your services, for free, to publications or websites who couldn't afford to pay for them. This might include local newspapers, community and sports magazines, charity websites, church and workplace newsletters, and so on. Get as much work in print or on websites as you can, to show that you're capable of sustained effort.

Only when you have a fair body of work to show should you approach magazine and newspaper art directors. But start small: writing to *The New Yorker* offering to draw their covers is unlikely to produce a positive response, at least in the early days.

Self-promotion is a key part of bringing your skills to the attention of those who matter. These days, it's easy to set up and maintain your own website, and you should take the opportunity to show off as much published work as you can in this way. Feel free, as well, to show 'personal' work done for your own entertainment – but be aware that this won't carry as much weight with potential employers as work you've been commissioned to do.

Another way of getting started is to get a job in a publishing office, doing menial tasks such as scanning and filing photographs. Before long you'll come across an image that needs tweaking; show what you can do, and if you're any good your skills will be recognized.

You can, of course, set up a website offering your services directly to the public. Many people offer photo restoration, custom greetings cards, and photo caricature services; a few make a reasonable living out of it.

Decide where your strengths lie. You may be proficient at restoring photographs, removing ex-spouses from family shots, or caricaturing politicians. Develop your area of expertise and find new ways of performing the task. People are far more likely to use you if you can offer a service that no-one else can.

Fred and Wilma on your fortieth wedding anniversary

Making cards, notices and invitations is an enjoyable hobby in Elements. But why settle for a standard, headon view of the text when we could show it on a billboard? It's easy to distort any text or images so they appear to be viewed in perspective, giving the design far more impact.

Transformation and distortion

COMPOSING MULTIPLE IMAGES into a single montage almost always involves scaling, rotating and moving the elements around. In this chapter, we'll look at the basics of using that most powerful tool, Free Transform: with its multiple keyboard modifiers, it's capable of producing good results.

There's more to distortion than simply scaling and rotation, though. In this chapter we'll explore how to make an image fit a flag, a mug and a computer screen, as well as several other surfaces, showing how to use Elements' tools and filters to match an image to just about any surface.

The science of transformation

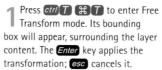

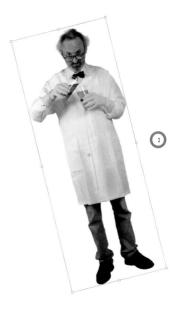

2 Click and drag within the box to move the layer around the document. Placing the cursor outside the boundary and dragging will rotate the layer around the center point.

HEN PUTTING A MONTAGE TOGETHER, it's almost certain that you'll need to resize one or more of its components to fit the scene. You may also want to distort an image for a particular effect: to give it a three-dimensional appearance such as photos scattered on a surface or placed on a virtual gallery wall, for example.

Free Transform allows you to move, rotate, scale and distort your image in real time so you can compare and position the layer in place to match the rest of the artwork. You can perform this on an individual layer or, if you have grouped multiple layers together, alter them in unison.

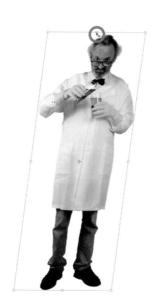

Hold (##) ## while dragging a center handle to skew the image. Additionally, if the (##) key is also held, the skew is constrained to horizontal or vertical movement.

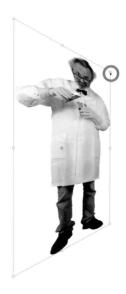

Press ctri all Shift \$\$\sim \shift\$ when dragging a corner to distort the image in perspective. This can be both horizontal and vertical, depending on the direction you move the cursor.

3 By grabbing and dragging a corner handle you can scale the layer up or down freely. This, by default, is relative to the opposite corner, which remains anchored in place.

4 By holding the him key whilst dragging a corner, the layer will be scaled in proportion to its original size. This option can be used when you need to ensure the shape remains constant.

5 Use the left or right center handles to adjust the width of the image. The top and bottom handles, as you might expect, scale it vertically.

HOT TIP

You'll need to be a little cautious if you intend to increase the size of the image. Too much will result in noticeable degradation, especially with photographs, as Elements has to add pixels to compensate. Wherever possible it's better to start with a larger image and reduce it to fit.

You can distort the image freely by holding (III) (III) when dragging a corner handle. This allows accurate matching of an existing part of the artwork: a billboard, for example.

9 Use the all ## key to force the image to scale around the center point, rather than the opposite corner. This works with most of the transformation modes.

10 You can change the reference point to one of nine positions from the Options bar. This allows you to rotate the image using a different pivotal point.

6

Distorted field of vision

BY MIMICKING PHOTOGRAPHIC EFFECTS we can fool the viewer into believing an image is real, if only temporarily. This technique has been used frequently in the movies, television and other media – especially before digital technology was accessible. Indoor sets would have lavishly painted backdrops to give the impression they were shot on location. The scenery would be out of focus and not instantly recognized as fake.

We'll use this trick here to create a field of sunflowers using just a single object duplicated and scaled down many times. One larger flower is kept in the foreground, drawing focus away from the rest. The copies are all partially covered by one another; this prevents the viewer from making an instant comparison. By blurring the rear rows and background, we are fooled into believing they extend far into the distance; we are accustomed to seeing photographs taken with a shallow depth of field so we don't question it.

Here's our field with a single sunflower. We'll start by duplicating the flower. Make sure it's the active layer. Press ctr) J. This is normally used to create a layer from a selection; as there isn't one defined here, it simply copies the entire image.

4 We can make some adjustments to the row. We'll begin by swapping some of the layers around. This gives us a more uneven appearance. To do this, click and drag the thumbnails above or below one another in the Layers panel. Keep them behind the original flower, of course.

Press [M] #J to duplicate the current layer.
Select the layer behind. Scale it down quite a way. Now duplicate it. Move them both to create a long row. Press [M] to merge them. Repeat this a couple more times until the foreground is more or less hidden.

How to Cheat in Photoshop Elements 8

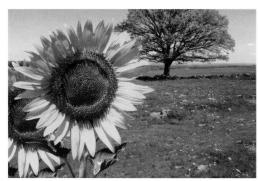

Now we'll complete the initial row. Press # all T. His will create a new one. Adjust the size and position as before. Add another two or three copies. Keep them evenly spaced; they wouldn't be growing too close together.

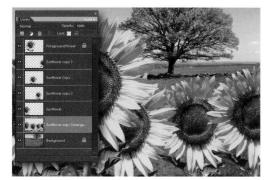

5 Now we'll start adding the rows behind. Group all four flower layers by multi-selecting them in the Layers panel. Press at all E & E to stamp them onto a new layer. This will be created above the group so drag it down the stack so it sits behind the others.

6 We'll fill that empty ground space behind the front row. Flip the layer horizontally via the Image > Rotate menu. Use Free Transform to scale and position the layer so its stalks are staggered behind the front row. Because they're hidden we can distort them a little more than before.

To create the impression of depth we'll add some Gaussian Blur. Start with the first merged group. Add a small amount of blur, enough to knock the focus out. Move to the next adding a little more. When you've finished with the flowers you can blur the background to match.

9 The ground beneath the flowers is still visible and noticeably blurred. Grab the Burn Tool ②. Set the mode to Highlights. Now use a large soft brush to paint in shadow over the grass. Finally, select the foremost flower rows. Add some shadow to their stems to complete the effect.

HOT TIP

If you're using a version of Elements which doesn't support layer grouping, you'll need to create the merged layers in a slightly different way. Start by creating a new layer above the layers you want to merge. Link the images together by clicking the empty box to the left of their thumbnails in the Layers panel. Using the keyboard shortcut ctri alt E ₩ Œ E will duplicate and stamp the layers down to the new

SHORTCUTS

MAC WIN BOTH

Transformation and distortion

Simple perspective distortion

NE OF THE MOST USED distortion techniques in photomontage is adding or replacing an image where it will be viewed in perspective. This could be anything from a photo lying on a table to a billboard in a street scene.

As we'll discover in the following tutorial, this effect can be achieved quickly and simply using the Free Transform tool. The task is made easier still if we already have a basis for our distortion – the laptop's screen, in our example. We'll also see how the effect can be made more realistic by blending the images to retain the original highlights of the screen.

Here we have our laptop along with the image we want placed on its screen. We'll use the screen's existing perspective as our guideline. Firstly, make sure the flower is the currently active layer by clicking its thumbnail in the Layers

panel. Now enter Free Transform mode by pressing [17] [17]. We'll begin by moving the image roughly into position. Click and hold within the bounding box. Now drag the photo across so it's covering the laptop's screen.

The image is now more or less in place. Check to see if any fine tuning is needed. It's best to do this before you commit to the transformation. This is mainly to avoid further quality loss but also because subsequent editing will result in the

Transform tool's bounding box being squared off to the document, rather than conforming to the image as it is now, making it very awkward to align the image. Simply grab and adjust any of the point(s) as before.

Press and hold (211) (##). This puts us into Distort mode, allowing the individual control points to be freely manipulated. Start by clicking and dragging one of the corners to the corresponding corner of the laptop's screen. Try

to leave a little space between the new image and the bezel of the laptop. This adds a bit more realism as displays generally don't extend right up to the edges. Repeat the process for the remaining three corners.

With the distortion applied, the photo of the flower looks much more a part of the whole image. It's still not completely convincing, though. Adding the new layer has hidden the reflection and shading on the original screen. This

has made the display seem a little flat. We'll fix this by changing the photo layer's blend mode, in this instance using the aptly named Screen. As the base layer is black, the two images blend, allowing the highlights to appear over the photo.

HOT TIP

It can be tricky aligning the new image if you can't see the target laver below. To make the process easier, simply lower the layer's opacity enough for the base layer to show through. Once you've applied the transformation, you can bring the opacity back to normal. In the latest versions you can do this whilst in Free Transform mode. For previous versions you would have to set it beforehand.

Transformation and distortion

Tricky selections

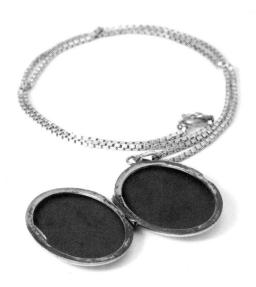

VEN WITH A WELL-STOCKED ARSENAL of selection tools at our disposal, there will be times when it seems we have been defeated. Take our example image, for instance: we want to select the inside of a silver locket so we can place our own images inside – easy enough, you'd think?

Given its shape, we'd instinctively reach for the Elliptical Marquee tool but there's a problem: the angle at which the locket was photographed means it's not a perfect oval; the marquee can only be scaled horizontally and vertically so, try as we might, we'd never get it to match. We need to be able to distort its shape, and that's the key word: using the Ellipse Shape tool, we have the ability to fine tune it to fit the most stubborn areas of our images and create the perfect selection.

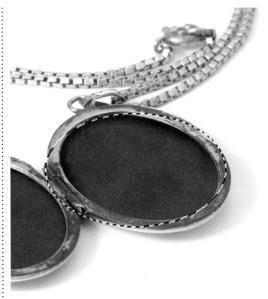

As we can see here, because the Elliptical Marquee can only be scaled horizontally and vertically, we simply cannot match the perspective. As soon as we get one part of the selection to match, the rest falls out of line. Wrestling with it is just an exercise in futility.

A Staying in Free Transform, hold (m) (#) to switch to Distort mode. Now we can manipulate each of the handles individually to get a precise match with the locket's edge. It can be a little fiddly getting it just right but the result will definitely be worth the additional time spent.

How to Cheat in Photoshop Elements 8

2 Select the Ellipse Shape tool **(1)**. We don't need to be too precise to begin with so draw out a shape roughly the same size as the aperture of the locket. It will be filled with color initially but that's not important as we only want to use its outline, which we'll deal with next.

Cancel

Make Selection

Rendering

✓ Anti-aliased

Feather Radius: 0

New Selection

Add to Selection

Subtract from Selection

Intersect with Selection

Cover the shape layer's opacity to 0%. This removes the color fill, leaving us with an unobtrusive outline to work with. Enter Free Transform (III) (#) and rotate and scale the shape; we can get a better match than with the Marquee tool but it will need adjusting slightly.

HOT TIP

We chose to hide the shape layer's fill completely here, as it's fairly easy to see its boundary on this image. For more complex images we could lower the opacity only partially to enable us to see through the shape. We can also change its color so that we get a high contrast against the area we want to select. Once we have the selection we want we could save it or simply keep the shape layer as part of the document so we can go back and use it again or modify it.

6

Locket and load

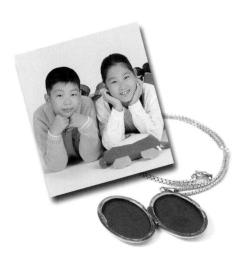

OLLOWING STRAIGHT ON from the previous technique, we'll be putting the selections we made to use. We'll add photos into the windows of the locket with a little-used function called Paste into selection. This is very similar in concept to clipping layers together, which we covered in the 'Hiding and showing' chapter. We can still scale, rotate and distort the image to get it looking the way we want. The main difference is that only one layer is used.

This makes for a tidier document but with one important caveat: once the images have been positioned they are set permanently on the layer. This might sound a little counterproductive when we are so keen to keep things editable, but there are times when we just need to make one-off changes and would most likely flatten the layers anyway; this saves us the bother of doing so.

First we need to open our source image. For ease, we've saved it as a layer on the psd file on the CD. Make it visible and active and then select the whole document (II) A #A. Now press (III) C #C to copy the image to the clipboard. Once done, we can hide the layer again.

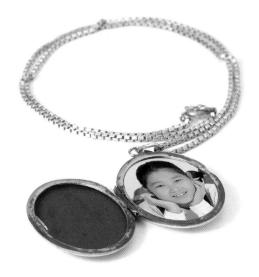

Hold (1) He and drag the control handles to distort the image so it follows the perspective of the locket.

Press (2) Fress (3) The committee the changes. At this stage we can still move the selection or go back into Free Transform if needs be. Finally, deselect to fix it in place permanently.

How to Cheat in Photoshop Elements 8

The selections have also been saved with the file so we can go straight to Select > Load Selection and choose Right Window. Make sure you're on the background layer then press Shirt cut V Shirt X to paste the clipboard image into the selection.

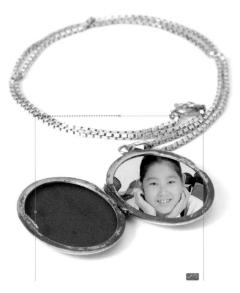

It doesn't look like much at the moment because it's been pasted in at full size and we can only see a small portion. Enter Free Transform (II) and scale the photo down so we can see the girl's face. We'll stay in Free Transform so we can adjust the perspective.

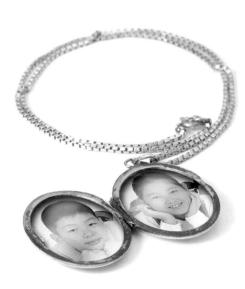

We've created a new layer above the locket and loaded up both window selections. These have been filled with 50% gray and the blend mode changed to Hard Light. We've used a soft white brush to add some highlights and an Inner Shadow layer style to give the impression of glass inserts.

HOT TIP

If you accidentally deselect before you've finished making adjustments, you can step back ctrl Z ₩ Z and the function will still be available, although you will lose the shape of the Free Transform frame. Don't, however, try reloading the selection as this will force Elements to stamp the image onto the layer.

5 To add the image into the left window we can load up the other saved selection and simply use the Paste into command again as it will still be retained in memory. Then it's just a matter of scaling it down and distorting to show the boy.

Transformation and distortion

Wrapping around surfaces

DDING ARTWORK TO CURVED SURFACES can present the montage artist with all manner of problems to overcome. The most awkward are objects such as cylinders. When they are viewed at an angle the perspective effect causes not only the width to recede as it moves further from the camera but the depth of the curves become considerably different between the top and base.

In these situations, applying a uniform distortion to the artwork simply won't do the trick. The result will be confusing and look unrealistic. There is, of course, a solution, demonstrated here by placing a graphic around the surface of a plain coffee mug.

Although it's not obvious at this stage, as a result of the perspective effect, the slight angle at which this mug has been photographed has caused the depths of the curves at the top and bottom to be different. This will be far more noticeable when the artwork is applied and initially distorted.

4 Open the Shear filter dialog. By default, there is no distortion. Control points can be added by clicking and dragging on the line. It's better to create these toward the edge, rather than a single point in the center. This gives a smoother curve. You can see the effect in the preview.

The artwork has been rotated back to the correct orientation. As you can see, the top is true to the curve of the mug but the bottom is far too shallow. Firstly, enter Free Transform mode. Holding (#) (#), drag the bottom corners in to match the perspective of the mug's edges.

How to Cheat in Photoshop Elements 8

The artwork has been imported from a separate file. Press (II) (T) (#) (T) to enter Free Transform. Holding (II) (S) and (Shift), scale the artwork down to the appropriate size. Using the modifier keys ensures it's scaled proportionately and remains centered.

Before we can apply the distortion, the artwork must be rotated by 90°. The Shear filter only operates on the horizontal axis. This can be achieved with Free Transform (hold **Fif**) to constrain to 45° increments) or from the menu: Image > Rotate > Layer 90° Right.

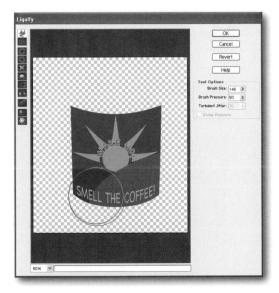

Open up the Liquify filter (under Distort in the Filters menu). Select the Warp tool. Using a large brush, drag out the lower part of the artwork to increase the curve's depth. Try to use as few strokes as possible to avoid the edge becoming uneven.

Our artwork now fits the shape perfectly. It still looks a little out of place, though. The problem is that the mug has shadows and reflections whereas the artwork appears flat. This is easily solved. Set the layer's blend mode to Multiply. Finally, lower the opacity a little.

HOT TIP

The display in the Liquify dialog only shows the active layer. This makes it difficult to match up with the existing image. Before you open the filter, move the document window over to one side. You can then resize the filter's window and place it next to the original for reference.

SHORTCUTS

MAC WIN BOTH

6

Making curls and folds

APER TENDS TO HOLD ITS SHAPE after being folded or rolled up for any length of time. This can be an annoyance in everyday life, as anyone who has experience of hanging wallpaper will testify. In the controllable world of digital montage, however, we can use these traits to our advantage.

In this tutorial, we'll see how distortion and shading can transform a piece of flat artwork into a convincing three-dimensional map; one that has been rolled and folded many times. Of course, the technique can be customized for many other situations.

We first need to add some extra blank space to accommodate the distortion. We'll do this by increasing the canvas, rather than shrinking the artwork. Press of the Canvas Size dialog. Check the Relative box. Increase the size by around 30%.

A Rotate the canvas 90° right. With the Marquee tool still selected, position the cursor in the center of the right panel. Click and hold to start a selection. Hold the all key. Drag out the bounding box to the edge of the canvas. This ensures the distortion will be centered on the layer.

Treate a new layer at the top of the stack. Hold ## and click the left panel's layer thumbnail. Now add and hold the *Shift* key. Click the other two layers in turn to add their selections. Fill this with 50% gray. Press *CHID** ## D to deselect. Set the layer's blend mode to Hard Light.

Load up the selection for one of the panels. Add some highlight and shadow using Dodge and Burn (see the chapter on Lighting for more on this technique). Because we've restricted the area, we get a nice solid crease line. Repeat for each of the other panels.

We need to separate the artwork into sections. We'll use the map's original fold lines as a guide. Grab the Rectangular Marquee M. Line the cursor up with the left fold line. Now drag out the selection to enclose that panel. Press etry Shift J # Shift J to cut it to a new layer.

5 Open the Shear filter. We want our edges to be curling upwards so the bend needs to go to the left. Click on the grid to add two new control points. Drag them out to form a shallow curve. Repeat this for the other two layers; vary the curves a little on each.

Hide the background layer by clicking its eyeball icon. Press ctrl Shift E # Shift E to merge the visible layers. Press ctrl T # T. Hold ctrl all Shift # Shift. Click and drag a top corner in towards the center. Reduce the height with the top-center handle.

Press (II) To re-enable the previous layer.

Now select the right panel. Again, cut this to a new layer. You'll now have three individual pieces. You could press (II) To move the layer down the stack; there's no benefit other than having them in a logical order.

Rotate the canvas back. Make the left panel layer active. Press eth T # T to enter Free Transform. Position the cursor over the right-middle handle. Hold eth Shift. # Shift. Click and drag to match it up to the adjacent layer. You may want to raise its opposite edge as well.

Load up the map's selection. Hold all . Use the cursor keys to nudge up by one pixel. This gives the impression that the map has thickness. All that remains is to add a shadow. This is simply a copy of the map layer flipped and distorted. Finally, it's blurred and the opacity lowered.

HOT TIP

Always use Canvas Size to create additional area to your document. As long as the background is separate from the rest of the image, you can adjust it as much as you like without losing quality; as would be the case with scaling down the artwork. Also, if like the map example, you do not need to stick to specific dimensions; use the Relative option and increase the size by percentage. You'll find it much easier to visualize than measurement units.

The ripple effect

ESPECT WHERE IT'S DUE to the photographers with the skill and, more importantly, the patience to capture the ubiquitous image of a leaf or other such object causing delicate ripples as it lands on water. As pretty and serene as this all is, many of us simply don't have the time to wait for that perfect moment. We don't need to, of course. The effect can be recreated quickly with neither a tree or a lake to be seen.

We photographed the leaf at a suitable angle to avoid the need to make excessive changes to fit in with the rest of the scene. We'll use a few different distortion techniques here. The main effect is creating the ripples; we'll use the rather misleadingly named ZigZag filter to create this.

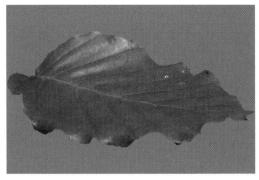

We'll begin by selecting the leaf and copying it to a new layer. The background layer has been filled with 50% gray, which will allow us to fine tune the effect once everything is in place. We'll hide the leaf's layer for the time being whilst we create the water texture.

4 Enter Free Transform (III) (III) The Holding (III) (

The leaf looks too flat on the surface as it has no reflection. Duplicate the layer [17] [3] [3]. Switch back to the original by clicking its thumbnail. Set the blend mode to Multiply. Now use Free Transform to distort the copy and give the leaf some depth.

2 Create a new layer. Press D to ensure you're using the default black and white palette. Fill the layer with the Clouds filter. We want a good spread of tones here. You can rerun the filter a few times by pressing AF #F until you're happy with the result.

Now to make the ripples. Select the ZigZag filter from the Distort sub-menu. Select Pond Ripples as the style. We're creating a close-up image so we need only a small number of ridges but a large amount of distortion. The exact settings will vary from image to image, of course.

The transport of the control of the

6 With the ripples in place we can make the leaf layer visible again. Make sure it's the topmost layer. Drag it to the top of the stack in the Layers panel if necessary. We'll use Free Transform to alter its size and adjust the perspective slightly.

Set the water layer's blend mode to Overlay. Switch to the background layer. Open the Hue/Saturation dialog (III) Check the Colorize box. Now adjust the hue and saturation to suit the image. Finally, drop the water layer's opacity to soften the effect.

We'll add a sense of movement by distorting the reflection. Open the Ripple filter. Set the size to medium. Increase the amount gradually to give it a slight distortion. Soften it down by applying a small amount of Gaussian Blur. Lastly, lower the opacity a little.

HOT TIP

It can be

difficult to use Free Transform when the area takes up the entire size of the document. especially if you need to expand it. Press ctrl - # - a couple of times to zoom out. You'll now be able to see the whole image and have space to use the control handles. If you are not using the maximized view mode, you'll need to drag the window out as well. This can be changed in the program's preferences by unchecking Zoom Resizes Windows.

SHORTCUTS

MAC WIN BOTH

Transformation and distortion

A flag for all nations

OMPONENTS OF A MONTAGE OR EFFECT are often created from the most unlikely of sources. The above image, for instance: just a photo of an old bedsheet hanging up? Well, yes, it is, but for the resourceful and imaginative artist it can be a whole lot more!

We'll be using the image with the Displace filter to transform a two-dimensional graphic of the Stars and Stripes into a realistic flag blowing in the breeze. The technique is versatile, too. As well as with fabrics, it can be used with many other types of texture: almost anything which has a raised pattern such as rock or tiles, or even the bark of a tree. In our example, the image can be saved as a template which can be reused with different nationality images or patterns.

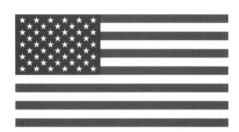

Here's our flag artwork. This is a rasterized vector image. Graphic objects such as this work really well in this format. They can be rendered at any size and will never lose their quality. Be sure to leave space around the image to allow for the distortion effects.

4 The Displace filter uses a separate texture map document to apply its distortion effect. Select Duplicate Layer from the Layer menu. Choose New for the destination. You'll need to give it a name. This will create a new copy of our grayscale sheet.

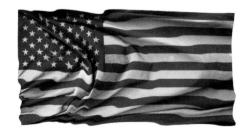

Turn the sheet layer back on. Set its blend mode to Multiply. The effect is taking shape but there's a bit of a problem: the two layers no longer match; as yet only the flag has been distorted. Press one with the two layers of the reapply the filter using the same settings, without opening the dialog again.

The sheet image has been opened with the Place command under the File menu. Once loaded it behaves in a similar way to Free Transform. Here it's been rotated and resized to match the flag graphic. Pressing File? accepts the changes and adds the image on a new layer.

Press eth Shift U **\$\frac{1}{2}\shift U** to desaturate the new layer. We don't need the color, just the tones of the folds. Add some more contrast by tightening up the highlights and shadows using Levels. This will give a much stronger effect on the texture map and overlay.

Load the layer's selection by holding and clicking its thumbnail. Apply a Crop from the Image menu to remove the excess from around the image. Now apply some Gaussian Blur. We need to keep the tones but soften the harsh edges. Finally, save it in Photoshop format.

Go back to the flag document. Turn off the sheet layer for now and make the flag layer active. Open the Displace filter dialog. Use the default settings and click OK. A file dialog will appear. Browse to where you saved the texture map. Double-click the file to apply the filter.

We'll add a shallow wave to the flag. Group the two layers. Press cit at E # E to create a merged copy. Hide the original layers. Now rotate the image 90° left. Open the Shear filter. Apply a very slight S curve. Rotate the layer back to its correct angle.

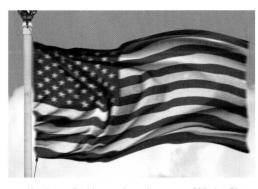

Here's our final image. A small amount of Motion Blur has been added to give a greater sense of movement. The addition of the flagpole and background boosts the realism of the scene. Save as a Photoshop document; you can always return to the image to change the nationality.

There will

be occasions when you find the filter has caused areas of unwanted distortion. as with some of the stars on the flag. This is largely unavoidable as the image has been stretched too far over an area of strong contrast. You can often disguise the problem with a carefully placed foreground object or perhaps, as with our final image, some blur, if the context allows. You could, of course, use the Liquify filter to reposition the stars, too.

6

Transformation and distortion

Not-so-extreme close-up

ILTERS OFTEN SUFFER FROM ABUSE, and consequently can quickly achieve cliché status. Even though their effects can be gradually increased, there is too much of a temptation to take it straight to the extreme. Spherize is one such casualty. Because of its potential for caricature, it rarely sees anything between –100% and 100%. It can, however, be used for much more subtle duties.

The following example uses the filter in moderation to create the illusion of an image being enlarged through a magnifying glass, in this instance on a collection of postage stamps. You'll also see how glass can be replaced using layer styles and blend modes. This is a great effect for drawing attention to something in your artwork or simply as a realistic component.

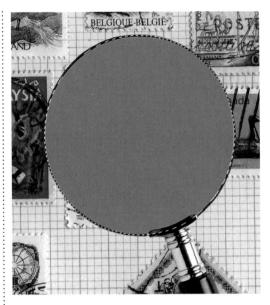

To save time, we've already cut away the original glass. Hold I am and click the New Layer icon in the Layers panel. This will create the layer beneath the magnifier. Make a selection around the inside edge of the frame with the Elliptical Marquee M and fill it with 50% gray.

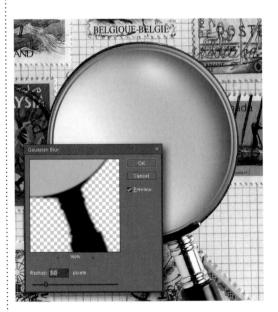

We'll create a shadow to add depth. Create another layer. Load the magnifier frame's selection. Fill the selection with black. Now load the glass layer's selection. This time fill it with a light gray. Press (III) (# D) to deselect. Now apply some Gaussian Blur.

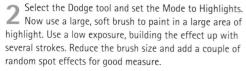

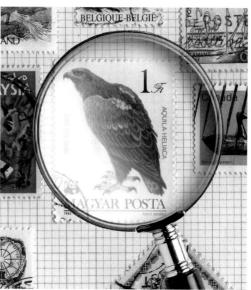

We'll use layer styles to give our glass some substance. Begin by applying the Scalloped Edge Bevel preset. Now add a High Inner Shadow. Set the layer's blend mode to Hard Light. The gray becomes invisible, leaving us with just our highlights and styles showing. Lower the opacity slightly.

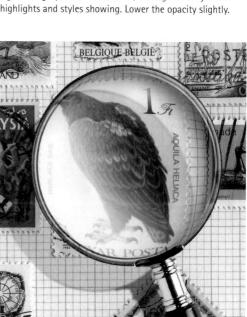

Duplicate the background layer. Load up the glass layer's selection. Open the Spherize filter. Apply the desired amount of distortion to the copy of the background; 80% in the example. Click the shadow layer's thumbnail to make it active. Press @ F & F to reapply the filter.

HOT TIP

Using selections to constrain filters is not only used for localizing the affected area. If you feather the selection first, the effect of the filter will be blended in or its strength lessened as it reaches the edge of the selected area.

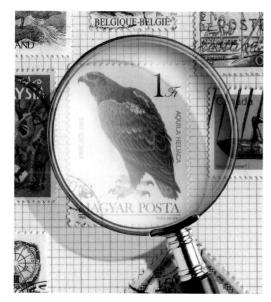

Press III for Free Transform. Scale, rotate and reposition the shadow layer to give the impression the magnifying glass is a distance above the background. Set the blend mode to Multiply. Finally, lower the opacity. The lighter gray fill now looks like diffusion through the glass.

SHORTCUTS
MAC WIN BOTH

Smoke without fire

HOTOGRAPHING SMOKE CAN BE TRICKY. You need to get the lighting correct and capture the picture at just the right moment or you'll have to start again from the beginning. Even when you do have an image you're happy with, using it in a montage involves a lot of fiddly selections and masking. Creating the effect from scratch is not as difficult as you might think.

In the following tutorial we'll see how smoke can be conjured up quickly and easily using the Liquify filter. Its range of tools lets you manipulate an image as though it were oil on water; this can produce natural-looking freeform effects.

Here's our candle. It's been placed on a black background to make the effect easier to see whilst we're putting it together. This can always be replaced with a more fitting backdrop once it's finished. We'll begin by adding a new layer crow all Shift N.

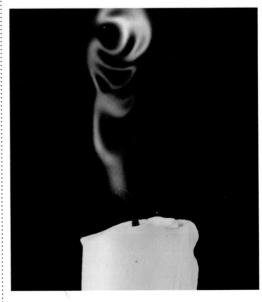

Photoshon Flements 8

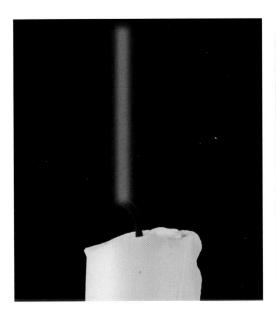

Select the Rectangular Marquee M. Draw out a long, thin box from the wick to the top of the image. Fill the selection with a strong color, red in this instance; it needs to show up well in the Liquify dialog. Press ctrl D # D to deselect. Lastly add some Gaussian Blur to create a soft edge.

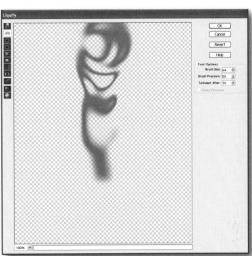

Now for the fun part. Open the Liquify filter from the Distort sub-menu. Experiment using a combination of the tools to spread and distort the line. Vary the brush size and pressure to create a more random effect. If you're using a pressure-sensitive tablet, check the Stylus Pressure box.

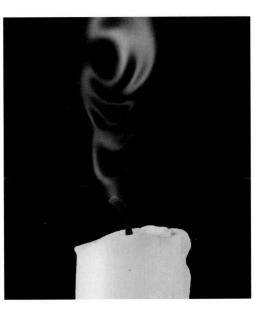

Create a layer above the candle itself and change its blend mode to Color Dodge. Set the foreground color to to the smoke using a cooling Photo Filter Adjustment Layer.

HOT TIP

The Liquify filter can be a little hit and miss. If you make a mistake, pressing

ctrl alt Z $\mathbb{H}^{\Sigma}Z$ steps backwards progressively. You also have the ability to restore areas selectively with the Reconstruct tool **(3)**. Simply paint over the required area to undo the changes. Varying the brush pressure controls the speed at which the image is rebuilt. If you decide to start afresh, click the Revert button. This will return the image to its initial state without having to exit from the dialog first.

MAC WIN BOTH

6

Transformation and distortion

Troublesome perspective

NE OF THE PROBLEMS WE FACE when we are creating montages from different photos is the angle at which they were taken. Unless they were specifically shot for purpose, the different elements of the scene may not fit together properly because their perspectives do not match.

Our example illustrates this perfectly. We have a young wizard casting a spell and a castle turret for his background. The boy's angle does not match the floor of the castle room, which was shot at a mid-level angle with a wider lens, so he looks out of place. We could try and distort his feet to match the perspective, of course, but that would be difficult and could end up looking unnatural. Instead, we'll adjust the angle of the floor. This, as we'll discover, is much easier than it sounds!

The image comprises two layers: the background layer and our young wizard. We won't duplicate the background this time as that will be confusing when we start distorting it. Instead, we'll convert it to a regular layer by double-clicking its thumbnail in the Layers panel.

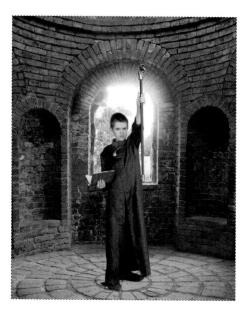

Our castle was shot in bright daylight – not very wizardly. First, hide the boy's layer. Make a selection around the inside of the window. The Quick Selection tool is perfect. Soften the edge slightly with Refine Edge or Feather. Press Backspace to delete the area then deselect.

How to Cheat in Photoshop Elements 8

We don't want to distort the whole image, of course. Grab the Elliptical Marquee tool M. Place the cursor in the middle of the floor. Press and hold M. while dragging out the selection to keep it centered. We want it to surround the whole floor area up to the edge of the walls.

Press end T ** T to enter Free Transform. Press and hold end ** Carefully drag the bottom-middle handle upwards keeping the box straight. Use the boy's feet to gauge the correct perspective. Press ** Enter** to commit to the change. Lastly, deselect end D ** D.

Press and # J to duplicate the background. Set the layer's blend mode to Multiply. This tones down the glare from the window and darkens the interior of the room giving it a much stronger texture. Press and # # E to merge the two layers together.

To finish this part of the project, go to File > Place and load Moon.jpg from the CD. Press File to set it in place. Press Shift of Shift 1 to send it to the back of the layer stack. Use the Move tool v to reposition it so it matches the bright spot of the window where the sun was.

HOT TIP

This technique is not without its problems: the brickwork of the walls has been distorted where we've brought the floor up. As it's an old building we can just about get away with it. If it were more prominent, however, we would need to patch it with the Clone Stamp tool or by pasting in a selection from another part of the image.

SHORTCUTS

MAC WIN BOTH

Transformation and distortion

It's a kind of magic

ONTINUING WITH OUR WIZARDLY project, we're going to conjure up a magical vortex from the boy's staff. Before we do this, however, we need to make a couple of final adjustments to the scene.

Both photos were taken in daylight but our scene is now lit by the moon. This casts a blueish hue and is much cooler. We'll simulate this by adding an Adjustment Layer which affects the whole image. We also need to add a shadow of the boy to fix him into the room properly. Having done this we can go on to create our magical effect, using the everversatile Clouds filter to produce the powerwaves emanating from his staff.

Select the boy's layer and make it visible again. Add a Hue/Saturation Adjustment Layer. Check the Colorize box. Drag the Hue slider into the blue range – around 220. Increase the saturation; around 50 here. Set the layer's blend mode to Multiply and lower the opacity to around 70%.

Press (tr) to invert the colors. Open the Levels dialog (tr) E.D. Drag the Shadows slider across to the right; the white areas will start to disappear, leaving only the brighter areas. Now use the Midtone slider to fine tune and give us this wispy lightning effect.

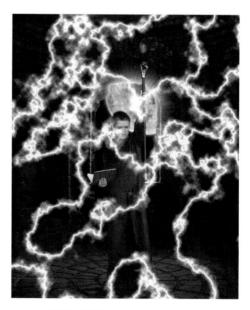

Press (III) to open the Hue/Saturation dialog. Check Colorize. Drag the Hue slider into the purples and increase the saturation a little. Set the layer's blend mode to Screen. The black areas of the layer disappear, leaving us with just the lightning.

How to Cheat in Photoshop Elements 8

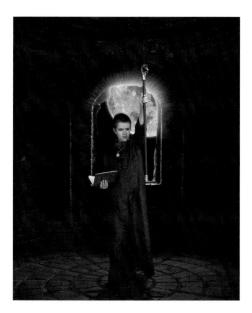

Next we've added a shadow, cast from the moonlight coming in through the window, in front of the boy. Rather than it being explained again here, you can find the techniques for doing this and also adding the shading on the boy's feet in the previous chapter.

Create a new layer at the top of the stack. Press **D** to select the default palette. Hold **all S** and select Filter > Render > Clouds for more contrast. Now apply Difference Clouds. We want the strong 'veiny' appearance. We can undo and reapply both filters until we get the best effect.

HOT TIP

For an extrapowerful effect, we could duplicate the lightning layer in step 5 before running the Twirl filter. The raw lightning could be edited to leave a few arcs jumping off the staff down to the floor and across the room.

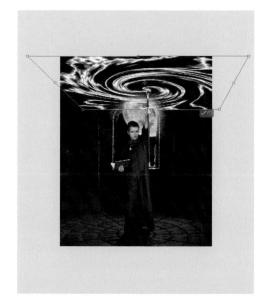

Open the Twirl filter (Distort). Drag the slider to around ±340°. This gives us a good effect without being overdone. Click OK to apply. Enter Free Transform (17) To Now hold (17) Hand drag the handles to distort and position the vortex over the boy's head into perspective.

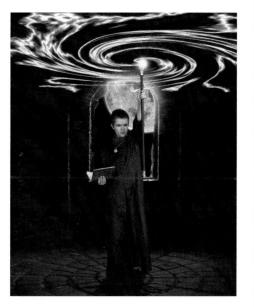

Load the boy's selection. Now grab the Eraser tool and erase the areas that fall behind the staff to make it more three-dimensional. Deselect and erase the stray parts of the effect around the edges. Finally, grab the brush tool and use a soft tip to dab a white glow at the top of the staff.

Transformation and distortion

Keep your composure

OMETIMES, WE HAVE the perfect image but it's been shot at the wrong aspect. Our example would be great for a promotional flyer or magazine cover but it's a landscape image and we would need it in portrait. We'd want to keep the four people in the image too, so cropping isn't possible.

Elements 8 has a new secret weapon: the Recompose tool. This behaves like Transform but with one important difference: it analyzes the image on the fly, working out what it thinks is important detail at what's not. In our case this is the grass and hills. The people remain untouched.

Opening our example image we can see that it's a landscape image but has a lot of space that could be reclaimed to make it narrower. If, however, we try to scale down disproportionately using Transform (III) I III) the end result

is not a pretty sight. By just scaling it down to half the original width the people are horribly squashed up, making the image unusable. Press the Escape key to cancel the transformation and it will snap back to its original state.

3 Because the tool looks for less detailed areas of the image first, it took away the left edge of the photo. We can prevent this from happening by using a selection to protect that part of the image. Press Escape to cancel

again – or undo by pressing (2012) (31) If you committed to the changes previously. Grab the Rectangular Marquee tool (10). Now drag the boundary across the image but leave a vertical section on the left-hand side of the image clear.

2 Select the Recompose tool at R

R

R

or choose it from the toolbox;
it's found as part of the Crop tool group. We
immediately get a bounding box around the
whole image. If we grab the middle-right handle

and start to drag across to the left we see that instead of the whole image compressing down, the wider expanse of the ground starts to disappear and the people are moved closer together but remain at their proper size.

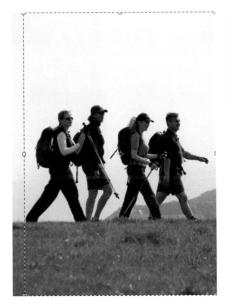

4 When we select the Recompose tool again and scale across from the right, it only affects the area within the selection, leaving us with a border which looks less cramped. Press Enter to apply the changes. On larger images this

may take some time as the image is rendered. All that remains is to crop out the empty section of the image and we have our portrait shot ready to be used as a flyer or magazine cover. This definitely is a simple and highly effective tool!

HOT TIP

If we want the image to be constrained to a particular size, we can select one of the presets from the Options bar. This contains many standard photographic sizes. When one is selected the image is automatically sized to those proportions. The results aren't always perfect but it can save a lot of time.

SHORTCUTS

MAC WIN BOTH

Drawing comparisons

ONE OF THE QUESTIONS MOST FREQUENTLY ASKED by newcomers to digital imaging concerns which program they should choose: Photoshop Elements or the full Photoshop product. There is no definitive answer; each has its merits. The basis for the decision should be one of individual requirements.

A common misconception is that Elements is Photoshop's poor relation, only suitable for photography hobbyists who need a simple program to catalog their images and perform quick fixes such as removing red-eye from portraits or correcting color casts. Although there is a definite leaning toward the amateur market, Elements is more than capable of producing the same standard of artwork as its big brother. Elements still has around 90% of the features found in Photoshop; it merely lacks some of the more high end functionality associated with professional pre-press. You'll find all the same filters and the majority of adjustments are present. Some are cut-down versions offering less in the way of fine tuning, though not at the expense of their usefulness. There is also a degree of symbiosis between the two programs. Look under the hood of Elements and you'll find technologies from recent Photoshop releases packaged to perform a specific purpose. Similarly there are parts of Elements that have traversed the other way.

There is, of course, one distinct difference: the price. Presently, Photoshop will happily relieve your bank account of \$600 upwards, depending on the version you choose. Elements, on the other hand, will cost you around \$100 for the full product (less for an upgrade from previous versions). This makes it an ideal solution if you have a limited budget.

So, with all that said, what exactly are the differences between the two programs and can you survive without whatever it is that's missing? As we mentioned before, Elements does not feature some of the tools required for press-quality printing such as comprehensive color management and the CMYK color space. This, however, does not mean it cannot be used professionally; the images in this book were all produced using it, after all. Most designers' applications such as Adobe's InDesign will convert the images and to an extent, allow you to adjust the color. There are also many third party utilities which perform the same function.

The differences become less of an issue when you start comparing the tools

and commands. Many of Elements' shortfalls can be overcome with a little lateral thinking. Here are the main 'extras' found in Photoshop, with workarounds:

Photoshop tool	What it does	Elements workaround
Pen tool	Draws Bézier paths	Use selections instead and save as alpha channels; save as .psd or JPEG2000 file
Curves adjustment	Adjusts color and brightness	Use Levels instead
Vanishing Point filter	Places images in scene in perspective	Use Free Transform to distort layer
Black & White adjustment	Changes color image to monochrome	Use Gradient Map Adjustment Layer with default colors
Layer masks	Allow user to hide image areas	Use Adjustment Layer (see page 46) or import Photoshop layer mask (see page 48)
Layer styles	Gives more control over layer styles	Be creative with built-in styles or import styles from Photoshop
CMYK mode	Prepares artwork for commercial printing	Use third party software to convert to CMYK mode
Smart filters	Allows editable filters with selective masking	Duplicate target layer and lower opacity; use Adjustment Layer mask to hide effect
Image Warp	Allows free distortion of layers	Use Shear or Liquify filters for similar effect

There are some features in the full version of Photoshop that have no Elements equivalent – such as Smart Objects, video and 3D Layers (Photoshop Extended edition only) and support for specialist video modes. But, in the main, Elements is capable of satisfying 99% of every montage artist and photographer's requirements.

Textures can make all the difference to a piece of artwork. Here are two versions of a wedding album layout. The first is flat and uninspiring; everything is clean and squared off. The second, with its satin background and gold-framed images, sets the mood and adds that all-important interest factor.

Materials and textures

OUR SURROUNDINGS ARE DEFINED BY TEXTURES. We can, for example, see at a glance that something is made of wood simply because of its familiar, grainy appearance. We recognize certain materials such as silk by the way the light catches their folds and creases.

In this chapter, we'll look at ways of creating textures such as wood and cloth from scratch. This gives you more freedom as you are not constrained to the size of your source images.

We'll also see how existing images can be manipulated to match your theme: torn edges for newspaper clippings or ticket stubs, or ageing an object by covering it in dust.

Curtains with a difference

LL THE WORLD'S A STAGE, as William Shakespeare would have us believe, and what stage would be complete without the familiar heavy red and gold drape curtains?

The following tutorial demonstrates a quick and easy way of creating an undulating texture resembling the folds of heavy, hanging material. This has many potential uses: you may want to mock up some decor for a room in the house. You could also use the effect to create a template or intro for a home movie DVD, or, as with our completed image, give a family member the stardom they deserve.

Start with a blank document. Create a new layer and select the Gradient tool (a). Choose a Linear Black, White gradient. From the Options toolbar, set the blend mode to Difference. Now position the cursor at the left edge. Hold (Shift). Click and drag a short distance to the right.

A Next we'll be adding some texture. Create a new layer. Use the Rectangular Marquee to draw a selection that encloses nearly all of the image. Leave a narrow rectangular section across the bottom of the document. Fill the selection with 50% gray.

The effect is now looking much better but is still a little two-dimensional. Deselect then press and the enter Free Transform. Click the bottom center handle. Drag it up a little way to create a small gap at the bottom of the image. This gives us some space for adjustment.

2 Reposition the cursor back to the left; around half the previous width works well. Now click and drag to the right again (remember to hold **Shift**). Repeat the process across the entire document. Vary the distance slightly each time to create the random pleats.

3 It's starting to take shape but the lines are a little strong at the moment, making the effect look too rigid. We'll soften the image with a little Gaussian Blur. Add just enough to smooth out the harsh edges, giving the impression of soft, rolling fabric.

HOT TIP

At first glance, the Liquify filter often appears to be cumbersome and only useful when creating over the top effects such as caricatures or surreal Dalistyle images. When used conservatively and with a little patience, it can manipulate smaller areas of an image to add subtle alterations to fit into a scene more convincingly.

5 Open the Fibers filter. Use low Variance and Strength settings to create an even, low contrast pattern. Set the layer's blend mode to Multiply. This mixes the two layers, darkening the tones at the same time. Finally, lower the opacity so the texture is visible but not too harsh.

Press the Helpsaturation dialog the Huelsaturation again. This time, create a golden yellow.

Open up the Liquify filter. Select the Warp tool. Choose a fairly large brush. Zoom in on the base of the curtain. Use the brush to distort the tops and bottoms of the gold trim. As viewers, we're most likely to be above this line, so perspective determines that the curves will face downwards.

9 Our curtain effect is complete. All that remains is to add a cutout from the photo of Auntie Mabel singing the Broadway hits on her birthday. Techniques for adding the spotlight and shadow can be found in Chapter 5, 'Light and shade'.

Quick and easy wood grain

HOTOS OF WOOD TEXTURES can be found in almost any stock library. You can, of course, take your own. As abundant as they may be, sometimes you may not be able to find just the right style to use in your artwork. Here's where filters come to the rescue.

On the previous page, we saw how the Fibers filter can be used to create the effect of plush material. Here, we'll use it to generate the effect of wood grain – it's very versatile. To further the realism, various inconsistencies such as knots and twists are added. Just like the real thing, once made, you can use it to apply to all sorts of objects: an ornate picture frame (as the inset shows), some polished flooring, or simply as a backdrop for your images.

Open a new document. Create a layer ctrl all Shift N

Shift N. Use the Rectangular Marquee M

to draw a suitably sized selection. Fill this with 50% gray.

Duplicate the layer ctrl H. J. Bring the selection back by holding ctrl H. and clicking either layer's thumbnail.

4 Add a few more knots and distortions; experiment with the different tools such as Bloat and Twirl. When you're happy with the effect, click OK. Set the layer's blend mode to Overlay. Although you won't notice any difference just yet, we're setting the layer up to allow color to be added.

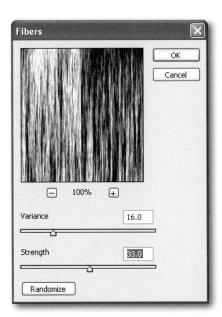

Make sure the foreground and background colors are set Lo the default black and white by pressing **D**. Open the Fibers filter dialog. Adjust the settings until you have a fairly reasonable-looking grain. Variance gives more randomness; Strength gives more contrast to the effect.

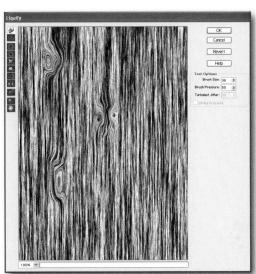

We'll add some variations such as whose Liquify filter. Grab the Turbulence tool. Set a medium We'll add some variations such as knot holes. Open the brush. Increase the pressure a little. Position the cursor in a suitable area. Click and drag a short distance down. If it doesn't work the first time, hit ctrl Z # Z and try again.

HOT TIP

A lot of the techniques in this book make use of neutral gray layers for shading and applying filters which can be controlled with blend modes. A time-saving tip is to try and keep the Fill dialog set to 50% gray. By doing this you can then use the keyboard shortcuts

Shift Backspace and then Enter to quickly fill the layer or selection.

Click the plain gray layer's thumbnail to make it active. igcup Open up the Hue/Saturation dialog ${\it curl} U \not \boxplus U$. Check the Colorize box. You'll see the effect immediately. Use the Hue, Saturation and Lightness sliders to create the shade you want your wood to be.

You may decide the grain layer is too dark or coarse. Try experimenting with different blend modes. You could also use the Levels dialog to change the contrast, making it lighter or darker. Here, we've changed the blend mode to Soft Light and lowered the opacity a little.

Pattern forming

ATTERNS ARE EVERYWHERE around us: grass, brickwork, ocean waves, wood grain – the list is endless. When we want to use them in our designs, we often need to have a repeating pattern; a background for a website or collage, for example. This is where we run into problems: attempting to create a tiled pattern straight from the camera or scanned image with no alterations will most likely result in ugly seams where each instance butts up against the next; this is especially noticeable with complex patterns. We need to be able to make them seamless to enable them to fill any required space with almost no visible flaws.

Here's an image of some pebbles. Grab the Crop tool (a), hold (b) to constrain to a square, and drag out a suitably sized boundary. We've chosen an area with a good random element but made sure there weren't too many obvious repeats such as large stones or other debris.

4 Going back to our original cropped image, select the Offset filter (under Other). Set the horizontal and vertical pixels to half the size of the document; our example is 500 pixels so we'll set it to 250 for each. Make sure the Undefined Areas are set to Wrap Around and click OK.

2 Firstly, we'll create our pattern straight from the cropped image. Press att/ A \$ A to select the whole document. Now, select Define Pattern from the Edit menu; we get a thumbnail of our pattern and a space to give it a name. We'll call this one Pebbles raw.

We want to hide the tile borders so grab the Clone Stamp (S), choose an area away from the center, hold and click to set it as the source. Now begin painting over the border lines. Continue this, choosing random areas until you are left with a continuous pattern.

Here we've created a larger blank document. Using the Fill dialog <code>ctrl</code> <code>Backspace</code> <code># Backspace</code> with the contents set to Pattern, we've selected our custom pattern and filled the area. Viewing at 100%, we can clearly see the tile borders: not very attractive.

6 Now, when we define a pattern as before and fill our large document, there are no harsh edges; much nicer. On close inspection we can still see a repeating pattern, of course, but this is much more easily disguised with the other elements of the design.

HOT TIP

It's tricky

avoiding the obvious repeats in the pattern; we can lessen the effect by using different scales of image, depending on the size of the background we're filling. We could also take more time and analyze the tones in the image when we are cloning out the lines, making sure there are no prominent areas of particularly strong highlight or shadow which might become more noticeable when we have a background built up with many instances of the tiles. If we were using a pattern with larger, more defined detail, such as leaves, it may be better to copy and paste certain parts, rather than clone them.

SHORTCUTS

MAC WIN BOTH

Lying on a bed of satin

REATING COMPLEX TEXTURES from scratch is not necessarily as difficult as it may at first seem. Earlier in the chapter we used gradients to create the folds of heavy curtains. A similar method can be employed to produce a more random and fluid effect resembling the intricate folds and wrinkles of finer fabrics. The major advantage of generating your own materials in this way is you are never tied to the size of a stock image. You can create the pattern to suit the dimensions of your artwork, without fear of repetition letting the effect down.

Hide the rose layer. Click the background layer's thumbnail to make it active. Select the Gradient tool G. Choose a Linear Black, White gradient. Set the mode to Difference, then click and drag the guide from corner to corner. This creates a good base for the effect.

Go to the Stylize filters sub-menu and select Find Edges. This produces a smoother version of our pattern and leaves the ridges well defined. It's looking good so far but we need to bring back some of the contrast. This is easily done by applying Auto Levels CHI Shift L. Shift L.

2 Pick a random starting point. Click and drag out another gradient. Make it shorter than before and repeat this several times. Change the position, length and angle on each. Try to create a good balance of small, intricate areas and larger, smooth sections.

The initial result is a little harsh, so we'll soften it with a little Gaussian Blur. Set a fairly low value, enough to remove the sharpness from the lines and produce a smooth transition between the tones. The amount will, of course, vary depending on the size of the document.

HOT TIP

Even in the relatively precise world of digital imaging, there is often a large amount of trial and error involved, particularly with techniques such as this one where you are building up the effect. Fortunately you can use Undo ctrl Z H Z to backtrack several stages and start over from a different point.

5 Open up the Diffuse Glow filter from the Distort submenu. We'll use this to add some texture and spread out the highlights. Push the Graininess up: around half way is sufficient. Add a small amount of Glow; be careful not to wash the image out. Set the Clear amount to its maximum.

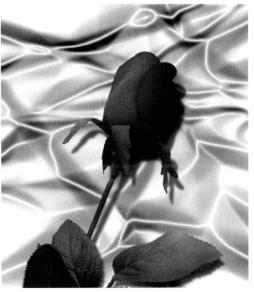

6 As a final step we'll add some color. The Hue/Saturation adjustment is perfect for this. Remember to check the colorize box. Some shading has been added to the rose along with a shadow to gel the scene together. More on this can be found in the 'Light and shade' chapter.

Making notepaper

SING PAPER IN A DESIGN can add that all-important handmade feel to it. This might be a piece of rich parchment declaring a special occasion or just a simple Post-it note to draw attention to a particular area of the artwork.

In this tutorial we'll create a piece of ruled notepaper using layers and selections. A key point to consider when creating objects from scratch is to give them some texture, in this case by adding some Gaussian Noise. This helps them to blend into a montage more convincingly – real life is never as pure as a digitally produced image.

Start by creating a new layer. Use the Rectangular Marquee to mark out the shape of your paper. Fill this with white. You can't see any difference, of course, as it is displaying against white. You can either hide the background layer or fill it to make it easier to work on the image.

We need to remove the excess part of the box. Hold *ctr* **\$\mathbb{E}\$**. Click the paper layer's thumbnail to load its selection. Inverse the selection *ctr Shift* **\$\mathbb{E}\$** * *Shift* **\$\mathbb{E}\$**. Now remove the unwanted area by pressing *Backspace*. This leaves us with a single line trimmed to fit.

5 Load the line's selection. Select the Move tool **V**. Press and hold **all Shift Shift**. Tap the down arrow key once. This duplicates the line. Hold **Shift** on its own. Nudge the line down a couple more times to create the spacing. Now repeat the process to fill the page.

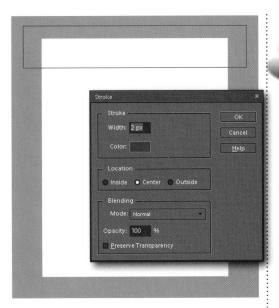

3 Create another new layer. Draw a new rectangular selection positioning the bottom edge where the first line on the page will be. The rest of the box needs to extend outside the area of the paper. Select Stroke from the Edit menu. Set the width and color for the desired effect.

To create the punched holes, draw a small circle using the Elliptical Marquee. Press **Backspace** to clear the pixels. Click and hold inside the selection. Hold **Shift** to constrain the movement. Drag the selection down into position. Delete the pixels again.

HOT TIP

Creating a selection before using the Move tool to duplicate parts of your artwork results in the copied area staying on the same layer. This is particularly useful when creating repeating patterns as we have here. Without doing so, we would end up with too many unnecessary layers.

Create the vertical margin using the same method as the horizontal line. I've chosen a different color here. By lowering the opacity we can control the faintness of the lines. When you're happy with the result press and E to merge the ruled layer with the page.

The art of paper tearing

OMPONENTS OF YOUR ARTWORK often need a more handmade appearance, rather than the clean, precise lines of a selection or crop. Images such as the newspaper clipping above look far more realistic with a roughly torn edge.

As you'll see in the following workthrough, it only takes a few quick steps to achieve the desired effect. The technique is also highly versatile and is easily adapted to a suit a variety of styles. You might, for example, want to create an old treasure map or a background of notepaper for a web page.

We'll use a scan of some crumpled paper. It's been placed on a separate layer. It's a good idea to work on a plain, contrasting background. This makes it easier to see what you're doing. Begin by loading up the paper layer's selection by holding (277) (35) and clicking its thumbnail.

4 Click the New Effect Layer icon at the bottom of the dialog. This creates another instance of the current filter. Use the menu to select Torn Edges. This adds a little more refinement. Again, use the sliders to fine tune the effect. Click OK to apply.

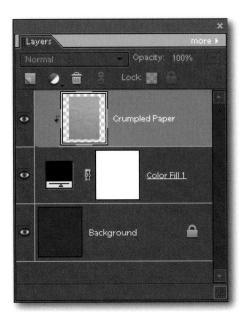

We'll be using the masking technique described in Chapter 3 to create the effect. Add a Solid Color Adjustment Layer beneath the artwork. The mask's shape is automatically defined from the selection. Switch to the paper layer. Press @ # G to create a clipping group.

Click the Adjustment Layer mask icon. Select the Spatter filter from the Brush Strokes sub-menu. Create the desired effect using the sliders. The filter won't affect the rest of the image as the edge is the only area of contrast. Don't apply the filter yet.

HOT TIP

As with the example, it's often necessary to combine different filters to achieve the desired effect. This is made simple by using the Filter Browser's effects layers. You can try different combinations and compare the result without the need to apply them first.

5 You'll notice part of the effect has been lost. There are also stray black pixels. This is because the affected area falls outside of the paper layer's bounds. This is easily remedied. Press (tr) (1) (1) (1) to enter Free Transform. Use the handles to scale the mask toward the center.

For extra realism use a hard-edged brush to erase random areas around the edge of the mask before applying the filters. You'll also need to merge the layers before you can add the image into your artwork. Turn off the background layer. Press art Shift E # Shift E.

Creating old paper

O FAR WE'VE SEEN HOW TO MAKE crisp notepad paper and produce the appearance of fairly carefully torn edges. We're going to turn the clock back a little farther now and create the effect of old, battered parchment.

This simple yet very effective technique is quick to use and can easily be incorporated into your artwork. It is, of course, particularly useful for making old maps – as with the above image – medieval-style letters, and anything else that needs to appear to have withstood the ravages of time.

Begin by creating a new layer. Use the Freehand Lasso to draw a ragged outline to mark out the edge of the paper. Apply a small amount of Feather to the selection; 1 pixel should be OK. Press Shill Backspace to open the Fill dialog; select Color as the content and choose a light, sandy color.

We have our mottled effect but it still looks too clean. We need to give it an earthier appearance: open the Film Grain filter located under the Artistic menu. Use very low settings to create a subtle, gritty effect across the surface of the paper.

Press [1] to duplicate the layer. Choose the Difference Clouds filter from the Render sub-menu; although we haven't constrained the effect, it only affects the area of the previous layer's pixels. The colors look a little strange but this is only temporary.

3 Set the layer's blend mode to Soft Light; this gives us a nice spread of tones. Depending on the effect you require, you can lower the opacity to make it less harsh. When you're happy with the result, press con G ** G to group the layers, then con E ** E to merge them.

5 To complete the effect we'll add some dark patches around the edge: select the Burn tool **a**, set its mode to Midtones, and paint over random areas all around the perimeter. This gives the effect of the paper having been handled and battered over time.

As an optional step you can create some holes in the paper to enhance the effect even more. Use the Magic Wand W to select the darker patches of the paper, feather the selection then hit Backspace to delete the areas. You can also darken the edges as in the last step.

HOT TIP

In step 3 we took the unusual action of creating a clipping group before merging the layers together. If we hadn't, it would have resulted in a thin, dark edge appearing around our paper; this is due to combining layers which have been feathered. This can, of course, work in our favor if we wanted to have a slightly heavier border.

Once finished, you can add artwork such as maps or lineart using the Multiply blend mode. These can then be grouped so the missing areas are hidden on the image overlay as well.

SHORTCUTS

MAC WIN BOTH

Ageing a photo in minutes

HERE ARE MANY WAYS to restore old, damaged photographs. You'll find one in almost every digital imaging how-to book. In this tutorial, however, we're going to do the exact opposite. By taking a perfectly good picture and applying a variety of effects, we'll create the impression that it has been less than well cared for. We'll also add the appearance of it being torn.

Although this might seem a little perverse, it serves as an extreme example of what can be achieved by combining and blending existing textures with a photo. In this case, we'll use the reverse side of an old, battered book cover. The dents, folds and creases provide an excellent basis for the effect.

Here's our scanned book cover. It's already been scaled to match the photo. We'll start by duplicating the layer by pressing on the layer by pressing on the layers panel.

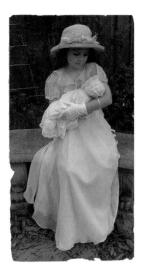

2 Our photo is placed on its own layer between the two covers. This is converted to a clipping group by pressing (M) (3) (6). This hides the pixels that fall outside the cover layer, giving us a nice, rough edge.

To create the border: Click the photo layer's thumbnail to make it active. Hold arr # and click one of the texture layer's thumbnails. Contract the selection; 15 pixels works well here. Inverse the selection arr Shift 1. Press Backspace.

Hide the background layer. Press out Shift E St Shift E to flatten the layers. Load the layer's selection. Select the Freehand Lasso. Hold all Shift Shift. Draw a rough selection to isolate a corner of the image. Expand this by around 3 pixels.

Use the technique shown earlier in the chapter to create a torn edge. Because we made the selection, it will only apply to the corner. Stop whilst you still have the mask enabled. You can see the problem. We only want the inside edge affected.

The sepia tone is created by adding a colorizing Hue/Saturation Adjustment Layer to the clipping group above the photo. The photo layer's blend mode is set to Hard Light, allowing the texture to show through.

Select and show the top cover layer. Press AND Shift U

Shift U to desaturate the image.

Set its blend mode to Hard Light.

Combined with the base layer, this really enhances the texture.

The effect is a little washed out.

Press L to open
the Levels dialog. Start to drag the
Shadows slider (left-hand triangle)
across to the right to increase the
contrast.

HOT TIP

It's a good idea to maintain a separate library of textures such as the book cover. Create a folder in the place where you create your projects or store your photos. Each time you scan or find a useful texture. place it there for easy access.

Doad up the photo layer's selection and inverse it ctrl Shift 1.

Shift 1. Press Backspace to remove the excess from the outside edges. Press ctrl 2 CD to deselect. Exit the mask view by clicking the photo layer.

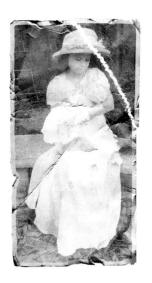

Hold oth H and click the mask's thumbnail. Press oth Shift J H Shift J. This cuts away the corner to its own layer. Hide or delete the Adjustment Layer. Use Free Transform to move and rotate it away from the rest of the photo.

1 1 Load the corner layer's selection. Nudge it to the left by a couple of pixels. Open the fill dialog. Select Color and choose a suitable background color. Set the mode to Behind. This will give a little thickness to the edge.

Materials and textures

A quick repair job

HILST WE'RE ON THE SUBJECT of damaged photos, it appears that this seaside Polaroid has seen better days. We could spend hours retouching and seamlessly blending the image to a state where nobody would ever know it had been in two parts. We're not going to, though. Instead, after crudely placing the pieces together, we'll create some strips of old, worn Scotch tape to make it look as good as new (almost).

This is a slightly over the top example to illustrate the technique. You could, of course, use the effect in your scrapbook projects or to stick virtual photos up in your web gallery. With a bit of customizing, it could easily become solid electrical tape or even sticking-plasters.

We'll begin by putting the two halves together. They're on separate layers so we can use Free Transform to place them together. If it were a single layer, you could use the Lasso tools to select the pieces first. We want it to look botched so you'll want to leave some overlapping areas.

Select either the Dodge or Burn tool **()**. Choose a soft brush set to Highlights. Create some light and dark shading to give the appearance of the tape lifting. You can switch between Dodge and Burn modes by holding whilst painting. Keep the effect subtle for the best results.

Create a layer above the photo. Grab the Lasso tool and draw a jagged selection. Press and said and release the mouse to switch to Polygonal mode. Drag out a side. Click and hold to switch back to freehand. Add the other ragged end. Finally, join it up with another straight line.

Press Shift Backspace to open the fill dialog. Select 50% gray as the Content. The hue of a neutral color can always be altered. Scotch tape is semi-opaque (even when aged) so set the Opacity to 50%. Finally, press at D to deselect.

HOT TIP

If you're using a mouse to add shading it's always best to use a low opacity (or Exposure with Dodge and Burn) and build up the effect gradually. Using a pressuresensitive tablet is, of course, the best way to get the most control over the painting tools.

To give our tape a really authentic appearance we've used the Plastic Wrap filter (from the Artistic sub-menu). This is supposed to be old tape: we need to add some discoloration. A Hue/Saturation adjustment is good. You can control the effect from one dialog.

Press and #T. Reposition the tape. Rotate it to follow the tear. You could draw additional pieces from scratch. A quicker way is to press # T. #T.

This creates a new copy on the same layer. You can flip and distort them enough to appear sufficiently different.

7

Letting the dust settle

UST IS USUALLY SOMETHING we don't like seeing. As with many things, there are exceptions, wine being one. Cellars often have bottles which have rested undisturbed for many years as they reach maturity and, as a result, have accumulated a thick layer of dust.

If, however, you're not a connoisseur and need a picture in a hurry, you can create the desired effect in a few easy steps. We'll be using a bottle for the workthrough but the technique could just as easily be applied to many different subjects: items in an attic, perhaps. You could even use it in promotional material for a cleaning company – a before and after shot, for example.

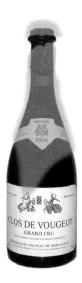

Here's our bottle. It's been isolated and placed on its own layer. Begin by grabbing the Selection Brush (A). Set the Mode to Mask. Now use a soft tip to paint in the areas where you want the dust to be. Don't worry too much about spilling over the edges; they'll be tidied up.

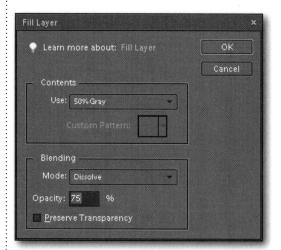

Create a new layer above the bottle. Open the Fill dialog **Shift Backspace**. Set the contents to 50% gray. Choose Dissolve for the blend mode. Now lower the opacity a little; to 75% in this case. Dissolve uses the opacity value to determine the visibility of the layer's pixels.

Switch back to Selection mode. Press ctr Shift

B Shift 1 to inverse the selected areas. Hold
ctr at Shift E Shift and click the bottle layer's
thumbnail; the keypress forces the selection to Intersect
mode. Anything outside of the bottle's edge is discarded.

The result is not too bad; it's a little uniform, though.

Press (ID) (B) to deselect. Add some Gaussian

Noise to give a more random texture. Follow this with a very small amount of Gaussian Blur; you just need to take the harshness away from the effect.

3 Even a thin layer of dust has depth. We need to create some extra space for the effect to sit outside of the bottle's edge. Choose Modify > Expand from the Select menu. I've used a value of 1 pixel here. You could, of course, use different values to produce thicker layers.

Almost done. Select the Burn tool . Set the Range to Highlights. Using the edge of a large, soft brush, darken down the sides of the dust layer. Use the shape of the bottle as a guide. Now hold all to to temporarily switch to Dodge mode. Lighten up the front area a little.

HOT TIP

For extra realism, you may want to create some areas where the dust has been disturbed. This can be achieved by using a soft Eraser set to a low opacity. Parts of the layer can be progressively thinned out; great for creating fingermarks where the object has been handled.

Materials and textures

You spin me round

OLLOWING ON CLOSELY from the previous theme, we're going to use noise to create a different kind of dusty texture: this time, it will form the worn groove of a much-played vinyl record.

We'll create the whole thing from scratch - if you'll pardon the pun - using just layers, noise and blurs. The result is exceptionally realistic and can be used as the basis for musically styled collages or perhaps a novelty greetings card for an aspiring rock star in the family.

Create a blank document and add a new layer. Select the Elliptical Marquee M and, holding Shift to constrain the proportions, create a large circle by clicking and dragging out from the top-left corner. Press **D** to select the default colors and fill the layer with black (alt Backspace) Backspace

Copy the layer ctrl J # J. Press alt Shift Backspace Shift Backspace to fill only the visible pixels with black. Enter Free Transform ott T # T and, holding alt Shift Shift to scale proportionally around the center point, drag it to the size of the inner circle of the record.

Press ctrl E # E to merge the layers. On a new layer, use the Polygonal Lasso 🔳 to draw a bow-tie shape across the record. Fill this with white. Deselect and add a strong Gaussian Blur, and drop the opacity to around 20%. Press ctrl G # G to clip the layer with the record.

2 Use Select > Modify > Contract to reduce the size of the selection by around 5 pixels to leave a smooth edge. Add some monochromatic Gaussian Noise; around 50% is adequate. Now select the Radial Blur filter: set the Amount to 100, the Method to Spin, and the Quality to Best.

The result is good but a little light so open the Levels dialog (III) (III). Begin by dragging the Shadows slider to the right so it meets the left edge of the histogram; this darkens the overall surface. Now drag the Highlight slider to the left until the texture becomes more defined.

Create a new layer. Now load up the record's selection and select the Gradient tool . Select a suitable preset; we've used Red, Green here. Now drag right across the surface of the record. Finally, scale it down a little smaller than the center circle with Free Transform to make

To create the center hole: press <code>ctd J # J</code>; now scale the layer down to the correct size and load up its selection. Hide the background layer and press <code>ctd Shift E</code> to merge the visible layers. Finally, press <code>Backspace</code> to remove the pixels.

HOT TIP

We used a gradient here to create a quick effect for the record's label. We could just as easily import some proper artwork, however, by loading the label layer's selection and using the Paste Into command that we covered in Chapter 6, or by using a clipping mask to hide the unwanted parts that extend outside of the label's boundary.

To add a more three-dimensional effect, we could also apply an inner-bevel layer style. If we do this after flattening the layers it will apply to both the outer-edge and the center hole.

SHORTCUTS
MAC WIN BOTH

A little light relief

PREVIOUSLY, WE'VE SEEN how shading can create the illusion of depth and form, changing a simple, flat object into a three-dimensional one. The same is true for creating raised surfaces. It would, of course, take far too long to paint even the most basic of textures by hand. Fortunately, Elements has a built in feature which does just that.

In this example, we'll create a traditional wax seal using a black and white logo as the basis for the effect. The edge of the artwork has been created purposely uneven to enhance the effect, giving the appearance of the hot wax spreading as the template stamp is pressed into it.

Press ctri V # V to paste the previously saved selection then deselect. Press ctri at F # F to open up the Gaussian Blur dialog again. This time, set a much lower value. We need to soften the edges but keep the detail visible.

7 Open the Lighting Effects dialog. Load the saved selection from the Texture Channel menu. The effect will appear in the preview window. We've chosen to use a centered omni light here. The exact settings will vary depending on the required outcome.

Press (III) (B) to deselect. Add a Levels
Adjustment Layer. Accept the default settings. Hold (all)
and click the mask thumbnail. Press (D) to restore the default colors. Now apply the Clouds filter. The reason for using the mask will become evident later.

The default effect is much too harsh for our needs. Soften it down with Gaussian Blur set to a high value. You're looking to achieve a smooth tonal blend similar to the above image. Deselect when you're happy with the result.

HOT TIP

When you hold alt S and click on a mask's thumbnail you switch to View Mask mode. This differs from the default setting as you can perform many of the functions that you can on an ordinary layer. You are, of course, restricted to grayscale as this is an alpha channel.

Hold (17) and click the mask's thumbnail to load up the selection. Only a few small areas will appear; this is OK. The boundary only shows on areas that have more than 50% opacity. Choose Save Selection from the Select menu. Give it a name and click OK.

Click the background layer's thumbnail. Re-enable the Magic Wand's Contiguous option. Select the area outside of the graphic. Press cut Shift 1 # Shift 1 to inverse the selection. Now press cut all Shift N to create a new layer. Fill with white.

The result is good but a little matt. Sealing wax has a mixture of flat areas and shiny highlights. The Plastic Wrap filter is perfect for this. It can be found under the Artistic section of the Filter menu. Use the sliders to bring out the detail and give it a more molded appearance.

9 Finally, use (III) # U to open the Hue/Saturation adjustment dialog. Click the Colorize box. Now adjust the sliders to add some color. We decided on the archetypal deep red. The image can now be saved or dragged into another piece of artwork.

Materials and textures

Stamp duty

HERE WILL BE OCCASIONS when we want to use a piece of artwork or effect repeatedly in our projects. We obviously wouldn't want to keep recreating it each time. We could, of course, save it in the conventional way then import it into a document when it's needed, but there is a better way - creating our own brush preset. This has several benefits: we can save them, either individually or as sets to create libraries; they are non-destructively scaleable and can be resized far more quickly than the usual transformation method; they take up relatively little disk space and because they are self-contained files, they can easily be shared between other Elements and Photoshop users.

When creating a brush, it's important to know how they work. In essence, they are very similar to a mask, using grayscale to determine their opacity. Pure black appears 100% solid, becoming more transparent the closer it gets to white, when it disappears completely. We'll see this in action here by creating a simple rubber stamp effect. We could create a brush from any piece of artwork, of course, even photographs.

TOP SECRET

Let's start with a new blank document. Select the Type tool . We want a bold font for this project: Impact is a good one. Set the text alignment to Center. Click the document to start a new text layer and type Top Secret, with a carriage return ([Enter]) in between the two words.

We need the artwork to be on a single layer so we can apply a filter before creating the brush. Hide the background layer by clicking its eyeball icon in the Layers panel. Now press can Shift E & Shift E to merge the visible layers together.

Select the Brush tool **(B)** if it's not already. Our brush will appear as the last entry in the currently selected brush presets. Although it will be stored automatically, we'll save it, as a precaution. Click the brush, then open the flyout menu and click Save Brushes. Name the file and click OK.

TOP SECRET

Create a new layer. Select the Rectangular Marquee M. Holding all S. click and drag the boundary out from the center of the document – remember to leave enough space around the text for our border. We can reposition the selection by additionally holding the spacebar.

5 Let's create a worn effect, as though not all the ink is being transferred. Press **1** to reset to the default color palette. Go to Filter > Distort > Glass. Choose the Frosted texture. Experiment with the distortion and smoothness settings to roughen the edges a little. Click OK to apply.

Save or discard the original artwork document and create a new blank one. Here we can see the outline of the brush. Just like a mask, the original white areas are hidden, leaving only the slightly uneven black areas where we applied the filter.

TOP SECRET

Select Stroke (Outline) Selection from the Edit menu. We need a strong border so a width of 20 pixels is good for this size image. Set the color to black and the location to Inside – this gives us sharp-edged corners. If we'd used Center or Outside, the corners would be more rounded.

Now we can go ahead and create our brush. First load the artwork's selection by holding (1) (3) and clicking its thumbnail in the Layers panel. Go to Edit > Define Brush from Selection. It's important to give it a meaningful name; this will make it easier to find amongst the other presets.

9 We've filled the background with color to demonstrate the effect. As it is a brush, we can quickly scale it up or down using the left and right square bracket keys

•• We can also change its color simply by setting a new foreground color – we've chosen red, of course!

HOT TIP

Although flattening the layers in step 4 goes against our principles of always keeping the original artwork layers, in this instance it's a very simple image and easy to recreate. If we were working on something more complex, we could merge it to a new layer using ctrl alt Shift E ₩ Shift E

器でShift E then hide the original layers to avoid confusion.

Finger-friendly stained glass

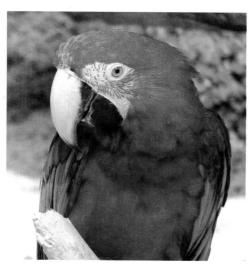

TAINED GLASS HAS BEEN AN ARTFORM for centuries. From the huge, ornate windows of churches and cathedrals to the understated adornment of an urban door, people love its radiance and color.

You may have discovered the Stained Glass filter in Elements; its results are passable but tend to resemble a mosaic more than the traditional effect. In this tutorial, we'll go back to basics and create some of our effect by hand, using a photo as a template for tracing the outline and then applying filters and layer styles to achieve our result.

This technique can be used for all kinds of projects. On its own it's a great effect for greetings cards. It could also be used as an ornate border for framing a photo. You could, of course, use this technique as a basis for designing the real thing.

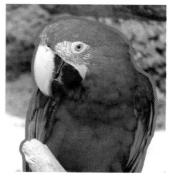

Begin by creating a new layer. Set the foreground to mid-gray. Use a small, hard-tipped brush to trace the outline of the bird. It needn't be perfect as long as you capture the shape.

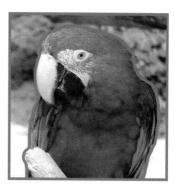

2 Select the entire document by pressing and A A. Choose Stroke Selection from the Edit menu. Set the same color and width as the brush. Use Inside as the location.

Reselect the outline layer by clicking its thumbnail. Grab the Magic Wand W. Click an area of the bird to select that section. The top of the head is a good place to start.

We need to ensure there will be no gaps between the leading and the glass. Expand the selection (Select > Modify). A value half the width of the leading is fine.

Open the Glass filter (under Distort). Set the texture to Frosted. A smoothness value of around 2 to 3 gives a good stipple effect. Raise the distortion level to blur the texture.

12 Change the layer's blend mode to Multiply. This filters out the lighter areas of the glass, allowing the color to show through, but still retains the effect.

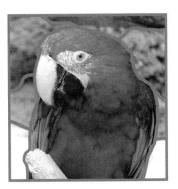

The background needs to be divided up into panels. Draw a few lines between the border and the bird's outline. Use some of the contrasting areas of detail as a guide.

A Now divide up the bird itself.

Again, use the prominent details to make up the panels. Remember that each section must be completely enclosed and connected by the leading.

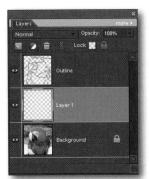

We need a separate layer for the individual colors. Press and hold (#) (#). Click the New Layer icon in the Layers panel. This creates a new layer beneath the current one.

Click the layer you created in step 5. Open the Fill dialog

Shift Backspace. Set the contents to color. Use the eye-dropper to pick a suitable shade from the photo.

Press (III) #D to deselect. Color the rest of the panels by repeating the process from step 6 onwards. I've also painted the center of the eye with a small black brush.

Add a new layer between the color and the outline. Press to restore the default foreground and background colors. Fill the layer with the Clouds filter.

You can use any

image saved in

Photoshop (psd)

format.

HOT TIP

Make the outline layer active.
Select the Wow Chrome layer
styles set from the Artwork and Effects
panel. Apply the Beveled Edge setting.
It may look a little odd at this stage.

14 Double-click the style icon to the right of the layer's thumbnail. Lower the drop shadow's distance. Adjust the bevel size. Around 6 pixels works for this size of image.

15 Here's our completed image. Adjusting the layer style has made all the difference. You may want to make the glass layer a little lighter using Levels or Brightness/Contrast.

Blueprint for design

IDS HAVE WONDERFUL IMAGINATIONS and can come up with all kinds of fantastic inventions – such as this idea for a failsafe alarm clock involving boiling water, melting ice cubes, and a tipping glass at the end of the process.

The trouble is, these designs are always sketched on whatever materials come to hand – in this case, a page torn from a spiral-bound notebook. We're going to see how to turn this sketch into an official-looking blueprint; but first, we need to find a way to get rid of the lines in the background of this ruled paper.

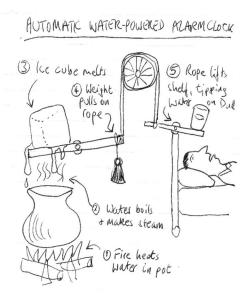

Begin by opening the Brightness/Contrast adjustment. Drag both sliders all the way to the right to set both Brightness and Contrast to their maximum values. This will make the rules fainter, but won't get rid of them altogether (unless your rules are gray, rather than black).

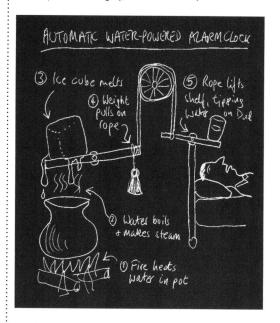

4 Now for the blue background. If the original artwork is still your background layer, double-click its thumbnail to turn it into a regular layer, then set the mode of this layer to Screen. You won't see any difference until you make a new layer behind it, filled with blue.

AUTOMATIC WATER-POWERED AZARMCLOCK

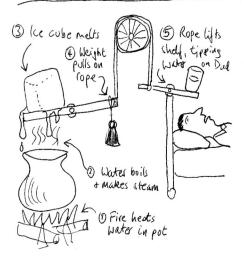

Now desaturate the image and shift U. This will knock out all the extra colors that crept in during the previous step. Use the Threshold adjustment to turn it to pure black and white. You may need to erase a few stray pieces of line; paint them out with a white brush.

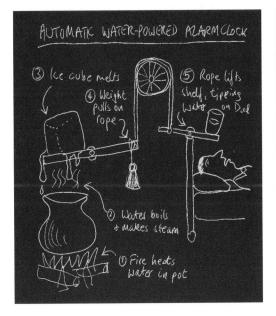

5 The white of the original layer is a little stark, so let's give it a touch of blue. Open the Hue/Saturation dialog and press Colorize. Reduce the Lightness slightly and change the Hue slider to get a pale blue; you may want to increase the Saturation a little as well.

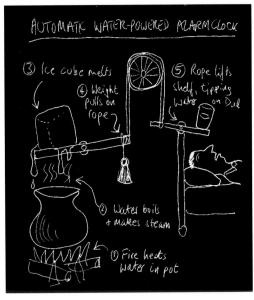

With the image fully cleaned up, we're ready to start turning it into a blueprint. Choose Invert to turn the image from black on white to white on black. If any of the ruled lines still show up, paint over them in black to hide them.

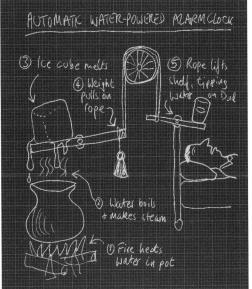

Finally, let's place a graph paper grid behind the image. This grid is white on black, and we've set the opacity to just 20% to make a faint background. It's a bit of a fiddle to draw graph paper from scratch, so we've provided this for you on the CD.

HOT TIP

The hardest part of this job is cleaning up the original drawing. It would be better, of course, if kids could be persuaded to use clean, unlined paper - but when inspiration strikes, we use whatever's to hand. This is an extreme example, with solid, dark rules; most clean-up processes won't be as complex as this one. But the combination of the Brightness/ Contrast and **Threshold** adjustments usually does the trick.

SHORTCUTS

MAC WIN BOTH

Unfinished illustration

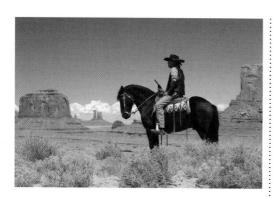

OU'VE PROBABLY SEEN THIS STYLE of illustration many times, where only parts of the image, generally the main detail, are in color and the rest is left as a sketch or given a lighter wash of paint. It's used a lot in children's books and architectural projects but is also an artform in its own right.

We're going to explore a variety of techniques here in order to create our illustrative style image. Starting with a photo, we'll first convert it to a sketch, then use filters to create a painterly effect, then combine the two, and finally use a layer mask to add or remove portions of the image. The use of layers and masks makes the technique very versatile, allowing us to decide how much of the color we show. We could, of course, simply leave it as a line drawing or decide to go for the full color picture instead.

4 We're finished with the outline for now so hide the layer by clicking its eyeball icon. The next step in the process is to create the painted on canvas effect. Select the background layer again by clicking its layer thumbnail and create another duplicate.

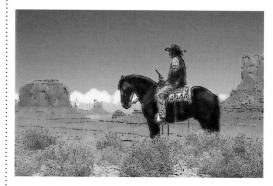

The image looks a little blotchy and formless at the moment. Make the outline layer visible again. Now set its blend mode to Multiply. This hides the white area of the layer, leaving just the outline so it overlays our painted effect. This really brings the image to life. We're almost done.

2 Change the blend mode to Linear Dodge. The document will go white; this is normal. Open the Gaussian Blur filter. Set the Radius to 0. Now drag to the right; we'll see the effect emerge. Stop when there is a visible outline – around a 2-3 pixel radius works well for this image.

Now we'll make the outline bolder. Merge the layers together (IDE) SE. Open the Levels dialog (IDE). Drag the Shadows slider to the right so it meets the left edge of the histogram. Now adjust the midtones and highlights to fade out the grayer areas of the image.

5 Open the Filter Gallery from the Filter menu. Select Paint Daubs from the drop-down menu. We used a Brush Size of 7 and a Sharpness of 4 with a Wide Blurry brush type. This gives us a great painterly effect. Don't click OK yet as we're going to add another filter.

6 Click the New Effect Layer icon at the bottom right of the window. Now select Underpainting from the dropdown. Here we've used a Brush Size of 4, Texture Coverage of 2 with the Texture set to Canvas, and a relief of 4. Finally, set the Light Direction to Top Left and click OK to apply.

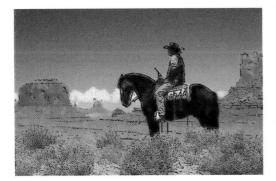

Only parts of the image have a canvas texture. Create a new layer beneath the painted layer. Fill this with white. Select Filter > Texture > Texturizer. Set the attributes to match those we used in the underpainting filter and apply it. Finally, set the painted layer's blend mode to Multiply.

Greate a layer mask on the painted effect layer. Press arm 1 ∰ 1 to invert the mask. This hides the content. Now, using a white brush – some of the wet media brush presets work really well – we can start to paint over the mask, bringing back those parts of the image.

HOT TIP

When using multiple filters to create a particular effect, whether you do this all within the Filter Gallery using layers or individually, it's always worthwhile making a note of what filters you used, their settings, and in what order you applied them. It will make it much easier to recreate the effect the next time!

SHORTCUTS
MAC WIN BOTH

Finding images for free

MOST OF THE TIME, you'll be using your own images for the project you're working on – you won't find a more inexpensive source than that. There will be situations, however, when you'll need a photo of an object that you don't have the time or resources to take. It may be completely impractical because it's not something you normally find in your home town or even the country you live in; a famous building or indigenous animal, for example. Whilst you could improvise by altering the project or modifying an image of something similar, there is a much better way of tracking down that elusive picture: the World Wide Web.

In recent years, as more people have switched to digital cameras and fast internet connections have become more commonplace, huge online stock photography sites have sprung up, containing hundreds of thousands of images. Sites such as **stock.xchng** (www.sxc.hu) and the curiously named **Morguefile.com** (traditionally a publishing term given to reference libraries of old images and cuttings) provide categorized and searchable libraries of people, places and objects from all around the world. Because they are submitted by the public for the public, the quality is not always superb, but it does mean you have a good chance of finding something bizarre which would not make it past the strict scrutiny of the commercial libraries. The biggest benefit, of course, is that they are completely free. The sites are kept running solely on advertising and the good will of public donations. This, of course, is great news for the montage artist on a tight or nonexistent budget.

The exact terms of use vary from site to site. Most, however, allow unlimited use for both private and commercial projects, providing it's not detrimental to either the photographer, their subject, or the site itself. When you download an image, it's usually anonymously; the photographer may like to know how their photo has been used but it's rarely mandatory. Stock.Xchng allow the contributors to set their own requirements: some require you to apply for explicit permission, depending on the content – generally, and understandably, when there are recognizable faces. It's one thing to allow a someone to post photos of you but quite another to find yourself placed in an image of questionable content.

In addition to the dedicated libraries, there are also community sites such as **Flickr.com** and, since more recently, **Wikimedia Commons** (commons.wikimedia. org). These operate under the new Creative Commons license – a system devised for intellectual rights management on the internet. Under this license, photographers can determine what can and can't be done with their images. This ranges from complete free rein to total copyright protection; the latter is very often negotiable through polite communication with the person concerned.

It's also worth noting the governmental public domain libraries. These offer more specific images, of military subjects and political figures and, of course, there is **NASA.gov** which holds a wealth of scientific, aeronautical and astronomical photos. Again, these images are all free to use for private projects but commercial use carries some regulations; these can be found in the site's terms and conditions.

If all else fails, you can always try a search through **Google** or **Yahoo**. Both have offshoots of their sites devoted to images. Great care must be taken here. Grabbing images from web searches puts you right in the middle of the copyright minefield. If you're using the pictures at a purely personal level, making backgrounds for your computer desktop and so on, you'll be OK – surveillance techniques haven't infringed the home just yet. If, however, you intend to publish these images as part of your website or as a printed design, make sure you obtain permission from the owner of the site or photo. There's usually an address to write to. If you are in any doubt as to the copyright status, don't risk it; at the very least, you'll receive an irate email asking for removal of the image; at worst, you may find yourself in court.

As long as you respect the rules and guidelines, there is a wealth of useful content to be found. It can also be a good source of inspiration; you never know what you may come across whilst performing a search. It can often spark a whole new project idea.

A list of free sites along with links to their web addresses can be found on the book's accompanying website: www.howtocheatinphotoshopelements.com.

Photoshop Elements Achievement Award FIRST CLASS awarded to John Q Public for outstanding photo trickery

The text above fits neatly enough onto its plaque, but it looks rather painted on, How much more impressive if the wording appears to have been carved into the wood. The words 'First Class' in this example use a metal style not detailed in this chapter, but it's on the CD for you to import into Elements and use in your own work.

Working with text

WE USE TEXT FREQUENTLY IN ELEMENTS. Although you may not think of it as being an essential component of most images, there are often times when adding a caption can lift an image.

But there's more to text than mere captions. Think how good it would look if you could engrave an invitation on stone or carve it into a piece of wood. How good your holiday slideshow could appear if the first frame showed the title written in a sandy beach. Or imagine customizing a photo of a classic car so that its owner's name was written in gleaming chrome along the side.

We'll look at all these techniques and more in this chapter.

Carving in stone

TONEMASONS TAKE YEARS to learn their craft: after all, the one thing that's certain about carving lettering into stone is that there's no undo key. Make a mistake and it will cost you dearly.

Fortunately, Elements is rather more forgiving when it comes to carving. All we have to concern ourselves with is arranging the text to its best advantage; we can leave it to Elements to add the bevel effect automatically.

As we'll see here, we don't even need to choose a color for the text. This, too, is added directly by Elements, building on the texture already in the stone for added effect.

We'll demonstrate this technique by adding an inscription to this blank gravestone, in memory of the unfortunate captain of the mutinous ship *Bounty*.

Begin by typing your text – centered, for a gravestone. Choose a serif font, such as Caslon Bold, for authenticity. No need to worry about the text color at this stage.

Hold ## and click on the text layer's thumbnail to load up the selection. Then hide the text layer, switch to the background layer, and press ## J to make a new layer from it. Choose Simple Sharp Inner from the layer styles panel to make the basic bevel.

2 Now lay out the text for emphasis. Hold **and Shift** and press the and keys to make selected text bigger and smaller.

5 We now need to modify that bevel, so open Layer > Layer Style > Style Settings. Change the bevel type from Up to Down to make it carved rather than raised. Adding an Inner Glow, using the default settings, brightens the carved lettering as well.

In order to distort the text, we first need to make it into a regular layer: choose Layer > Simplify Layer. Now use Free Transform to distort the corner handles into perspective.

To make the carving more realistic, carefully erase the layer with a small Eraser where the grass goes over it. Here, we've also darkened the background layer using the Levels adjustment and added a new somber sky to complete the spooky graveyard effect.

HOT TIP

Although we created the text on a new layer, we later discarded that layer, instead loading its selection from the original background. This allows us to keep the stone texture, making the carved lettering look that much more convincing.

When choosing a font for stone carving, be sure not to pick one that's too light or the bevel effect will make it unreadable. Always choose the bold version of a font, where possible.

Neon signs with layer styles

Joe's CAFE

LEMENTS COMES WITH A BUILT-IN selection of neon styles – called Wow Neon. But they're brash, too bright, and look unconvincing on the screen; they're also set to colors that will look dull and muddy when printed out.

Our approach is rather different. We'll use a layer style for the basic neon outline, but will then add our own color glow as a separate layer for a better effect.

As a first step, though, we'll look at how to round off our basic design, above, to give it the sort of smooth corners required for the neon to work properly.

Joe's CAFE

After designing your text and any other elements, merge them into a plain white layer. Now apply Gaussian Blur to soften the edges. We've used a 6 pixel radius blur, which applies quite a high degree of smoothing.

4 We need to adjust that glow, so double-click its icon in the Layers panel to open its dialog. Reduce the size of the glow to around 10 pixels and raise the opacity to 100%, then click the color swatch and change it to pink.

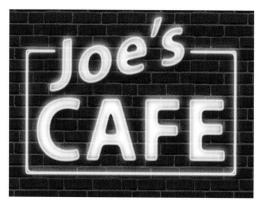

Now for the glow. Make a Magic Wand selection from the original flat layer created in step 2 and feather it by around 12 pixels. Make a new layer and fill the selection with white, then move it behind the neon layer.

Press to lock the transparency on this glow layer, then paint each section a darker version of the neon above it. This makes a glow that's more like translucent plastic, making the lettering stronger and more readable.

2 Now for the clever part. Open the Levels adjustment and drag the white and black sliders together so that they almost touch the gray slider. This tightens up the blur, producing a round-cornered version of the artwork.

5 Time for a background. To get rid of the black in the lettering, change the layer's mode from Normal to Screen: the black disappears, leaving just the neon tubing visible. Add a drop shadow in layer styles for more impact.

9 Need neon in a hurry? Here's a quicker method. Select all the pieces with the Magic Wand tool after step 2, then use Select > Modify > Contract to make it around 4 pixels smaller. On a new layer, fill the selection with black.

Joe's— CAFE

3 Select all the elements with the Magic Wand tool and use **(M) (B)** to make a new layer from the selection; fill it with black. From the layer styles panel, drag a small inner glow onto the new layer.

We want all the elements of our sign to be in different colors. Select each part with the Magic Wand tool, and use crip Shift J \$\frac{1}{2}\text{Shift J}\$ to cut them to new layers. The layer styles will also be copied: edit to change the color.

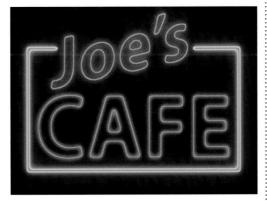

10 Load the Cheat layer styles (see page 307) and apply one of our Neon styles to your outlined text. We've made these in a variety of colors, so you can split the text into different layers and apply a different color to each one.

HOT TIP

The Gaussian Blur/Levels technique used in steps 1 and 2 can be used to smooth out any artwork, adding rounded corners to just about anything. The more you blur, the more rounded the corners will be. Drag the white, gray and black sliders to the left or right to change the thickness of the lettering after blurring it: experiment to see what works best for your design.

Note: you can't change the color of the inner glow in layer styles in Elements before version 5.

SHORTCUTS
MAC WIN BOTH

Instant chrome

LEMENTS OFFERS A WIDE VARIETY of ready-made layer styles you can apply to your artwork – among them is a selection of good-looking chrome effects.

As with most layer styles, though, some adjustment is needed before they fit the artwork perfectly. You'll almost always need to adjust the bevel size and the rather overenthusiastic drop shadow in order to make the style work with your image.

Here, we'll go a step further and make the chrome reflect its background to match the chrome detail already present on this car.

Here's our initial lettering: it's set in the freeware font Deftone Stylus, which is easy to find online. After typing the text, turn it into a regular layer using Layer > Simplify Layer so we can distort it more easily.

4 That's far too big a bevel for our purposes. Double-click the layer styles icon in the Layers panel and change the Bevel size to around 8 pixels. Make a note of this number, as we'll need to use it later.

Make a new layer and fill with any color. This is a red sampled from the car body. It looks fairly convincing as it stands, as the inner color matches the car well, but we can make it better still.

2 Use Free Transform to shear the text so that it fits the side of the car. Hold (III) (III) as you drag a corner handle to add a little perspective to it: the lettering gets slightly smaller towards the right-hand side.

3 Now open the layer styles panel and go to the Wow Chrome section. Drag the first style, named Wow Chrome Beveled Edge, onto the layer to apply the effect to the text.

open lines

5 We need to reduce the drop shadow amount, too: a far smaller shadow with a smaller offset is needed. By dragging the Lighting slider clockwise, we can also get a better chrome effect.

8 Go to the Background layer and select a portion of the reflection in the fender with the Lasso tool. Make a new layer from the selection and drag it above the inner color text layer, as shown here.

9 Now press etn 6 **B** 6 to group the reflection with the inner color layer. Enter Free Transform and scale the reflection so that it fills the whole of the lettering. The chrome's now a perfect match to the original car.

HOT TIP

In step 9, you may have some difficulty making the reflection fit the full extent of the inner part of the text. Don't worry if it doesn't quite reach the edges: you can always use the Clone tool to copy any of the texture out to the sides, and any missing portions of the top can easily be painted in by sampling and then painting with a softedged brush.

SHORTCUTS

MAC WIN BOTH

No mess pumpkin carving

TRADITIONAL PART OF HALLOWEEN is the scooping out of pumpkins to make Jack-o'-lanterns. Gone are the days of crudely cut out toothy grins, however; it's now an artform, with people spending hours carving intricate images of witches and ghosts in order to out-do their neighbors. This is all very messy and time-consuming, of course.

We can achieve a similar image effect to use in our design, without going near the pumpkin's innards. We'll be using a dingbat style font which, instead of having the standard individual letter characters, has entire words or images. This allows our artwork to be completely re-editable; we can change the motif at any time without having to redo the whole image.

It is an impossible image, of course – there are areas where the text is floating which couldn't really be achieved – but we can afford ourselves a little artistic license here as it makes a great party invitation or poster.

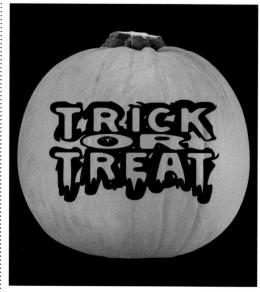

Here's our pumpkin with the text layer. We've used a dingbat font: the aptly, named Trick or Treat, which gives us the whole artwork in one go by typing one character, in this case the letter A. At present it's looking somewhat flat and not at all like it's been carved.

4 Create a new layer above the text layer and load the pumpkin's selection. Contract the selection (under Select > Modify) by around 15 pixels and fill it with 50% gray. This creates a smaller copy that we can use for the texture inside the pumpkin.

Make sure the text layer is active and the Type tool is selected. Go to the Options bar and click the Warped Text button; select Bulge from the menu and choose Horizontal as the direction. Now drag the Bend value to the right to try and match the curve of the pumpkin.

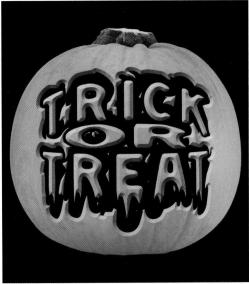

Choose the Bevels presets from the layer styles panel; choose Simple Sharp Outer and apply it to the text layer. The effect needs adjusting so double-click the style indicator to the right of the layer's label. Adjust the bevel size, around 10 pixels for this image, and change the direction to Down.

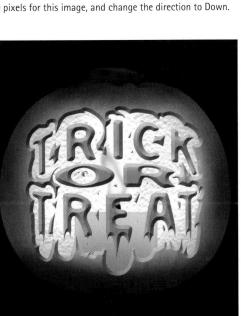

Grab the Dodge tool , set the mode to Highlights, and use a large, soft brush to create the impression of a glow radiating from the center. Create a clipping group with the text layer to hide the excess. Finally we've added a candle and shading to complete the effect.

HOT TIP

follow the technique, the font must first be installed from the CD. Browse to the Goodies folder: the font file is named TRICTB . TTF. Use the following instructions to install it: In Windows: Open the Fonts setting from the Control Panel, go to File > Install New Font, and browse to the place you unzipped it to; select the name, make sure Copy fonts to Fonts folder is checked and click OK. For Mac OS X: Double-click the zip file to extract the folder, doubleclick the font file to open Font Book, and click Install Font. You may need to relaunch Elements to get the font to show up in the list.

5 Select the Texturizer filter and set the texture to sandstone and the scaling to 200%. Apply a small amount of Gaussian Blur to soften the effect. Now use Hue/Saturation (III) (III) set to Colorize and change the color to a warm yellow hue. Press (III) (III) to deselect.

Write on the button

BUTTONS, OR BADGES as they are also known, are often placed on the front of greetings cards bearing a slogan or message for the recipient to wear on their special day (begrudgingly or otherwise). Why not, then, create them virtually to add an extra element of interest to your own designs.

The text on buttons is often written around the edge in a ring. Although there is no built-in function to do this in Elements, it's by no means impossible; as with many things, it's simply a matter of improvisation. The Text Warp function allows us to bend the words to fit. Best of all, as it is a type layer it stays editable. You can go back and change the wording at any time whilst retaining the quality.

Begin by creating a new layer. Use the Elliptical Marquee M to draw the outline of your button. Remember to hold Snin to make it a perfect circle. Fill this with 50% gray for the moment; we can give it a proper color at a later stage. Press CIID # D to deselect.

4 The arc doesn't fit because the text is too short. The answer is simply to pad it out using spaces. We can add these before and after the words because we set centered justification. I've hidden the circle and selected the text so the result is visible. The spacing gives us a perfect arc.

2 Select the Type tool **1**, set the Alignment to center, and click to create a new text layer. We need to split our slogan into two halves as we can only bend the text to a maximum of 180° in one go. Don't worry about the size at this stage; we can adjust that in due course.

3 Select Warp Text by selecting its icon from the options toolbar. Choose Arc from the style menu, make sure the mode is horizontal, and increase the bend to 100%. You can also reposition the text without leaving the dialog. It's looking good but we still need to adjust it slightly.

5 We can now add the second part of our text. This time, we need to bend it in the opposite direction. Open the Warp dialog again and pull the Bend slider all the way to the left. Add some extra spacing as we did before. You can also make adjustments with Free Transform if required.

6 We can add some color to the button itself. This can be done with a Hue/Saturation adjustment or the Paint Bucket. I've also added some highlights using the Dodge tool along with a layer style to round off the edge and add a Drop Shadow. A thumbs-up in the center completes our effect.

HOT TIP

Not all fonts work well with this technique; because of the effect of the warp tool, wider lettering may become too distorted and give an undesirable result. Try to use a condensed font wherever possible. There are many different styles available from sites on the internet so you will generally be able to find one which fits in with the theme of your design.

SHORTCUTS
MAC WIN BOTH

Three-dimensional text

HEN WE WANT TEXT TO STAND OUT we tend to use a bold font, often in a different typeface to the rest of the document. To really draw attention to it we can take it a little further and give it a three-dimensional effect so it jumps off the page at the viewer.

Three-dimensional text is usually generated by dedicated programs or by using plug-ins; but, as we'll see in the following tutorial, we can create the effect in a few simple steps using the standard Type tool and a crafty trick with selections, layers and the Move tool.

The technique can, of course, be used to add emphasis to your artwork as a heading; you could also use it as part of a montage, creating a sign to place over a store, for example, or, as the image above shows, adding some personalized jewelry to a photo.

GOLD

We'll begin by creating a new text layer: grab the Type tool , set the Alignment to center, and click in the middle of the document to place the cursor. Select a suitable font: larger, rounded styles work especially well. Type out your text, remembering to leave some space around it.

Turn the original text layer off to avoid confusion.
Enter Free Transform oth THT, hold oth all Shift

Shift, and drag the top-left corner handle up a little
to add some perspective. Keeping the keys held, drag the
top-middle handle to the left to tilt the text back.

Make the rear text layer active again. Grab the Burn tool on, set a fairly low exposure, and choose a large, soft tip. Using a combination of Midtone and Highlight modes, darken the areas that would be in shadow. Hold all to switch to the Dodge tool to add in some extra highlights.

GOLD

GOLD

HOT TIP

The addition of

shading really

helps to bring

an image to life. A traditional

artist might use different shades of the same color to produce highlight and shadow in their picture; we can brighten or darken the

Unsurprisingly, our text does not look very golden at all. We chose the copper gradient because it gives us a good contrast with strong highlights. A Levels adjustment can be used to alter the hues. The technique for this can be found in Chapter 4.

COLD

Press and A A A to select the canvas. Grab the Move tool V, hold down A S, and, using the cursor keys, nudge once to the right and once upward to copy the pixels. We'll repeat this rhythmic sequence until the letters have the desired thickness.

Press **II** To create a new layer from the current selection. This will become the face of our text; we can alter this separately from the rest of the effect. This also serves as a mask so we can add shading to the edges of the lettering without affecting the front.

9 To finish off we've filled the background with black to set the gold off. A new layer has been created above the text; we've added some small sparkles on the brighter points; these are made with the Crosshatch brush under the Assorted tip presets in the brush panel.

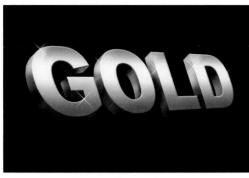

existing color using Dodge and Burn - in effect, painting with light. By switching between the Midtone and Highlight modes, areas can be put into shadow. the color made richer, and hotspots added; this is especially good for metal effects. It is, however, worth noting that the results can

SHORTCUTS
MAC WIN BOTH

up gradually.

be fierce if overdone so it's good practice to use a low exposure and build the effect

R Working with text

Writing in the sand

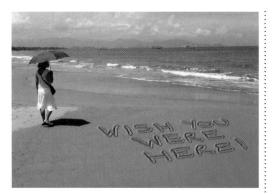

HERE'S SOMETHING ABOUT AN EXPANSE of smooth, untouched sand that begs us to carve something into it; this could be a message of adoration to a loved one or simply a declaration to prove you were there.

We're going to recreate the effect here using distortion and layer styles, similarly to the stone carving we made earlier in the chapter except that we'll create the excess sand around the letters where it would have been scraped out.

This quick but effective technique lets us write whatever we want, all without getting a single grain of sand between our toes; it won't get washed away, either.

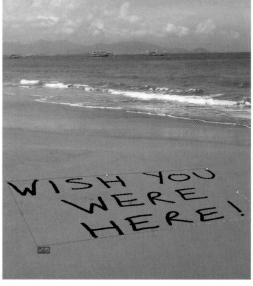

Begin by bringing in the text layer. We've hand-written this to make it more realistic but the effect will work just as well with a rasterized type layer. Press (II) (II) (III) and drag the corner points to position the text in perspective on the sand.

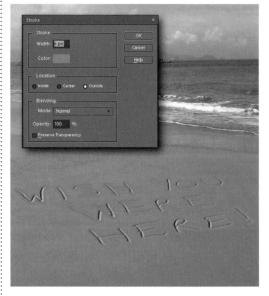

Add a new layer and reload the text's selection. Select Stroke from the Edit menu and set a suitable value for the width; use the Color Picker to select a suitable color from the sand, set the Location to Outside and apply to create an outline around the text. Press (217) (2) (2) to deselect.

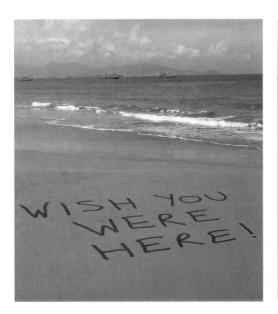

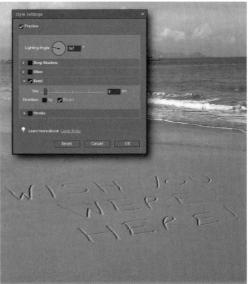

3 Apply the Simple Sharp Inner bevel preset from the Effects panel. Double-click the layer's style icon in the Layers panel to open the control dialog. Lower the bevel value, adjust the lighting angle and set the direction to Down to create a carved appearance.

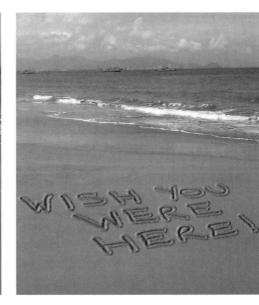

6 Set the blend mode to Dissolve and lower the opacity to give the outline a broken-up, grainy effect. We've also lowered the base text's opacity and darkened the two layers a little using Levels, giving the impression of the wet underlying sand showing through.

HOT TIP

The Dissolve blend mode is great for creating grainy effects or for eroding parts of the image. Unfortunately, because it uses the opacity of the laver to determine the intensity you cannot soften the pixels by applying a blur. To get around the problem first create a new layer beneath the target layer then merge them together. The resulting layer preserves the effect, which will no longer be affected by blurring or further changes to the opacity.

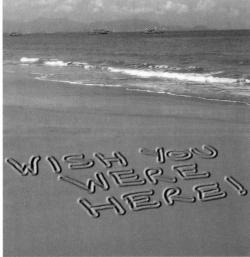

5 Apply a small amount of noise to add some texture; we used the Uniform, Monochromatic setting with an amount of around 12% here. Add a Simple Inner bevel and decrease its width a little. This time keep the direction set to Up to give it a raised appearance.

Chop and change

T'S FAIRLY SAFE TO ASSUME that you wouldn't consider mercilessly plunging a scalpel into a priceless painting solely to advertise your upcoming art exhibition; unless, of course, it was one of those avant-garde affairs, in which case it would be positively frowned upon if you didn't. That aside, it's surprising how often we start hacking into our images without a moment's thought and, whilst we do have the safety of the Undo command, there are far better ways to take chunks out of our artwork.

By using a combination of text layers, clipping masks and layer styles, we can create the effect of words being cut out of a piece of material (or almost any other substance) to reveal a surface beneath. What's more, this technique is completely editable as we never actually cut into the image; we simply create the illusion of doing so.

We'll start by creating the cut-away effect to show the background beneath the fabric. Grab the Type tool and place the text; the color is not important as we'll only be using it as a template. We've used a heavy font here for clarity but most weights will work just as well.

That's looking a lot better. Before we add the cut-out text itself we'll make some space for it on the artwork. Grab the Move tool and drag the text down towards the bottom. Because the style is applied to the text layer the effect also moves, so we can position it wherever we want.

We need to reposition the new text but this time we want the pattern to move with it. Click the text layer's label (not the thumbnail), hold (2) (3), and click the texture layer's label to form a group. We can make this more permanent by clicking the chain icon to link them together.

We can bring in the image layer to use as our revealed background now: this is placed above our text layer with which we've created a clipping group by pressing (II) (3) (3). In doing this we've hidden all but the area where our text is visible.

3 It's not looking too convincing at the moment; there's no sense of depth. Make the text layer active and go to the Effects panel; select layer styles and from there choose Inner Shadows from the menu. Finally, select the Low preset by pressing Apply or by double-clicking its icon.

HOT TIP

At the time of writing, the current version of Elements does not have the option to adjust the inner shadow layer style. Although the default settings work well in our example, they may not look as good on different image sizes. To compensate for this we've included a collection of presets on the accompanying **CD.** Information on how to install them can be found in the CD content section at the back of the book.

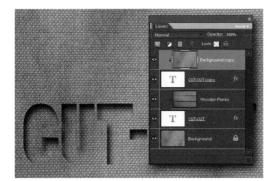

Holding (a) S, click and drag the text layer's thumbnail to the top of the layer stack. This creates a copy without having to relink the original's clipping mask. Duplicate the background layer and drag it above the new text. Finally, create a clipping group with the two new layers.

6 We still have the previous style set from the copy.
Right-click the style indicator icon and select Clear
layer style. Now go back to the Effects panel and select Drop
Shadows from the drop-down list. The Low preset works well
here.

Press and # to enter Free Transform. We can now move and rotate the text and its overlay into position in unison. The bounding box seems far too large compared to the text but, remember, we are transforming the entire texture layer. Press Inter to apply the changes.

9 With everything in place we can change the text without having to reapply the effects and textures. Double-click the type layer to edit it. This works both ways, of course: you could just as easily change the styles or replace the backgrounds, leaving the text intact.

R Working with text

Elements of design

OU MAY NOT REALIZE THIS but with Elements we have at our disposal a highly competent layout tool for both text and graphic-based designs such as newsletters, posters and flyers. Many functions are already built-in and others can easily be emulated. With rulers, grids, paragraphs, layers and much more to work with, we can produce professional-looking documents with relative ease.

In the following project we'll be looking at some of these features and building a simple column-based layout as we might find in a newspaper or magazine article. The principles for creating a full page are the same, we'd just need to add more columns and arrange them across the page.

ew					
	Name:	Document			
<u>P</u> reset:	International Paper				
	Size:	A6			
	Width:	A6			
	width:	A5			
	Height:	A4			
		A3			
	Resolution:				
		B5			
	Color Mode:	B4			
		B3			
Backgrou	nd Contents:				
		C6			
		C5			
		C4			
		DL			

When we start a new document we have a host of different presets to choose from, or we can create our own custom size, of course. We need to take care when doing this as it may cause problems when we go to print it.

2 One of the most important parts of the design process is the grid. This can be found under the View menu and can be toggled on and off. We can also adjust its size and color from the program preferences (III) (**) ** **(**)*(**)

			1	
 		 -		
	1	1		

6 Let's put this into practice: we've set up a blank document on which we've created a typical layout comprising a border and three columns spaced with gutters. Rather than create

the guides individually, we duplicated them by holding [a]] then clicking and dragging with the Direct Selection tool. If we also hold [shift] when clicking, we can copy sets of guides.

This is a text box. It can be moved, scaled and even skewed. The type within will automatically reflow to the new size and shape.

If there isn't enough space to contain the paragraph, a small cross will appear in the bottom-right corner. We can then choose to resize the font or frame..

In addition to the grid we can add our own document guides using the Line tool **(J)**. To add more to the same layer, hold **(Shiff)** before clicking. Release and hold **(Shiff)** again to constrain to the horizontal or vertical.

4 We also have rulers which we can use to precisely place our design elements or set up guides. The ruler's origin (0,0) can be moved by clicking and dragging from the top-left corner or double-clicking there to reset it.

Normally, when we add text, we click the cursor at the point we want it to start and type. If we click and drag, however, we create a text-box which can hold individual paragraphs.

Sweet success!

Congratulations go to Margaret Jones for winning the Horti-cultural Society's home-produced jelly contest for the second year running. There seems to be no stopping her when it comes to preserves; and we're not about to try, they're delicious!

She attributes her

success to the home-

secret extra ingredient

grown fruit and a

which goes into each jar.

"And my patience and dedication, of course." She adds, smiling broadly. We look forward to seeing (and tasting) more of her produce; and long may she reign as queen of the fruity spreads. AJ.

Here's the completed article, demonstrating how the paragraphs are laid out around the image. Unfortunately, Elements doesn't automatically hyphenate or flow

text from one column to another but it's not too much effort to do this manually. To the right we have the Layers panel showing the structure of the document.

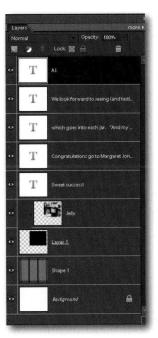

HOT TIP

A useful trick when adding images to the document is to duplicate the layer and create a clipping group. This way, you can use Free Transform to scale the only base layer, which gives us the ability to hide areas of the photo without the need to resize or crop it permanently.

SHORTCUTS

MAC WIN BOTH

lmage size

IMAGE SIZE is a conundrum that puzzles many Elements users. Just what is 'dots per inch' and how does the concept relate to the megapixel (Mp) sizes quoted by the manufacturers of digital cameras? What resolution is required for printing, or saving files for the web?

Image size is traditionally measured in dots per inch (dpi), even if you're accustomed to working in centimeters. You can, of course, work in centimeters per inch, but we'll stick to dpi here to be in tune with the convention.

Computer monitors typically display images at 72 dpi. This means 72 pixels across and 72 down, which amounts to 5,184 physical pixels in each square inch of screen space. This is the resolution you should work at when designing for the web. In Elements, when you view an image at '100%', you're seeing it at 72 dpi: in other words, each pixel in the image precisely matches one pixel on the screen. Viewing images at a smaller size – say, 50% – means that each pixel on the screen displays an average of the color of four pixels in the original document. If you zoom in further, to say 800%, you can see each pixel with much greater clarity; they'll clearly appear as squares.

Commercial printing uses only four basic colors: cyan, magenta, yellow and black. All other colors are simulated by overprinting these four. The bigger the printed dot, the more of that color is seen, so if in one region there are equally sized cyan and yellow dots you'll see green. If the cyan dots are twice the size of the yellow, the result will be turquoise. Clearly, these dots need to be tiny if we're not going to notice them, and the smoother the paper, the smaller the dots can be. Newspapers print at around 100 dpi and glossy magazines at around 250 dpi, occasionally more.

When printing on an inkjet printer, however, the color is made up from arrays of tiny dots of equal size. The more dots that are clustered together, the stronger the density of that color. Inkjet printers typically print at 1200 dpi, which produces a smooth tonal range with a dot that's barely perceptible. That doesn't mean you need to work at 1200 dpi in Elements: a size of 150 dpi is more than adequate for getting excellent color prints from most inkjet printers.

Digital cameras capture pixels on a CCD chip: the better the camera, the more pixels on the chip, and so the higher the resolution at which the image can be

Original image, composed of smooth colors

Image converted to square pixels on computer monitor

Image printed using dot clusters on inkjet printer

Image printed using different sized dots in magazine

recorded will be. If a camera is quoted as having an image size of 3.2 Mp, it will produce images that measure 2048 pixels wide by 1536 pixels high. Multiplying these values together – to give the total number of pixels in the image – produces 3,145,728 pixels overall, or rather over three million pixels, and that's what the 3.2 Mp name refers to.

If its images were printed in a newspaper, a 3.2 Mp camera could produce a high quality image at up to about 10 x 8 inches. The same image in a glossy magazine could be used at up to around half an A4 page; if printed any larger than this, the pixels in the image would be larger than the printed dot size, and we'd start to see ungainly pixelation in the finished result. When shown on a web page, however, the same image would easily fill the entire area of a huge 30 inch monitor.

The software that comes with most flatbed scanners tends, confusingly, to offer the ability to adjust both the size and the resolution of scans. In fact, these both amount to the same thing; it's the number of pixels captured in total that counts, not the relative dimensions. The easy solution is to scan an image at the size you're going to want to use it, at a resolution appropriate for the medium on which it's going to end up – printed out or on the screen. Err on the high side: you can always reduce an image's size in Elements but you can't easily increase it without loss of quality. Bear in mind, though, that the larger the file, the slower it will be to work on in Elements.

The Image Size dialog in Elements has the ability to resample images to any size and resolution you choose, but if you uncheck the Resample Image button, it will adjust the size and resolution together. This is a useful method for turning, say, digital camera captures – which typically have a resolution of 180 dpi – into screen-ready files with a resolution of 72 dpi.

The camera never lies, we're told, but sometimes we wish it would be less scrupulously honest. The photo above is a charming shot of two people who love each other, but how much nicer it would be for them if some of the ravages of time were washed away. And perhaps they could be in a better location, as well.

People and animals

THE LATE, GREAT W. C. FIELDS told us never to work with children or animals. Sound advice, for sure. But we photograph people and pets more than just about any other subject so we need to know how to work with them in Elements.

In this chapter we'll look at how to fix blemishes, how to reverse the ageing process, and how to make people look slimmer. We'll also explore several other everyday tasks to enhance our images – as well as some tasks, such as swapping heads, that are far from commonplace. Whether you're making a birthday card for a friend or simply enhancing a family photo, we've got the solutions to make the job easier.

9

Heads on bodies

NE OF THE MOST IMPRESSIVE tricks we can play in Elements is to place a celebrity's head on the body of a family member. It's easy enough to come across suitable celebrities on the internet: one of the best places is Wikimedia, which includes thousands of images of celebrities that are free to use in its Wikimedia Commons department.

The trick to making this technique work lies in choosing a head shot at the right angle to work with your image. Don't worry about the size and the color as we can easily fix that later; all that matters for now is that the orientation is as close as you can find to the head in the original photograph.

1 We found this picture of Arnold Schwarzenegger on the Wikimedia website. It's just the right angle to fit on the body of the dad in our family shot. The first step is to cut it out from its background, using any of the techniques described in Chapter 1.

Although we got the size and angle right in the previous step, Arnie's coloring didn't match the rest of the photograph. The best way to adjust the color of the new head is to use the Levels adjustment, which also allows us to correct the contrast.

2 Drag the cutout head into the image to where you want it to appear. To make it roughly the right size, it helps if you position it next to the target head, rather than on top: by being able to see both at the same time, we can be sure to get the size right.

5 There's a hard line under Arnie's chin that needs to be dealt with. The simplest way of removing this is to use a small, soft-edged eraser to smooth out the join; for more control, use an Adjustment Layer mask, as described in Chapter 3.

Rotate and further scale the head as necessary using Free Transform, and place it on top of the original head. Take your time with this step as it's the key to making the montage work. Here, we've rotated the head anticlockwise slightly for a more appealing look.

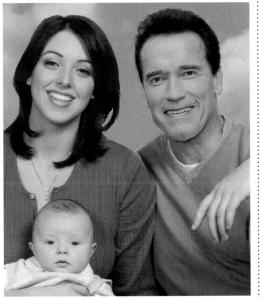

Finally, we need to remove the pieces of the original head that are still visible behind Arnie. On the background layer, use the Clone tool to sample pieces of the background and paint them in to cover up the original ear and other features that stick out.

HOT TIP

When you cut out a head to use in a montage, don't cut it directly beneath the chin: take as much neck as you can as well. This will help you to blend the head into the new body, as it's easier to fade one neck smoothly into another than it is to blur the line beneath a hard chin.

Photomerge: faces

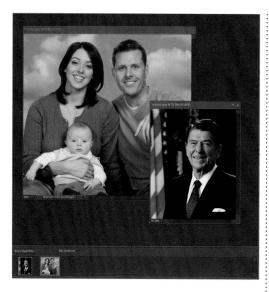

N THE PREVIOUS PAGES we looked at how to place a head on a different body. Elements 6 brought us a new technology, Photomerge, which automates the process.

Unlike the previous method, Photomerge doesn't require us to cut out the original head first: it can recognize a head shape within an image, even against a background as complicated as the one behind Ronald Reagan in this example.

The technology isn't perfect, and it can be a little tricky to control, but it's a quick way of moving heads between images and can be a lot of fun to play around with.

To begin, make sure the head you want to copy into the mix is on the left in the Panel Bin – drag it there if it isn't in place already. Now choose New > Photomerge Faces. You'll be prompted to drag the final image into the space on the right.

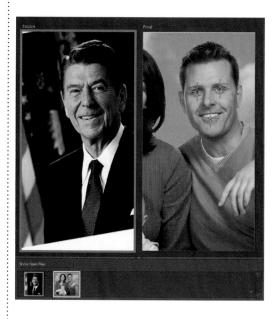

4 Move the markers on either image and press Align Photos again to correct the distortion. It can take a few tries to get it right: you need to move the markers in the opposite direction to what you'd expect in order to undistort the face.

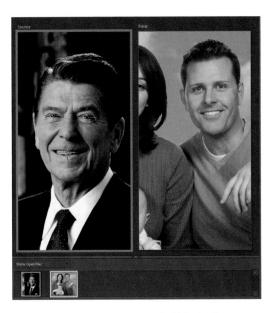

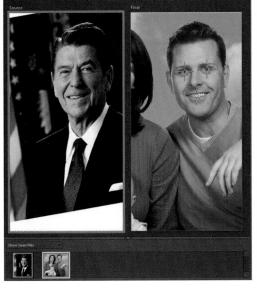

2 Now click on the Alignment tool within the Photomerge dialog and three numbered crosshairs will appear. Drag these onto the first image – one for each of the eyes and one for the mouth. Accurate placement of these markers is essential to making this technique work, so zoom in first.

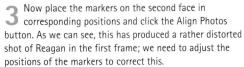

HOT TIP

If you find that

too much of the image has been copied into the picture, use the Eraser tool within the Photomerge dialog to remove some of the drawn pencil line. Experiment with erasing and redrawing pencil lines until you get a result that works well.

Now for the fun part. Grab the Pencil tool and draw over Reagan's face. In a couple of seconds, the face will appear superimposed over the family photograph. As we can see, though, it's also darkened up the sky behind the figure, and Reagan's ear overlaps the original ear.

We can't do much more editing here, but pressing Done will produce a new document with two layers – the original family shot and the family with Reagan placed over the top. Erase parts of this layer or use an Adjustment Layer mask (see Chapter 3) to make a better fit.

9

Cosmetic surgery: healing

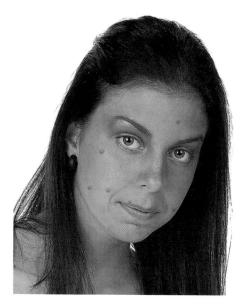

ERE'S A GRUMPY TEENAGER. So what else is new? Well, this teenager has a reason to be grumpy: she's about to go on a hot date and her face is covered in acne spots. (To be fair to the original model, we should point out that we added these blemishes ourselves.)

A two week course of antibiotics could clear this up – but we have a quicker method. Using the Healing Brush and the Spot Healing Brush – how appropriate – we can lose those ugly spots with just a few clicks.

Using this innovative tool isn't always plain sailing, however, as we'll see here: when the blemishes are close to an edge, unwanted effects can occur. This tutorial explains the best way to prevent those errors.

Choose the Spot Healing Brush (shortcut:) and make sure it's set to use a hard-edged brush. This seems contradictory: you'd expect a soft brush to blend in better. But that's not how this one works. Paint roughly over the spot on the forehead and you'll see where you've painted.

When we paint over the spot on her left cheek, however, something goes wrong. The tool has inadvertently sampled the edge of her face, producing what looks like an ugly scar. There are occasions when the Spot Healing Brush doesn't have a clear enough region from which to sample.

heat in Photoshop Elements 8

As soon as you release the mouse button, the Spot Healing Brush does something extraordinary: it samples the texture around the place you painted and blends that texture in perfectly with the surroundings. Our first spot disappears instantly.

spot in turn on the girl's right cheek. Paint just enough area to cover the spot, and no more, for the tool to perform at its best.

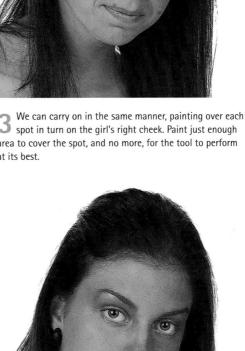

Undo that last step and, instead, switch to the regular Undo that last step and, misease, shall Healing Brush. This works in a slightly different way: first, we hold all and click a point from which to sample the texture - the forehead works well - and then paint over the spot. Now, it disappears as we wish it to.

The spot above the lip presents a different problem. It is just too close to the mouth. Before healing, make a selection that includes the spot but stops at the top of the mouth. Now, when we use the tool, it won't act outside that area - and so the mouth is left intact.

HOT TIP

The Healing Brush is a hugely powerful tool. Use it to remove birds from the sky, beetles from a rock, or even commonly unwanted picture elements such as telegraph wires and signposts. The really clever thing about it is that you don't need to match the lighting or even the color: only the texture is sampled, and it is blended in perfectly with the background.

9

Cosmetic surgery: weight loss

HIS IS THE WEIGHT LOSS PROGRAM the world's been waiting for: no diets, no exercise – just a ten-minute workout with the Liquify filter.

In order to make this procedure work properly, you'll need to cut out your image from its background. Otherwise, the existing background will be too distorted to look realistic.

We'll use this image of a woman who, while not obese, would perhaps value the opportunity to shed a few pounds.

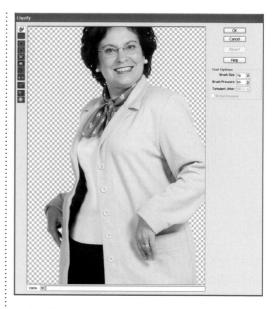

1 Use Filter > Distort > Liquify to enter the Liquify dialog. The default tool is Warp: use this to push the waist in, as we start to slim our model. Use a large brush size: small brushes will simply create additional wrinkles and that's the very thing we want to get rid of.

4 Don't forget such details as slimming the ankles – again, by pushing in from either side. It's details like this that make all the difference between a convincing montage and one that looks fake. But be careful not to get carried away if you want a realistic result.

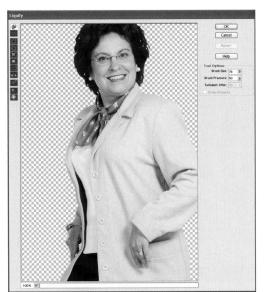

2 It's easy to distort the hands by accident when smearing them with Liquify. The solution is to stick with a large brush size and to click and drag directly on the hand. With luck, the entire hand should move as one; switch to a smaller brush to clean up if necessary.

5 The face is trickier. With a smaller brush size, push the chin and neck inwards. Switch to the Bloat tool and press on the eyes to make them slightly larger: this accentuates the features and makes the whole face look less chubby.

Push the bottom and the tops of the legs into the center to make them appear slimmer. Again, be careful not to distort the hands.

HOT TIP

Use the square bracket keys (and) to make the brush size smaller and larger. The size changes very slowly when you do this; to speed it up, hold the shift key as you press the bracket keys.

Although we've looked at making realistic changes here, there's no limit to what you can do with the Liquify filter. Try changing expressions or growing devil's horns out of someone's head.

9

Age and youth

OW OFTEN HAVE YOU TAKEN a photograph of an elderly relative only for them to complain that they look much older than they expected? We all have an idea of how we appear to others, and the image in our minds is often several years younger than we really are.

If only there were a way to take the years off without resorting to expensive and painful surgery. Well, there is: we can harness the power of Elements to darken hair, remove wrinkles, tighten that sagging chin, and present an altogether more youthful appearance.

We've taken the approach to extremes in this tutorial; generally, you'd only want to remove a few lines and creases. And perhaps fix that chin. Oh, and you may as well darken the hair a little while you're at it...

The first thing to do is to tighten that sagging chin. Go to Filter > Distort > Liquify and use the default tool to push the chin up and in. Start with a large brush; you can use the and keys to make the brush size smaller and larger.

The Spot Healing Brush would have trouble with wrinkles close to facial features. Instead, switch to the regular Healing Brush and [at] (S) click on the center of the forehead to set the source point. Now when you paint over the wrinkles they'll heal perfectly. Remember the bags under the eyes and the wrinkles beneath the chin.

Select the hair with the Lasso tool and apply a 5 pixel feather to it crital D *D to soften the edge. Make this into a new layer with crit B and open the Levels dialog. Drag the middle gray triangle to the right to darken the hair.

3 Use the Spot Healing Brush 1 to paint out the lines on the forehead. It will sample texture from around the area you paint, patching the lines perfectly. Because there's so much clear forehead texture around the wrinkles, the tool works well here.

HOT TIP

If there's no color left in your figure's hair, use the **Hue/Saturation** adjustment, checking the Colorize button, to add some artificial coloring. You may need to color the eyebrows as well; select them when you select the hair and apply the same treatment to them.

Let's address the hair loss that our unfortunate senior citizen has suffered. Rebuilding hair is tricky, but here's a simple solution. Select the top half of the hair and use to make a new layer from it. Drag it down using the Move tool or Free Transform so it covers more of the forehead.

Switch to the Smudge tool and choose a soft-edged brush – or one of the star-shaped custom brushes. With a pressure of around 70%, smudge the new hair both up into the original, and down onto the forehead. This tool makes it easy to blend the new hair in with the old. Our rejuvenated favorite uncle is now complete.

Adding people to the scene

HE SCENE IS AN ENGAGEMENT PARTY: the blushing bride-to-be shares a glass of champagne with her future husband. Such a shame her father couldn't be there to enjoy the occasion... but, thanks to Elements, he can be. Adding people to a scene is just one of the techniques every Elements montage artist should be familiar with.

After a lot of painting in and out, pressing X to swap between foreground and background colors, we're able to tuck Dad firmly behind the couple. We need to make the glasses they're holding slightly transparent, and this is how it's done. Still on the Adjustment Layer mask, set the

foreground color to white (to paint the figure back in), and set the opacity to just 20%. Now, when we start to paint over the glasses' area with a hard-edged brush, we begin to reveal a hint of Dad's shirt pattern as seen through the champagne glasses.

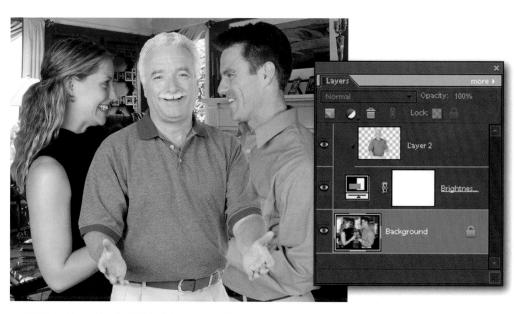

We'll start by cutting the bride's father out from his original background (we've already done this for you in the version included on the CD). Once he's been moved into the engagement photo, the first step is to use Free Transform to make him the right size. Again, we've done this for

you. Next, we need to place him behind the happy couple. Although we could do this with the Eraser tool, it's far easier using a custom layer mask – see page 50 for how this is done. Once he's grouped with his Adjustment Layer, we can paint on that layer to hide him behind the couple.

The final problem is one of coloring. The photo of Dad was too blue in comparison with the bride and groom photo. So, switch to Dad's layer and open the Levels adjustment dialog. Begin with the blue channel (2013) (#3), dragging the middle gray slider to the right to

reduce the amount of blue in the image. Then switch to the composite RGB channel and drag the same slider to the right to reduce the brightness overall. Finally, switch to the red channel (17) (1) (1) and this time drag the slider slightly to the left to increase the amount of red a little.

HOT TIP

Using the layer mask technique makes it far easier to slot a figure into a scene. But be sure to pay attention to the colors: it's rare that the skin-tones from two different photographs will match, and it's here that most montage artists fall down badly. It can help to think backwards: if an image is too green, try adding blue and red rather than simply taking out the green.

SHORTCUTS

MAC WIN BOTH

People and animals

Cleaning up the scene

T SEEMS FITTING TO FOLLOW the previous technique of adding people to an image with one for removing them; and, thanks to an impressive new feature in Elements 7, what would have been a laborious and highly time-consuming task has been made as simple as making a few strokes of the pen.

The aptly named Scene Cleaner is the latest addition to the Photomerge set of commands in the Guided Edit section; its function is to remove unwanted people or objects from around the subject of the photograph. This might be a popular scenic view with a steady flow of visitors or, as with our example, a particularly popular attraction at a show. In situations like this, it's not always possible to stop people moving into the frame but what we can do is take several shots in roughly the same position but with enough time in between for different areas to be populated. When we open the images in the cleaner, they are automatically aligned so we can blend different areas from each together and hopefully finish up with a largely uninterrupted scene.

All the project images can be found on the CD in the Tutorial Images folder.

Opening all four images, we can see the people are in different positions in each one but that no photo is good enough individually. Select the Guided link from the Editor and choose Photomerge > Scene Cleaner. A dialog will appear asking you to choose the images. Click Open All.

Grab the Pencil tool and set its size; it doesn't need to be large – around 20 pixels is sufficient. Now paint over the man in white, start from his head and looping around his body – the color reflects the source photo you are currently working on. When we release the mouse, he disappears!

Now we can focus on the area at the rear of the car. Looking at our image set, Car 4 looks like the ideal candidate. We'll concentrate on the man in the suit: draw across him so all areas are marked. When we release, we see that the man behind the car is also removed; clever stuff!

2 Once we're in the Scene Cleaner's dialog, we need to select our base photo: we've chosen Car 2 by dragging its thumbnail from the Project Bin over to the final image frame. We can see the images have been cropped slightly; this is due to the automatic alignment process.

3 Now we can start work on the image: the first task is to remove the three men standing behind the car. To do this we need to choose a suitable source image from our set. Clicking through each of the photos, Car 3 has the least obtrusive background, so we'll use that.

HOT TIP

Painting over the man in blue results in both other men being removed – almost. There is still a bit of his red shirt visible through the window of the car. If we try to remove it, however, we bring in the man in blue from the source image. Fortunately, we can Undo this:

6 We'll switch to a different source photo now. Car 2 seems the best choice. We only need to click once to remove the remnant of the red shirt; this is replaced by the man's head in the distance, which is much less distracting. That's all we need this image for at present.

Our scene is just about complete now. It's worth pointing some of the additional options: if we check Show Regions, we get a color overlay showing where areas have been replaced and blended. We can also fine tune by using the Eraser to remove sections we don't want.

images to use with the Scene Cleaner, or any other tool which uses a lot of files, you don't want to keep going back and opening them each time if you need to stop working on the project for a time. There is a little-known option in the **Project Bin** under the Bin Actions menu called Save bin as an album. Using this we are asked for an album name: the image locations are stored so we can then open them all by selecting the album name from the dropdown list.

Although the man in the suit has been removed, his reflection in the body of the car remains. We can remove that just as easily, of course. We could replace it with the man in the white shirt, as it should be, but that's too noticeable; instead, we'll use the version from Car 4.

People and animals

Eyes wide shut

E MAY HAVE the ability to take as many pictures as we want with our digital cameras, but unfortunately we still can't guarantee they'll be great shots every time, as is the case with our example. While the kids obliged us with a lovely pose for the portrait, one of them blinked at precisely the wrong moment.

All is not lost, however: using another picture (shown in the inset) of the girl in which her eyes are open, we can copy them from one image to the other and blend them in seamlessly, rescuing our photo from the delete pile.

The second image has been brought into the document as a new layer, and we've lowered the opacity to enable us to see the original image below. The girl is facing slightly to the right in the first photo but to the left in the second, so we

need to flip the layer horizontally. We can now use Free Transform to scale, position and rotate the layer, matching it as closely as possible. Don't spend too much time trying to get it perfect first time; we can make finer adjustments later.

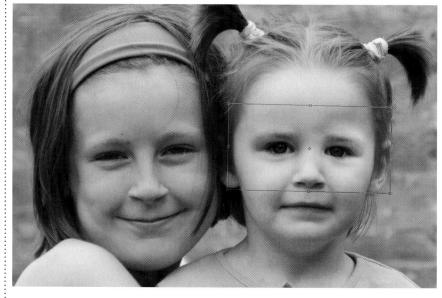

With just the eyes overlaid on our original photo we can see that, whilst it's a very close match, we still need to do a little finetuning. Enter Free Transform mode again; because we're now working on a smaller area, we can

make more accurate adjustments. In this case all that's needed is a very slight rotation and a nudge upward. These changes can make all the difference. Our brains are trained to read faces and any anomalies can be glaringly obvious.

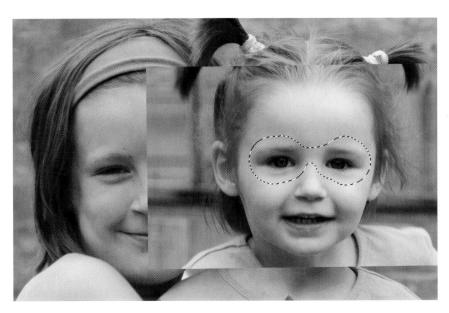

Now we have the layer in place we can bring its opacity back up to 100%. At this point we could use the eraser to remove the excess from the image; there is a far better way, however. Grab the Selection Brush A and choose a large,

soft tip. Paint in a loose, mask-like selection over and around the eyes; now press etr) \(\) \(\) \(\) \(\) to create a copy of the eyes on a new layer. We can hide or discard the previous image as it's no longer needed.

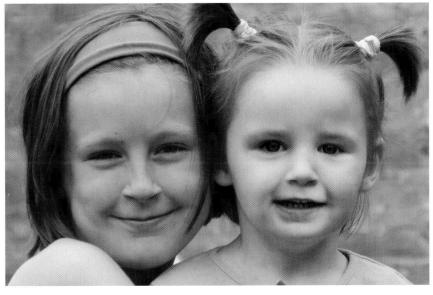

We're almost done – there's just a bit of tidying up to be carried out. Because the second image has slightly different lighting, some areas are too bright for the original photo. Select a medium size, soft eraser , lower its opacity,

and use its edge to feather out the area around the periphery of the eyes to bring back some of the original shadowing. As she has such a nice smile in the other photo, we've added that in the same way to finish the image off.

HOT TIP

In this example it was fortunate that the two faces were shot at very similar angles, enabling us to copy and position them as a single layer. You won't always have this luxury but the chances are good that one of the eyes will fit with very little adjustment. This can be duplicated and flipped to create the pair.

It's also worth noting that in some instances you may need to copy more of the face, particularly if the subject's expression is dramatically different in each image; the shape of the features will change slightly and could affect the realism of the result.

SHORTCUTS

MAC WIN BOTH

Warhol-style pop-art

HE ICONIC IMAGE OF MARILYN MONROE is one of Andy Warhol's most famous works. He used the screen printing process to transfer photographs to canvas which were then overlaid with blocks of heavy, garish color, giving them the now–familiar impressionistic style. The aim was to streamline the process to enable the images to be mass–produced whilst each would be slightly different to the last.

We can recreate the effect surprisingly easily: by simplifying the photo to purely black and white, we can build up the image using individual layers of color – a digital version of screen-printing, as it were. Because we're using Adjustment Layers we can, of course, edit the image time after time, changing its colors or altering the level of detail.

Start by isolating the woman from the background; the best choice for this image is the Magic Wand . Disable the Contiguous option to select all the black areas at once; tidy any stray areas on the face with the Selection Brush . Inverse the selection and copy to a new layer.

4 Add another color layer the same as before but select a yellow for the hair. Again, paint over the mask to reveal the color. Now add a white layer for the eyes and teeth; this time set the mode to Overlay. The order of the layers can be important as the blend modes affect surrounding layers too.

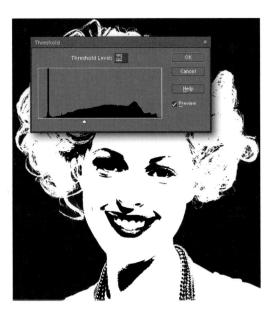

Add a Threshold Adjustment Layer above the new layer. The initial result is too strong and we've lost a lot of the detail. Slowly drag the slider to the left until all but the main features are visible — make sure the eyes are fairly well defined. Press [21] [3] [4] to create a clipping group.

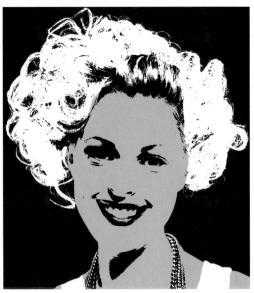

3 Create a Solid Color Adjustment Layer above the Threshold layer. Select a suitable color for the skin-tone and set the blend mode to Darken. Now click the layer's mask thumbnail and fill it with black to hide the effect. Using a hard brush, paint in white to reveal the areas of color.

HOT TIP

Holding alt 🔽 whilst selecting an Adjustment Layer from the menu in the Layers panel forces its option dialog to appear. From here you can rename it, choose to create it as a clipping mask, and set the blend mode during the creation process.

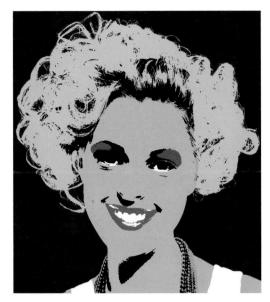

5 Create a red layer for the lips; this will need to be set to Lighten. Paint in the eye-shadow and the necklace. If you're finding it tricky to see which parts should be a certain color, hold all and click the original photo's visibility icon; this toggles the effect on and off by hiding the layers.

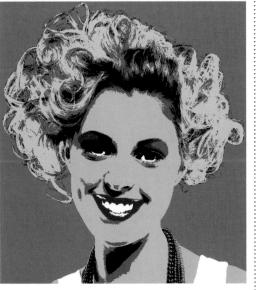

Duplicate the head layer and place it at the top of the stack. Set its blend mode to Color Burn and lower the opacity to 50%. Create a new Threshold adjustment, and this time drag the slider to the right to increase the black detail. Add a plain, colored background to complete the effect.

9

Hollywood glamor

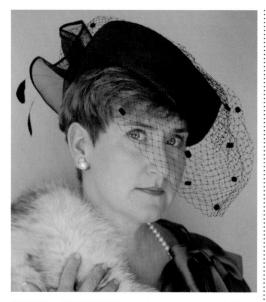

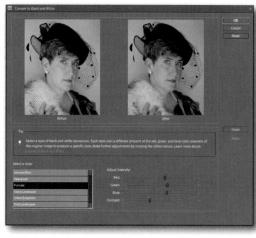

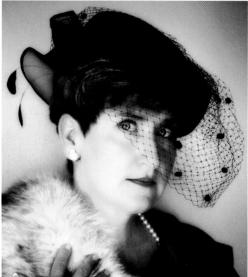

We'll start, as ever, by duplicating our background layer by pressing and \$\mathbb{H} \mathbb{J}\$. From the Enhance menu, select Convert to Black and White. This opens a dialog showing the before and after image along with presets and fine tuning controls. We'll use the Portrait preset.

ONTINUING ON THE THEME of iconic portraiture, we're going to take a look at the photographic style of the 1940s and 50s and, in particular, images of the film stars of the day. These were often shot in high contrast black and white but with a selective soft focus effect. This smoothed out the skin, giving the subject a glowing, dreamlike appearance.

4 Create a duplicate of the blurred layer. Go to Filters

> Distort > Diffuse Glow. Set a moderate amount of
Graininess. The Glow should enhance the highlights but not
overpower the image. Finally set a high Clear amount. This
controls the amount of diffusion, similarly to opacity.

This preset levels out the tones of the image, which looks OK, but we want a more high-contrast style. Drag the Contrast slider to the right – a value of around +40 works well. For other images it may be necessary to try different presets or alter the individual color settings.

We'll blur the image to smooth out the model's skin.

Duplicate the black and white layer. Now open the
Gaussian Blur filter. We'll need a fairly heavy effect so set a
radius of around 8 pixels. Change the layer's blend mode to
Overlay. This enhances the contrast and softens the skin.

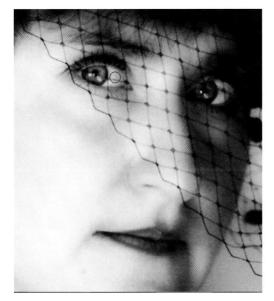

We can see the effect is too strong. We'll leave the blend mode on Overlay but lower the opacity to around 45%. Merge the two layers (I) E E. Now grab the Eraser and, using a small, soft brush, go over the eyes, lips and eyebrows to reveal the lighter, sharper image below.

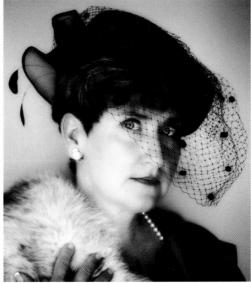

6 Use a larger brush size to bring back the detail in her hair and the fur she's wearing; be careful not to go over her hand. Finally, open the Correct Camera Distortion filter dialog. Drag the Vignette slider all the way to the left. Now lower the midpoint a little to finish off the effect.

HOT TIP

For a more contemporary image, duplicate the original photo layer. Drag it to the top of the Layers panel so it's above the rest. Set its blend mode to Color. This gives us a really great colored effect, as we can see from the second image on the far-left. Try experimenting with different blend modes to see what looks best for you.

Bobblehead caricature

YPICALLY, CARICATURES FOCUS on one or more of the subject's features which are then drawn greatly exaggerated. Bobbleheads, on the other hand, have huge versions of the person's head atop a ludicrously small body. The head and body are usually connected by a spring, which, when tapped, causes the head to bob about – hence the name. These collectable models generally depict sporting personalities but some movie stars also have their own jittering counterparts.

As we'll see in the following example, we can, of course, create our own digital versions. This simple yet effective technique can be used to make great humorous greetings cards or gifts for friends and relatives.

Our singer is already on a separate layer so begin by loading up his selection. Select the Freehand Lasso tool; holding all Shift Shift, carefully draw a line starting from his ear and down around his jawline. Close this off with a loosely drawn area around the rest of his head.

A Now we've toned down his features we can give him a real plastic appearance with the Plastic Wrap filter. Experiment with the slider adjustments until you have the desired effect; we want to keep it fairly subtle. As before, apply this to the body layer as well.

Copy the head to a new layer with (III) (III). Click the original body layer's thumbnail and use Free Transform to scale it down to a suitably comical size; we want to emphasize the face whilst retaining the body detail. You may also want to tilt the head slightly to the left.

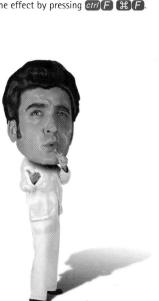

Here's our finished image. We've increased the saturation a little and added some shading under his head with the Burn tool; this helps to bond the image together. We've also given him a shadow to place him properly – see Chapter 5 for more on how to do this.

HOT TIP

The results from the Plastic Wrap filter can vary immensely depending on the lighting and quality of the source image. If you are having difficulty producing a balanced effect, try duplicating the layer(s) before applying the filter. Doing this enables you to fine tune the result by altering the opacity and blend mode to produce a more subtle effect.

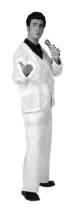

5 We need to have the hand with the microphone in front of his head. Hide the head layer for now and make sure the body layer is active. Draw a selection around the hand using the Lasso, copy it to a new layer and move it above the head in the Layers panel by dragging its thumbnail.

All in the mind

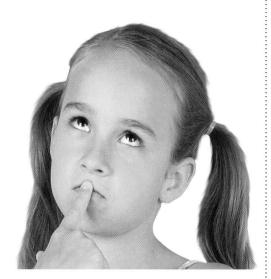

HAT'S ON A YOUNG GIRL'S MIND? Hard to say with any certainty – but we can make a safe bet that it would include teddy bears, ponies and candy. We're going to show these interests graphically, by lifting the top of her head and placing all these items inside.

The only thing we have to concern ourselves with here is the correct order of the layers in the stack. In order to place everything inside the head, we need to position the objects between the face and the interior – which means splitting that rim into two, so the front half will remain in front.

The first step is to draw the inside of the head, as an ellipse. But Elements has no tools for drawing an ellipse at an angle; we'll make it easy for ourselves by first drawing a circle, on a new layer. Here, we've filled it with blue and set it to Multiply so we can see through it.

Load up the ellipse selection by holding (#) # and clicking on its thumbnail in the Layers panel. Use Select > Modify > Contract to make the selection around 8 pixels smaller; then, using the Burn tool, darken the interior so that it looks hollow.

Use em T % T to enter Free Transform and rotate and squeeze the circle so it becomes an ellipse at the right angle. Don't stretch it all the way out to the right: remember, her head is actually some distance inside all that hair.

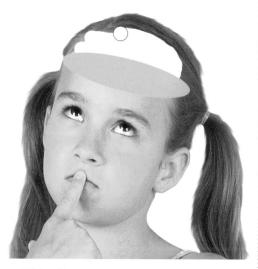

3 Fill the ellipse with a flesh color sampled from her skin and change its mode back to Normal. With the ellipse selected, move to the girl's layer and press Backspace to delete her head from this area; then deselect. Use the Eraser to remove the top part of the head above the ellipse.

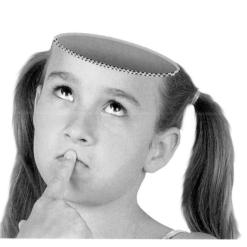

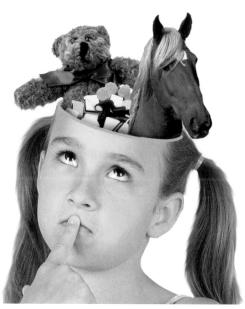

Send the head interior to the bottom of the layer stack, so that it's placed behind the head. We can now add all our objects as we like, behind the head layer, and they'll appear to be inside it. Add a little shading, on a new layer, to complete the effect.

HOT TIP

All the elements inside this head are behind the head layer. If we wanted the horse's nose. for instance, to poke in front of the head, then we'd need to select the nose and use ctrl J # J to make a new layer from it. When we bring this to the top of the layer stack, we can move the horse and its nose together and position them as we wish.

SHORTCUTS

MAC WIN BOTH

People and animals

Dog in a basket

AIR AND FUR are among the trickiest materials to cut out in Elements. Take this photograph of a dog, for instance: we can see its wispy, shaggy fur well enough, but how on earth are we supposed to cut it away from all that grass?

The solution, as ever, is to cheat. Rather than even attempting to use one of the many selection methods to trace around the fur, we'll do a smooth cutout and then redraw the fur using the Smudge tool.

We're going to practice our technique with a dog's fur here, but we can use the same method on people: it's far easier to recreate the effect of flyaway hair using the Smudge tool than it is to try to cut it from a complex background.

Begin by cutting out the dog from the background, using the Lasso or Selection Brush or any of the selection tools described in Chapter 1. No need to be too accurate here – you don't need to trace over every strand of hair; but cut inside the hair rather than outside it, so that no grass is included in the selection.

4 Continue all the way around the dog, pulling out clumps of fur with the Smudge tool. Refer to the original photo if you like, but it's just as easy (and just as convincing) to guess at what the fur will look like. If you find 80% pressure is too great, reduce it for a smaller effect.

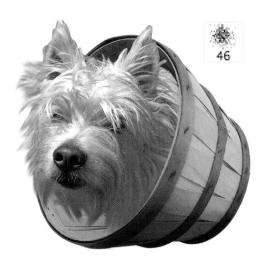

We've decided to place our dog in this basket, for no reason other than it looks cute there. To make this work, we've first copied the front half of the basket to a new layer; with this section in front of the dog and the original behind, it's easy to manipulate the two so that it looks as if the dog's sitting inside.

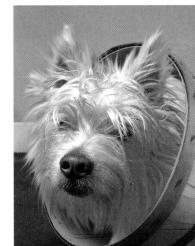

3 Switch to the Smudge tool, set to a pressure of around 80%. The key to making this easier lies in choosing the correct brush for this tool: a Spatter brush, which is one of the default Elements brushes, is perfect. Drag out clumps of fur around the edge of the dog, following the direction in which it would naturally grow.

We now need to tweak out a few individual strands of fur for added realism. Still using the Smudge tool, choose a small, soft brush – around 3 pixels in diameter – and pull out the strands one at a time. This greatly increases the realism of the fur.

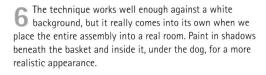

HOT TIP

This technique works best if you have a pressuresensitive graphics tablet: it's far easier to tweak out the fur if you can vary the pressure, rather than relying on the uniform pressure provided by a mouse alone.

Tiffs, JPEGs and the rest

ONE OF THE MOST BAFFLING issues facing the Elements user is the Save As dialog. It should be straightforward: after all, all you want to do is save your file. So why are there so many options? Here are all the main file types you'll see listed, with an explanation of what they're used for.

The formats you'll need

Photoshop (.psd) is the full file you're working on, containing all the layers, styles, effects, Adjustment Layers, and so on. Save in this format when you want to carry on working on your image.

JPEG (.jpg) stands for Joint Photography Experts' Group, and is a highly compressed format that's good for delivering images over the internet. There's a trade-off between high quality and small file sizes: the higher the JPEG value, the more faithful the image will be to the original, but the bigger the file.

TIFF (.tif) stands for Tagged Image File Format, and this was the file format of choice before JPEGs came along. It's not lossy, as JPEGs are, and the resulting files are much bigger; unlike JPEGs, it can contain both layers and selection channels, so is good for exporting images for use in other applications.

JPEG 2000 (.jpf, .jp2) is a newer version of JPEGs that offers better quality and also supports selection channels. Most web browsers can't read this format, though, so it's no good for internet delivery. Sadly, Adobe have dropped support for this format in Elements 8 and files in this format will no longer open by default. All is not lost, however: a fully functional third party plugin is available from the following website: http://www.fnordware.com/j2k/. With this installed you will be able to use the dedicated JPEG2000 sites, http://www.thefullmontage.com and http://www.absolutvision.com.

Compuserve GIF (.gif) stands for Graphics Interchange Format and is a format that was introduced in 1987 and is used primarily for web delivery. It includes

only a very limited range of colors, so images will look very rough; on the plus side, it can contain multiple frames of an animation.

PNG (.png) stands for Portable Network Graphics, and is a more recent format intended for internet delivery. It's not that commonly used, although it does support transparency, and so is useful for web designers.

Photoshop Raw (.raw) is the high-end, high bandwidth version of images captured by professional-quality digital cameras. Many professional photographers prefer this format for its extended tonal range.

Photoshop PDF (.pdf) stands for Portable Document Format, which was developed so that one complex file including text and graphics could be viewed identically on multiple computer platforms. The Photoshop Elements version is there to provide compatibility.

The formats you won't need, but may as well know about

BMP, or 'Bitmap' (.bmp) is a format designed for use internally by MS-DOS and, later, Windows. It's hugely wasteful, resulting in enormous file sizes.

Photoshop EPS (.eps) stands for Encapsulated PostScript and is the format images used to be converted into for color printing. It's now rarely used except for jobs in unusual color spaces – such as those to be printed in CMYK plus a special Pantone color.

Scitex CT (.sct) was a high-end reprographic format in the early days of desktop publishing. CT stands for 'continuous tone'.

Targa (.tga) was a graphics format used on graphics cards for IBM-compatible PCs. Many games still create screenshots in Targa format; the online game Second Life accepts textures in this format, which supports transparency.

The formats you don't even need to know about

PICT (.pct) and **PCX (.pcx)** were internal formats used by early Mac and DOS computers respectively. Along with Photo Creation Format and Pixar, they're only provided as options in case you want to open graphics files created many years ago on ancient computer systems.

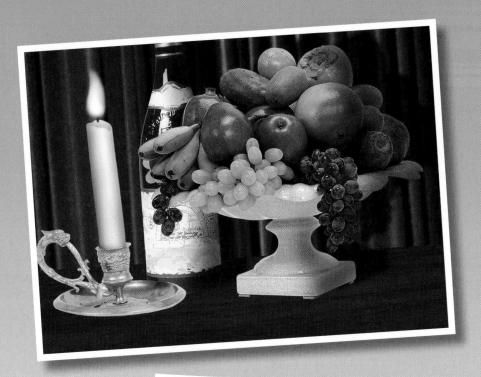

A simple still life, above: the fruit bowl, candlestick and bottle are all on separate layers, as are the table and the curtain behind. Adding the shadows was straightforward enough, but the scene is dull and looks unrealistic. Adding reflections to that wood surface really brings this picture to life, giving it an extra dimension.

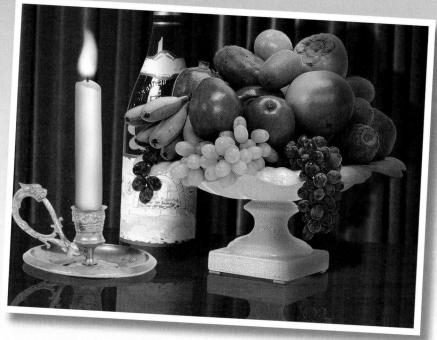

Shiny surfaces

GLASS, METAL AND WATER all have one thing in common: they're shiny. Which means that any objects placed on these surfaces will have reflections.

Making reflections can be as easy as simply flipping an object vertically and lowering the opacity. But it can also be much more complex, if the object in question is photographed from an angle. We'll show how to split an object into its constituent planes in order to reflect each one individually.

We'll also look at making rippled reflections in water, show how to place people and things inside bottles, and look at that most easy and powerful tool for making instant liquid – Plastic Wrap.

Upon reflection

DDING A REFLECTION TO A SURFACE converts it from being flat and matt to bright and glossy. The more vivid the reflection is, the shinier the surface appears. Different materials produce varying levels of reflectivity depending on how much light they absorb or let through. A piece of glass on its own will let most of the light through. This results in a sharp but faint reflection. Add a backing to it, such as silver, and you have a mirror. This bounces most of the light back, giving a perfect copy of the person or object.

In the following tutorial we'll create a soft reflection by fading it out as it extends further away from the original object. This gives us a similar appearance to the acrylic surfaces used in product photography. This technique can easily be adjusted to suit your requirements by altering the depth and intensity of the effect.

Here's our subject. It's already on its own layer. We'll need to duplicate this to use as our reflection. Press [217] #]. We'll be using the lower layer for the reflection. This will allow us to place it behind the original, giving the impression of depth and substance.

4 Grab the Gradient tool **6**. Select a Linear Black, White gradient. Click the Adjustment Layer's mask thumbnail to make it active. Position the cursor at the bottom of the document. Holding **6**/11, click and drag the cursor up. I took it to around a third of the way up the original apple here.

2 Flip the layer vertically via Image > Rotate. Use the Move tool votage the layer down. Hold for to constrain the movement vertically. This ensures the two images remain aligned. Leave an overlap so the reflection layer remains slightly behind.

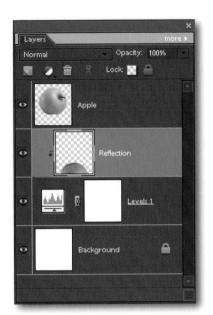

We'll use a mask to allow us to fade out the reflection a little. Add a Levels Adjustment Layer between the background layer and the reflection. Accept the default settings. Click the reflection layer's thumbnail in the Layers panel. Press @ G & G to create a clipping group.

HOT TIP

You can adjust how the mask affects the reflection without having to recreate the gradient each time. Click the mask's thumbnail to make it active. Open the Brightness/ Contrast dialog. Increasing and decreasing the Brightness changes the opacity. Altering the contrast determines how smooth the blend becomes. A higher value produces a much harsher transition whilst lowering it gives a much more gradual fading effect.

5 We'll add some blur to the reflection to give it slightly more softness. Click the reflection layer's thumbnail to make it active again. Open the Gaussian Blur filter. You won't need to use a lot for this effect, just enough to knock it out of focus a little.

6 To finish off we'll add a shadow. This is created with another copy of the apple filled with black. See the chapter on Light and Shade for more on the technique. For reflective surfaces such as this the shadow needs to be much lighter than if it were cast on a matt surface.

Complex reflections

N THE PREVIOUS PAGE we created a reflection for an object that had been photographed head-on: a simple task of flipping the image vertically and placing it beneath the original. Problems start, however, when the photo is taken from an angle, as we can see from the image above. Elements can only work in two dimensions so inverting the image gives undesirable results.

For tricky jobs such as this we need to break the object down into separate layers; these can be distorted individually to produce the correct effect. The first step is to divide the object into separate layers: grab the Polygonal Lasso and make an outline around one side of the box. Press [17] ** It to copy it to a new layer. Now repeat this for the other side remembering to make the original box layer active again, of course.

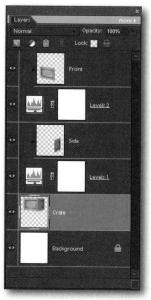

Create a Levels Adjustment Layer below one of the side layers. Make the layer above active again by clicking its thumbnail, and create a clipping group by pressing (I) (B) (D) the same for the second side of the crate. These will be our masks to fade the reflection away.

Go back to the front panel layer and flip it vertically, then press ctrl T # T. Drag it down and match one of the corresponding corners on the base of the original box. Hold ctrl Shift # Shift and drag the opposite center handle up to skew the panel into position.

Repeat the last step to add the side panel. At present we have two boxes on top of each other; a good effect in itself but we need to make it more like a reflection. The first thing to do is drop the opacity: around 30% works well here - do this for both layers.

HOT TIP

When you are dividing an image up it's important to ignore the way the object is constructed and look at its overall geometry. In our example the crate is constructed from recessed panels so the real 'sides' start and end in a different place to those we need to select for the technique to work correctly. Try to imagine the object as being made up of solid, neutrally colored panels to decide where the selection should be made. Also remember that, the more detailed the object, the more layers you will have to create; boxes might be easy, something as complex as a car would be far too timeconsuming.

5 Select the Gradient tool **6** and choose a Linear Black, White gradient. Make sure you have one of the Adjustment Layer's masks selected. Click half way along the bottom edge of the panel then drag straight up to the top of the reflection. Again, repeat this for the other panel.

Finally, we'll add a shadow to place the crate firmly on the ground. Create a new layer above the background; use the Polygonal Lasso to draw a selection around the bottom of the crate. Fill this with black and blur it slightly, and lower the opacity a little.

Window reflections

HE VIEW THROUGH THIS WINDOW is far from inspiring: the side of the house next door adds little life to the scene. We'll replace this view with a new one to improve our outlook.

The complications arise when we begin to place figures in the scene. A person in the room will look convincing enough just standing in front of the window, as long as he appears at the right scale for the room; but, if we leave it at that, we're ignoring the fact that there should be glass in the window, which should create a reflection.

Adding a reflection certainly makes the glass itself exist as a medium. But how do we make the glass cope with multiple reflections? The answer is to subtract one reflection from the other, to create a wholly convincing effect.

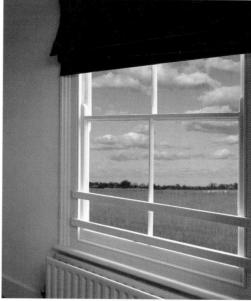

We can easily select the window area using the Lasso tool. By making a new layer, filled with a solid color, we create a mask for the window; any view placed on top of this layer, and grouped with it, will be seen 'through' the window.

The man is reflected in the window and we should be able to see a reflection of the rest of the room as well. Almost any suitable interior will do, as long as its horizontals match that of the window perspective: it doesn't need to be a view of the same room.

2 Placing our figure in the scene, looking obliquely down the field, adds that human element that brings the image to life. But the window itself looks distinctly empty and we need to add glass to it.

The trouble with the previous step was that we could see through the man to the room behind. Of course, his reflection should obscure the room. So hold (1) (3) and click on his thumbnail to load his selection; then switch to the room reflection layer and delete from there.

Because of the angle of view – and the symmetry – of our figure, we can simply duplicate him and position a slightly reduced copy (to allow for perspective), grouped with the view, at a low opacity – here, around 50%.

6 We made the reflection of both the room and the man strong enough to see what we were doing in the previous few steps. In reality, we'd expect a much less visible reflection. Here, we've reduced the opacity of both layers to just 20% for a more convincing result.

HOT TIP

Our man happened to be at exactly the right angle to allow us to 'translate' him through the window. In most cases, you'd need to flip your figure horizontally in order for the reflection to work properly. It's a lot easier if the window isn't at an angle as extreme as the one in our example.

From railway to waterway

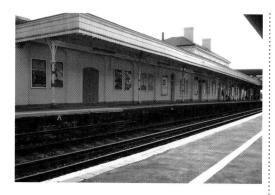

REATING REFLECTIONS IN WATER requires a slightly different approach to those of solid surfaces such as metal or wood. Being a liquid, it has different properties to take into account such as turbulence and refraction. We need to distort the reflection to match the state of the water. This could be anything from the subtle ripples on a pond to the hazy, elongated lights of cars on a rain-soaked road.

In the following example we'll convert this railway platform into a canal. By using a combination of layers, filters and distortion techniques, we can quickly create a realistic water effect which can be tailored to suit many different images, for example: beautiful lakeside scenes, rock pools for a sea life project, or simply puddles on the ground.

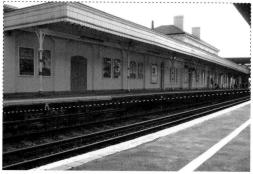

First we'll create the reflection: draw a selection using the Polygonal Lasso, following the perspective of the platform; We've used the yellow letters as a guide. Create the rest of the selection around the top of the image. Now save the selection via the Select menu.

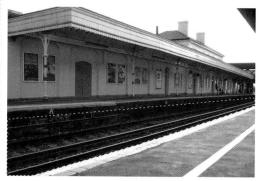

Inverse the selection <code>ctrl Shift</code> [] **\$\\$Shift** []. Go to the Select menu and load the selection we saved earlier. Make sure Subtract from Selection is checked and click OK. Now grab the Polygonal Lasso, hold <code>att</code> [], and remove the area of the platform from the foreground.

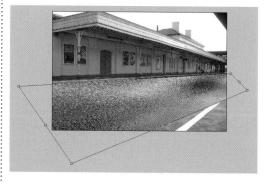

Use Free Transform to distort the water into place. This doesn't need to be a perfect fit; the texture can become too pixelated if it's stretched too much. We need to adjust enough to stop it looking too flat. Once you've done this, press [17] [3] [6] to group it with the base layer.

2 Copy the selected area to a new layer oth J # J.

Flip the layer vertically to make a mirror image. Select
Image > Transform > Skew. Hold Shill and drag the layer
down to line the layers up then pull the right-middle handle
up to correct the perspective.

Hide the reflection layer for now and click the background layer's thumbnail to make it active. Select the line at the edge of the platform with the Magic Wand; hold **Shift** to add any missing areas. Add a small amount of feathering; 1 pixel will be fine here.

5 Create a new layer between the platform and the reflection. Fill the selection with 50% gray and deselect. Paint in a slight unevenness to the back edge using a hard brush; remember to make it less pronounced as it moves further into the distance.

6 Add another layer above the last. Press D to select the default palette, now fill the layer with the Clouds filter to generate a random pattern. Choose the Glass filter from the Distort menu. Set the texture to Frosted, now use the sliders to create a fine-rippled effect.

Make the reflection layer visible again. Set its blend mode to Soft Light and group it with the water layer. We need to add some ripple to the reflection itself as it would be distorted by the water's surface. This is easily done with the Ocean Ripple filter.

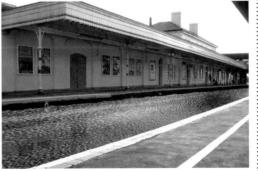

9 Select a large, soft eraser; using the edge, erase some of the lower area of the reflection to fade it out. We'll also add a little tint to the water. We've used a Photo Filter Adjustment Layer set to Cooling at a very low density. You could use a Hue/Saturation adjustment set to Colorize.

HOT TIP

Although it's generally good practice to avoid using the Eraser, there are times when it's quicker and more practical to do so. In this instance we couldn't use the grouped Adjustment Layer masking technique to fade the reflection: you can't nest clipping layers, they would have to be merged first. If you're worried about making a mistake. duplicate the layer as a precaution.

SHORTCUTS

MAC WIN BOTH

Goo, slime... and molasses

LEMENTS IS AWASH WITH FILTERS for performing special effects – everything from knocking up a quick pointillist Seurat painting to making an image look like it's reflected in rippling glass.

Sometimes, though, filters can have surprising results. One of our favorites is Plastic Wrap, which – surprise, surprise – makes objects look as if they're wrapped in plastic. This isn't a job it does very well, but what it can do is to make glistening, slimy liquids from the most basic of ingredients.

Here, we'll show how to use the Plastic Wrap filter to add a few spoons of molasses to the top of this man's head. Why? Well, why not?

Begin by making a new layer. Select a mid-gray and, using a hard-edged brush, paint in the area to be taken up by the goo. If you're having trouble painting convincing drips down the face, try using the Smudge tool to smear the color where you want it to go.

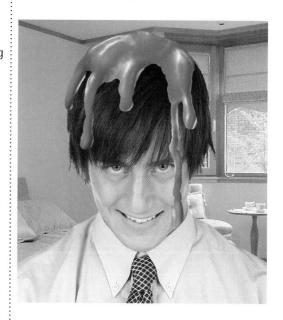

Here's the result of that Plastic Wrap filter: a glistening dollop of – well, something gray. We can fix that in the next step. If you find you don't get the effect you want, undo the filter, add a little more shading, and use apply it again without having to open the dialog.

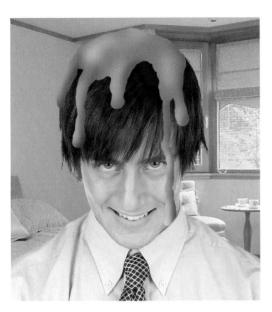

Now add some shading to it using the Dodge and Burn tools, set to Highlights. Remember, if you hold when using either tool, you'll get the other one temporarily. All we're aiming for here is a random lumpy texture, to give Plastic Wrap something to work on.

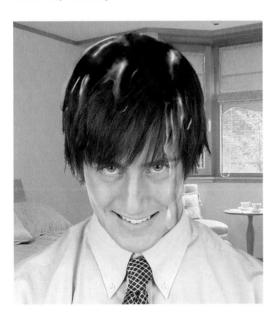

When we change the mode of this layer from Normal to Hard Light, using the pop-up menu at the top of the Layers panel, all the gray disappears, leaving us with just the highlights and shadows. As it stands, this looks more like water than molasses.

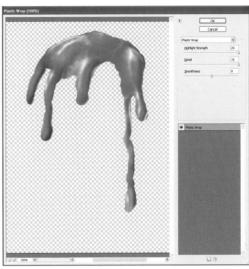

Choose Filter > Artistic > Plastic Wrap. (Why is it in the Artistic section? No idea.) Push the Highlight Strength and Detail settings up to their maximum – no half measures here – but leave the Smoothness round about the mid point to add some texture to the stuff.

6 We can add color using the Hue/Saturation dialog, checking the Colorize button and dragging the Hue slider until we get the color we want. If we left this slider at the far right, we'd get a convincing impression of a bottle of red wine poured over the man's head. Your choice!

HOT TIP

Plastic Wrap can be used to create all kinds of liquid effects - spilt wine, dripping water, vinegar, coffee, or oil - just by changing the hue and the brightness. It's also good for creating icicles and all kinds of shiny, lumpy surfaces.

The real effectiveness of this filter depends on getting the shading right in step 2: keep applying the filter, using Undo if it isn't right, then adding more shading and reapplying the filter until it works. Subtlety is the key here: don't go for deep shading; paint in the shadows and highlights with a very light touch.

Preserving the occasion

VER BEEN AT A SPECIAL OCCASION – a birthday, perhaps, or a family event – and wished you could keep it forever? Taking a series of photographs is one method, but here's another that will preserve your favorite memories for all time in a unique way.

The technique we use here will help us to place this girl in a preserving jar. But it could also be used to place snorkeling kids into a fish tank or to position people and objects in just about any glass container.

We'll begin with the cutout photograph of our girl blowing the candles out on her cake, and then we'll go on to make her look as if she's really inside the glass jar.

Here's our bottle. If you want to photograph your own container, make sure it's against a plain white background: a white sheet of paper behind it will work well. And try not to use the flash on your camera or you'll get an ugly glare off the glass surface.

Press (III) G HG to group the new jar layer with the girl's layer so it only shows up where it overlaps her layer. The rest of the jar is now returned to its original appearance. But the effect is now too strong: the girl has almost disappeared inside that container.

When we place the girl on top of the jar, we can resize her to fit the shape using Free Transform (). She may now fit the jar, but the effect is far from convincing: we need to add a couple of treatments to make it look as if she's really inside.

5 We can reduce the strength of the effect by lowering the opacity of the duplicated jar layer. Experiment with different settings to see what looks best: here, an opacity of 40% gives a good balance. The value you end up with will depend very much on the glass container you photograph.

3 Duplicate the jar layer and move it above the girl's layer; then change the mode of the jar to Hard Light, using the pop-up menu at the top of the Layers panel. The effect is to make the whole jar too bright, and we can correct this in the next step.

Finally, we need to pay attention to the thick glass at the top of the jar, where it meets the lid. Use a small, soft-edged Eraser to remove those parts of the girl's head behind these thicker glass areas, and we'll get a much more convincing result.

HOT TIP

Changing the opacity of the duplicated jar in step 5 is the key to making this technique work. Rather than dragging the Opacity slider, there's an easier way. With the Move tool selected. use the number keys, either on the keypad or on the top row of the keyboard. Pressing 4 will give you 40% opacity, 5 will give 50%, up to 0 to return to 100%. You can get intermediate values by pressing two keys in quick succession - so pressing 4 then 5 will give you 45%.

SHORTCUTS

MAC WIN BOTH

Keeping it real

POSSIBLY THE GREATEST COMPLIMENT you can receive for one of your montages is when the viewer does not realize it is one in the first place. Creating this effect need not be as time-consuming and laborious as you may think: a large part of producing a convincing image, after all, is creating an illusion to fool the viewer. It may not survive close scrutiny, but unless we're trying to conclusively prove to NASA that we reached the Moon long before Neil Armstrong, we can afford a little artistic license.

Creating a realistic image depends on a number of factors: most importantly, the individual components of the artwork need to fit together as seamlessly as possible. The direction from which the people and objects are lit needs to be the same – there's no point having someone caught in a spotlight, for instance, if their face still appears to be in shadow. We also need to make sure the shadows themselves are correct and, more importantly, present to begin with; everything casts a shadow of some sort, even if they are too faint to notice initially — they help to define depth, placing their associated object within its surroundings. Getting the color right also plays an essential role: be careful not to use garish hues as this could result in an unnatural-looking image.

So, with all that said, how do we go about translating it into our artwork? The answer is often staring right back at us: a lot of the time we'll be adding to an existing photo so we can take our cues from there, adjusting the new elements accordingly and sampling the colors and tones, comparing them as we go. Things become trickier when it comes to building a picture from the ground up where our clues aren't there to guide us — we're far from helpless, though.

Just as a traditional artist studies their subject and surroundings to set it to canvas, we can do the same. It's by no means a crime to use reference material to make sure we achieve the correct effect and it's certainly preferential to trying to use guesswork alone. A good starting point is, of course, the internet, and image search engines such as Google or Yahoo are superb resources; it's highly probable that we'll find what we're looking for, and, because we're not actually including the image within our artwork, copyright is not an issue and we need not be too

concerned with its dimensions as long as it's possible to see the detail. We can, of course, take our own reference shots as well: again, these don't need to be award-winning photographs, they just need to be of a good enough quality for us to be able to see the effect, so even quick snaps from a cell phone should be sufficient.

There will be occasions when we need to see different versions of the same effect and also have the ability to view it from different angles; something that a still image cannot offer. In these situations improvising with props is often a great solution as they don't necessarily need to be the exact objects and only need to be crudely put together; as long as the outcome is a good representation, we can transpose it to our design. It's surprising how many things we can find within immediate reach with which we can improvise: we might, for example, want to see how a shadow falls across an uneven surface such as a staircase; so, instead of grabbing the nearest family member and having them stand in different positions, we can quickly put together an impromptu mock-up by folding a sheet of paper and positioning a suitably illustrative object; then use a flashlight or similar maneuverable light source to create the desired effect.

We're not always going to be producing images depicting plain old reality, of course; we'll often be creating montages that are highly stylized or in a fantasy theme: there will always be a demand for fairy princesses and other such magical pictures, after all. These often demand more attention to detail than their more sublime counterparts; people tend to scrutinize them far more closely, even though they know they cannot be real. It's highly unlikely we'll stumble across a real photo in a search but we can still apply the same principles from the real world to our artwork: reflections, shadows and color still play their part in creating a convincing scene. We do have the advantage that nobody can really say how a picture of this ilk really should look, so we can be a little more lenient with the rules.

Finally, remember that there will always be flaws and unexpected elements in a real scene: try not to make your images too clinical. Try adding some random areas of light and shadow — it's often the smallest details that have the most impact.

Two images of a car on an airport runway. It's the identical car in both photographs, but, in the top image it looks false and out of place, whereas in the bottom one it belongs in the scene. The difference is that in the top picture the car is too high for the perspective of the scene; in the bottom one, the perspective is correct.

The third dimension

ALMOST EVERY PHOTOGRAPH WE TAKE captures a scene in three dimensions. When we want to add, edit, or adjust objects in the scene, we need to pay close attention to the perspective in the original scene if we're going to achieve anything like a convincing montage.

There are complex rules governing how perspective works, and these have been continually refined ever since they were first formulated by the Persian philosopher Alhazen in the 11th century. Since we're dealing with photographed images, rather than a blank canvas, we can read the existing perspective out of the scene: in this way, by using our eye and drawing vanishing point lines, we can guarantee that any new picture elements we add are consistent with the scene we started with.

Lifting the lid

ESPITE THE HUGE NUMBER OF IMAGES available through stock photography sites, there will come a time when you cannot find exactly the right one for your project. This is not always a problem, as we'll see in the following tutorial.

The image of the wooden box is perfect except that it's closed and we want it open. Unlike the real thing we cannot simply remove its lid: the rear sides of the box don't exist. With a few selections and transformations we'll create the missing areas using copies of the existing sections.

Our first task is to isolate the lid from the rest of the box. The Polygonal Lasso is perfect for this. Create a selection around the whole of the lid. Press ctr. Shift is solid. It could be considered the selection around the whole of the lid. Press ctr. Shift is selection a

Make sure the box layer is active. Create a selection around the front side of the box. Press and make to create a copy. Move this layer down the stack so it's behind the rest. Now reposition and distort it into place as the back side of the box.

Make the lid visible again. Change the layer order so the lid is behind the box. Enter Free Transform (II) T. Start by lowering the lid so its front corner lines up with the existing sides of the box. Hold (II) \$\mathbb{R}\$. Now distort the outer corners to match.

3 Next we'll cut a hole in the top. This serves two purposes: we can use the edges as a guide for the missing sides and it will also give them substance. Create a selection following the perimeter of the lid but a few pixels inside the edge. Press Backspace.

5 Repeat the last step to create the remaining side; remember to switch back to the box layer first. Switch to the back side layer. Make another copy. Again, move it to the bottom of the layer stack. Distort this to create the floor of the box.

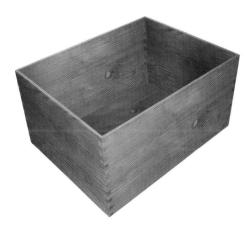

All that remains is to add some shading inside the box. Grab the Burn tool ②. Set the mode to Highlights. Use a large, soft brush to paint in some shadows; you'll need to switch between the layers. We only need a few subtle areas in this instance as the original lighting works quite well.

HOT TIP

It can be helpful to have a guide to follow when distorting in perspective. Sometimes you'll be able to use other areas of the original image. You can also create your own reference. This could form part of the object, as with the rim of the box. You can also use layers to create an overlay which can be turned on and off during the creation process.

SHORTCUTS
MAC WIN BOTH

Lifting the lid 2

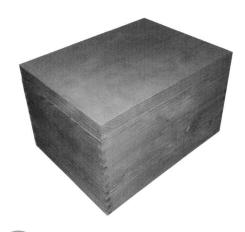

N THE PRECEDING PAGES we opened a box by removing its lid completely. You may, however, decide that you want to keep it in the image, opening as though it were hinged.

This is not difficult to achieve. We can't, of course, simply pivot the lid to open it. This is two-dimensional artwork after all. Instead we'll use geometry in our favor. By flipping and rotating the lid, its angle is mirrored against the box. Once in place, we can use a variation on the previous technique to create the hollowed-out effect.

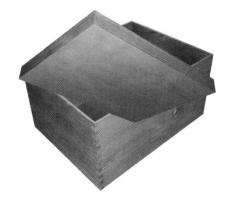

To avoid unnecessary steps in creating the open box we'll use the completed image from the last technique. The original lid has been selected and placed on a separate layer. The first thing to do is flip the layer. Do this by selecting Flip Layer Vertically under Image > Rotate.

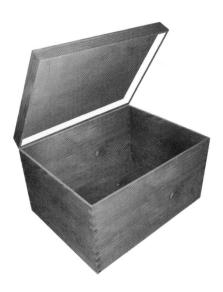

Use the Move tool to push the panel toward the rear of the lid. This creates a recessed area. Don't place it too far back; we need to give the illusion that it has thickness. Again we can see the problem. The rear and side panels are missing.

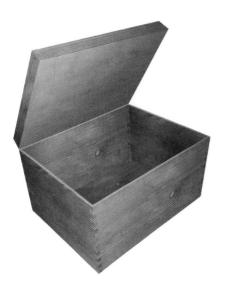

2 Use Free Transform to move and rotate the lid into place at the rear of the box. You'll notice it doesn't quite fit: it's too wide. Use the corner handles to squash the lid up a little so it meets the corners of the box. Make sure it meets the edge; you may need to rotate it a little more.

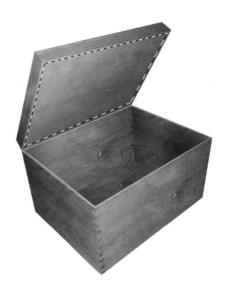

We could leave it at this stage. That lid looks a little heavy, though. Use the Polygonal Lasso to create a selection a few pixels within the edge of the lid's panel. Press ctal Shift J & Shift J to remove the area and place it on its own layer. Drop it behind the lid in the Layers panel.

Whilst this is a very efficient may require it at a different angle. To do this you'll first need to break the lid down into separate layers comprising its component parts. These can be maneuvered into the correct position individually to produce the desired effect. A similar technique is used to create a complex reflection in the chapter on shiny surfaces.

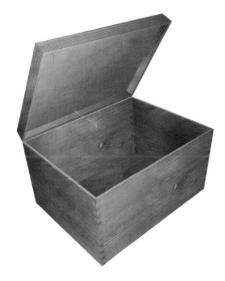

5 Click the lid layer's thumbnail to make it active. Select the top edge of the lid. Press (I) (H) to copy it to a new layer. Drop this new layer behind the lid and panel layers in the stack. Use Free Transform to distort it into position. Repeat to create the missing right-hand side panel.

Select the Burn tool ②. Set the mode to Highlights. Choose a large, soft-edged tip. Paint in some areas of shadow on the inside of the lid, particularly at the top and in the corners where less light would reach. You may also want to darken the inside of the box itself.

Tiling the floor

HERE'S NOTHING LIKE A SPOT of redecorating to brighten things up. The old wooden floor of the changing room in this photo could certainly do with renewing. Let's replace it with something a little more lavish: a nice marble checker to complement the border on the wall, perhaps?

The effect is not as difficult to produce as it might seem. We'll create the pattern on a layer, using the Clouds filter to add the marbling effect. We already have the existing perspective to use as a guide so it's simply a matter of distorting the new floor into position.

You can, of course, use any pattern or texture with this technique. Perhaps use it to visualize ideas for decorating your room before you commit to a particular design.

Create a new layer. Select the Rectangular Marquee M. Draw a selection holding holding to keep it square. Fill with black. Holding to all H. S., click and drag the selection to create a copy. Place it alongside the last square. Fill this with white. Repeat this twice more to finish the pattern.

Add another new layer. Fill this with the Clouds filter. Apply the Find Edges filter from the Stylize menu. This gives us a nice marble-like texture. Set the blend mode to Difference. Lower the opacity slightly to reduce the contrast. Press (III) E to merge the layers together.

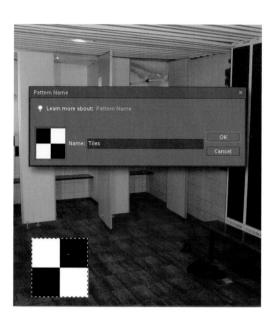

We'll use this to create a repeating pattern. Load the layer's selection. Select Define Pattern from Selection from the Edit menu. Give it a meaningful name for later reference and click OK. At this stage you can either delete the layer or hide it as it's no longer needed.

Create a new layer at the top of the stack. Press **Shift Backspace** to open the Fill dialog. Choose Pattern for the Contents from the drop-down menu. Select the tile pattern from the panel. Clicking OK will fill the whole layer with our new pattern.

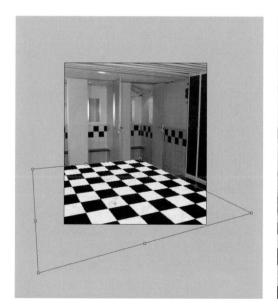

5 Now we have our new floor we need to distort it into position. Enter Free Transform. Hold ## and distort the corner points to match the floor in the photo. You'll need to zoom out to be able to maneuver the left-hand side of the new floor into position.

We need to mask out the areas around the bench and the cubicles. This can be achieved by using the original floor as a clipping mask (see Chapter 3). A Hue/Saturation adjustment adds a slight color cast and darkens the floor down. Some shading is added to complete the effect.

HOT TIP

It can be tricky to get the perspective right when you don't have the whole area to match up to. Try to find as many points of reference as possible. In this image we have the lines of the original floor. The problem is that they are hidden beneath the new layer. You can, of course, lower the opacity; a better solution here, however, is to change the tile layer's blend mode to Multiply or Screen. This will hide the white or black squares respectively, allowing us to accurately match up the visible edges.

SHORTCUTS

MAC WIN BOTH

Opening doors

NE OF THE NEATEST TRICKS we can play in Elements is to open a closed door. It's impressive to see it done, but here's the real trick: it's very easy to do.

The procedure makes use of the Free Transform tool, which performs perspective distortions with ease – and without us even asking anything of it. Distort a corner handle or two, and the object in question will do its best to fill the space in a truly three-dimensional manner.

In this tutorial we'll concentrate on opening the door and giving it some thickness so it looks real. The view through the door we'll leave as a gaping black hole; overleaf, we'll see how to fill this hole with a convincing view.

Use the Polygonal Lasso to trace the shape of the door, then use (III) (#) to make a new layer from it.

Load the door region by (III) (#)-clicking on its thumbnail, then make a new layer behind it, filled with black. The three layers are shown here offset to show the stacking order.

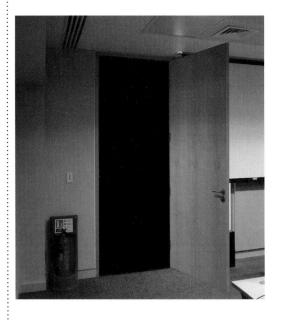

We can distort this new piece of door in a similar way to how we distorted the door itself, using Free Transform to adjust not only the width but the height. The edge where the side touches the door should be slightly higher than the edge away from the door.

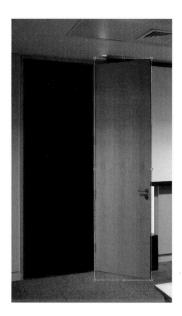

2 Enter Free Transform on the door layer using (III) (III) and drag the center-left handle to the right in order to flip the door so it's facing the other way.

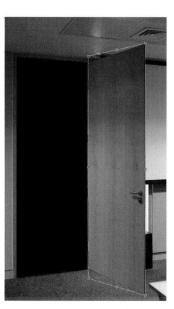

Now for some perspective. Hold ## Shift as you drag the top-right corner handle up; repeat this for the bottom-right handle until the door looks like it fits the space.

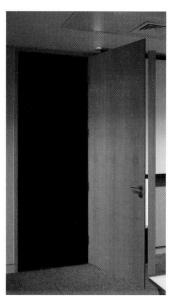

To give the door some thickness, we'll need to add a side. Make a rectangular selection with the Marquee tool from the door itself and make a new layer from it; move it to the side.

HOT TIP

Getting the perspective on the open door exactly right is the only tricky part of this exercise. There's no simple way to describe precisely how this should be done, but, if it looks right, it probably is. In step 5, we distort the side of the door to match the opened door. It can be hard to do this accurately in Free Transform, so here's a simple solution: make the side higher than you need, then remove the top and bottom with the Lasso or even a hardedged Eraser to fit the door.

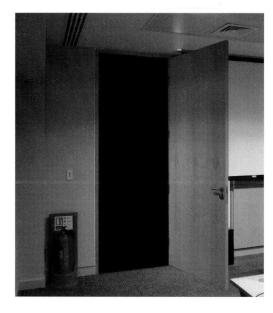

Brighten up this door side a little using Levels or the Brightness/Contrast adjustment – whichever you prefer. Here, we've also drawn in a lock mechanism, just for the sake of completeness: a rectangular selection was filled with a color sampled from the door handle.

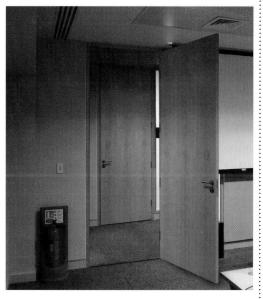

Now, that all-important shadow. It's only a tiny amount of shadow, painted on a new layer beneath the door layer, but it makes all the difference to the realism of the scene. And how about copying the original room, grouped with the black layer, to make the view through the door?

The third dimension

Using perspective

In this photograph of an office hallway, we're going to remove the elevator and replace it with a corridor. At first glance, the task looks daunting. While there are plenty of horizontals here that are parallel to the wall facing us, there

are very few at right angles to it. But we're fortunate in having that side wall, containing the doors, just in view: using these, we can read the perspective for the scene, which is enough to give us our vanishing point.

the trickiest techniques to master in Elements. It's the factor that distinguishes convincing montages from those that just don't feel quite right. But, by following a few straightforward rules, it's possible to make perspective work for you, rather than against you.

The key to reading perspective in a photograph lies in using horizontal lines in the original image to calculate where the vanishing point of the image lies: once we've established this, anything we draw will naturally fit the scene.

We can now draw two new perspective lines, to give us the top and bottom of our hallway. Start from the left corners and finish at the vanishing point. It's now possible to draw our first wall by using the Polygonal Lasso tool to follow these perspective lines then filling the selection with a color to match the other walls. Group this wall layer with the black base layer we made in the previous step, so it only shows up where the two overlap.

4 We can now recolor the black layer to make a suitably colored ceiling. It's behind the wall layer, so the wall still shows up. To make the carpet, copy a section of the existing carpet and paste it in place, grouped with the ceiling layer but behind the wall layer. You may need to distort it to fit.

2 Begin by making a new layer. Then choose the Shapes tool, set to draw straight lines. Draw two lines that follow the strongest horizontals in the left-hand wall: in this case, the bottom of the doors and the very top of the

wall. Where these lines converge, over on the far right of the image, is the vanishing point. Next, on another layer, draw a selection that matches the face of the elevator opening – going right down to floor level – and fill this with black.

5 After drawing in the end wall, finishing off the scene is simply a matter of copying the elements we want from elsewhere in the picture. Here, we've taken a copy of the door on the far left, and distorted it to match the perspective of the hallway.

A section of skirting board, taken from the far left of the facing wall, is copied and then

stretched to run along the base of the new wall, and another small copy bent around the end wall. Finally, we made a new layer and added some shading to it with a large, soft-edged brush to give the impression of the corridor darkening as it recedes into the distance. This final touch accentuates the sense of the corridor as a real space, adding extra realism to the scene.

HOT TIP

When we distort the copies of the original door in step 5, we run into a tiny problem: because the door wasn't viewed head on, we can't use the bounding box in Free Transform to match the perspective of the view. Instead, adjust the distortion so that the bottom of the door lines up with the bottom of the wall, then drag the top corner so that it follows the angle of the top of the wall, once again pointing directly towards the vanishing point.

The third dimension

Make your own jigsaws

ITH THE MULTITUDE OF FILTERS in Elements, it's perhaps surprising that, hidden among the stained glass and other effects, there isn't one for creating jigsaws.

Here's a technique that makes use of a custom shape that we've included for you on the CD. To install it, follow these steps:

- 1. Exit Photoshop Elements.
- 2. Locate the file Cheat.csh in the Goodies folder on the CD.
- 3. Copy the Cheat.csh file to the folder Program Files\Adobe Photoshop Elements 7.0\Presets on your hard drive.
- 4. Restart Photoshop Elements.

The jigsaw shape will appear in the Shapes submenu when you switch to the Shapes tool, in the item named Cheat.

Choose the shape Jigsaw Portrait from the Cheat section of the Shapes dialog. Once the shape is selected, use the Shapes tool to drag from corner to corner within your image, so that the entire space is filled with the jigsaw pattern. You'll see it appear as faint lines as you do so.

4 To give the pieces some depth, add an Emboss effect. Open the Style Settings dialog and reduce the size of the Emboss to about 5 pixels; add a slight drop shadow to make the pieces look more three-dimensional. You can play around with the Emboss settings until it looks right.

2 Once you release the mouse button, the shape layer will be filled with the default color – generally blue. We'll only be using this as a template, so there's no need to change the color of the layer: it won't appear in the final illustration.

Show let's make the dividing lines clearer. Load up the selection of the shapes layer again, then inverse the selection using ctr/Shift \(\) \(

Load up the shape layer's pixel area by holding **(277)** and clicking on its thumbnail in the Layers panel. Then return to the image layer and use **(277)** to make a new layer from that selection. Hide the shape layer to see the image made up of jigsaw pieces.

To take one piece out of the jigsaw, go to the lines layer we just created and click in one of the pieces with the Magic Wand. Return to the image layer and use ctr Shift J \$\mathbb{Shift} J\$ to cut the selection to a new layer. Move it to the top of the layer stack and move and rotate it as you like.

HOT TIP

We've included two versions of the jigsaw on the CD - one in portrait (vertical) orientation, the other in a landscape (horizontal) shape. Choose whichever one is most appropriate for the shape of the image you're working on.

SHORTCUTS

MAC WIN BOTH

The third dimension

Out of bounds

HE 'OUT OF BOUNDS' TECHNIQUE is a popular one with Elements artists, and it's not hard to see why: breaking a picture out of its frame makes for an arresting image. That's why we used the technique on the cover of this book.

The process can be as simple or as complex as you want to make it. Here, we'll look at a rather more detailed version of the trick, using not a photograph but a painting – *Little Thieves* or *Petites Maraudeuses*, by William-Adolphe Bougeuereau.

Here's our original painting. The format – one girl helping another down from a wall – is perfect for our purposes.

The carpet is added on a new layer: solid color, Gaussian Noise, then Gaussian Blur. We've also deleted the section of wall behind the painting.

The first step is to select and copy the figures to a new layer, using a combination of your favorite selection tools.

Use Shadows/Highlights to brighten that dark skirt and the Dodge tool to lighten the legs; then clone out the foliage on the skirt.

Now place the picture frame between the two layers, distorting it using Free Transform until it follows the angle of the wall in the painting.

Let's now add our own wall. Make 4 a rectangular selection on a new layer filled with solid color; the skirting board is easily painted at the bottom.

Now enter Free Transform and, the bottom-right corner down until it matches the painting's perspective.

holding ctrl Shift # Shift, drag

The shadows behind the girls give them some distance from the wall: use the techniques outlined in Chapter 5.

We've added a chair to give a sense of the room continuing out of the frame, and to make that plain wall look a little less bare.

Finally, add shadows for the chair and picture frame. And, while we're at it, we may as well include a plaque to the painter.

HOT TIP

The real key to this technique lies in constructing a setting to match the perspective of the original painting or photograph. You'll almost certainly have to adjust the lighting, particularly in the shadow areas: here, the feet looked fine in the original painting but were much too dark against the carpet.

RGB or CMYK?

PICTURE THE SCENE: you've spent hours creating the perfect birthday card in Elements. It features a lovingly crafted cutout image against a bright green background, a dazzlingly bright red headline, and a contrasting blue caption. But when you print it out on your inkjet printer, the text looks dull and lifeless and the background is far darker than it looked on the screen – despite having used the best quality glossy photo paper. What can have gone wrong?

The problem is the fundamental difference between what you see on the screen and what can be printed on paper. And it all comes down to two acronyms, RGB and CMYK.

RGB stands for red, green and blue, and refers to the colors used by computer monitors. In standard 8-bit mode, each pixel on your screen can display each of these three colors in 256 different levels of brightness. 256 is 28, or 2 multiplied by itself 8 times – which is what 8-bit means. By combining these three basic colors, each pixel can display 28 x 28 x 28 different colors – over 16 million in total.

We start with a black screen, and the more color we throw on it the brighter it becomes. These are known as 'additive' colors for this reason: we're adding light to blackness. When we add the maximum value of each of the three primary colors, we get white.

Printing ink on paper, however, works in precisely the opposite way. Rather than using red, green and blue, printers use cyan, magenta and yellow. But when we print, we start off with white paper; the more colors we add, the darker the result (just as you find when you mix paints together). These are known as 'subtractive' colors. If we add 100% of cyan, magenta and yellow together, we get black. Or rather, we don't; we get a muddy brown. That's why printers use an additional color, black, to deepen the shadows and strengthen the printed image. The four colors combined give us CMYK. Surprisingly, no-one seems to know precisely what the 'K' stands for. Most claim it means 'key', although that seems a poor substitute for 'black'.

When you mix the primary colors together, either on screen or on paper, you get some surprising results. On screen, mixing red and green makes yellow, red and blue make magenta, and green and blue make cyan. Do those colors sound familiar? They should do – they're the primary colors of printing inks. And, when printing, mixing magenta and yellow produces red, magenta and cyan makes blue, and yellow and cyan makes green.

So what does this have to do with poor quality printing? The trouble is that while your monitor is capable of displaying a huge range of colors, CMYK is capable of reproducing only a very limited part of that color 'gamut', as it's known. That's the reason why commercial printers use additional Pantone colors, chosen from swatch books similar to those you'd use to choose household paints. If you want a color that can't be achieved with CMYK, you need to use additional inks.

Some inkjet printers try to get around this problem by using six colors, rather than four. And this does expand the range slightly, but the unfortunate fact remains that not everything you see on your monitor is capable of being reproduced on paper.

What's the solution, then? Can't we just convert our images to CMYK before we print them and see what the difference is? Not in Elements, we can't, although we can in its big brother, Photoshop. The ability to prepare print-ready artwork is one of the reasons Photoshop costs nearly ten times as much.

Avoid 100% green or blue, as these are the colors least likely to reproduce well; dazzling pinks are also problematic, although 100% magenta and solid red will work well. If a color combination on your monitor looks larger than life, then that's probably a good indication that you won't be able to print it. Ultimately, though, it comes down to experience: seasoned users get to know which colors will work and which won't. If in doubt, sample colors from your photographs rather than creating them from the Color Picker – you're much more likely to get printable colors that way.

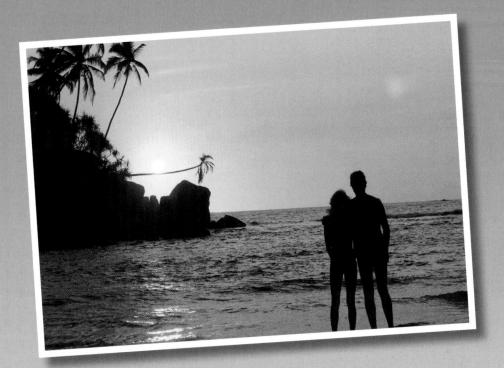

Two versions of the same vacation scene. The top one, as a Photoshop Elements file, takes up just over 4Mb of disk space. The one on the right, saved as a low quality JPEG file, takes up just 78K. Can't spot the difference? That's because Elements' innovative Save for Web feature can make huge size savings with minimal loss of quality.

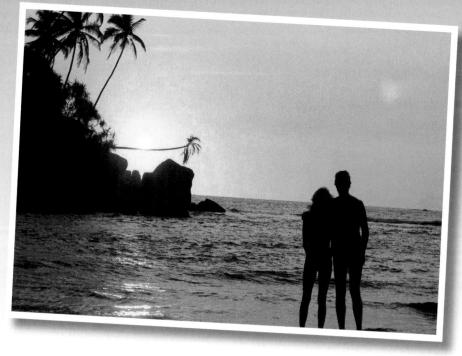

Print and the internet

CREATING FANTASTIC IMAGES in Elements is one thing. Getting them off your computer screen is another matter entirely. As with most techniques, there are right and wrong ways of doing the job.

In this chapter we'll explain how to save files for speedy internet delivery, both for single images and for animations. (We'll also look at how to create eye-catching animations directly in Elements.)

We'll also show a useful technique for making your printed results look far more like what you see on screen, without having to get your printer or monitor calibrated. And we'll walk through the processes involved in designing the cover of this book in Elements.

Saving files for the internet

E ALL WANT to share our photographs and montages with others, and the internet provides a simple, easy way to do just that. But rather than just taking your Elements file and uploading it to a website, you first need to save it in a format that web browsers will understand.

JPEG, GIF and PNG are the three most common file types. Elements provides a useful way to save images for web delivery: it's called Save for Web, and you'll find it under the File menu.

Here, we'll look at what each of the three formats has to offer, and see how to use the Save for Web dialog to get the best possible results from your digital images.

Here's a detail of our original photograph, enlarged so we can see the detail. At at 313K, it's far too big for internet delivery.

2 As a 256-color GIF image, we can see a little blockiness appearing in the white of the teeth: this image is a hefty 264K in size.

Reducing the number of colors in this GIF file to 64 reduces the file size to 168K, but we can clearly see the 'dither pattern' in the skin tones.

4 As an 8-color GIF, the file size comes down to 72K: it's now acquired the appearance of a poorly photocopied sepia print.

5 As a JPEG file with a quality of 50, this is very close to the original, but its size has been reduced to just 73K – fine for the internet.

6 Taking the JPEG quality down to 20 produces some marked 'blockiness', and reduces the file size to 38K.

7 For the sake of comparison, here's the file at a JPEG setting of 0. The image is just about unusable, but takes up just 19K of space.

A 24-bit PNG file produces the best results, but at a cost: this file is a massive 604K – nearly twice the size of the original.

The first step in Save for Web is to choose the file type. JPEG is best for photographs and GIF is best for areas with a lot of flat color, such as buttons and badges. PNG supports transparency, unlike JPEGs, and produces good quality – but at the cost of increased file size.

Unless you're creating page furniture for web pages, it's best to stick to JPEG format as this will give you the best results. There's a trade-off between file size and quality: the better the quality, the larger the file will be, so the longer it will take people to download.

A JPEG setting of 50 or more will produce an image that's almost indistinguishable from the original file. The more complex an image, the larger the file will be, so a shot of a cloudy sky will produce a much larger file if there's an intricate fence in front of it.

As you drag the Quality slider, you can see the results of the JPEG compression in the right-hand pane (the left one always shows the original image). If it's not showing an area you want to concentrate on, drag within the window to move it and both images will pan together. You can also zoom in using the Magnifying Glass tool at the top left to see an area of interest in detail.

JPEG files can be set to 'progressive', which means that they will load in stages, each pass producing a more detailed version of the image. This was an issue when most people had slow modems but is now rarely used.

Beneath each image is a readout showing the file type, the size the resulting file will be, and the time taken to download it. Click the tiny arrow at the top right of the images to change the speed of download: the default 28K applies to old-fashioned modems, which are hardly relevant in the era of high speed broadband.

You can also choose to reduce the physical image size as well, using the New Size section (center right). This will, of course, reduce the file size as

well, but you need to be sure of the dimensions you want to end up with before playing with these numbers.

If you have a favorite combination that works well for your images, you can save it as a preset and then apply it to each image that passes through the Save for Web dialog. You can also choose to include ICC profiles, which aim to maintain consistent color: unless your computer has been calibrated to do this, it's best avoided.

The Matte box is used for saving GIF and PNG images with transparency: if you want to place images on a colored background in a web page, specify that color here and the transparent pixels will be blended with it. This is necessary because GIFs and 8-bit PNG files only support one level of transparency – on or off.

When you've chosen your settings, press OK and the standard Save dialog will open. Be sure to specify a different name for your file to avoid overwriting the existing image.

HOT TIP

You may find that you have a particularly large image you want to save for internet delivery and you can't get the file size small enough - if, for example, you want to upload a large image to a site that sets a limit on file sizes. In this case, consider applying a little Gaussian Blur to the image before entering the Save for Web dialog: this will smooth out some of the fine detail and will go a long way towards making JPEG files far smaller.

Presenting your work

F YOU WANT TO SHOW OFF your creations in printed form, Elements has a powerful photo-book generation engine with customizable layouts and themes. These can be printed on your own printer or, if you reside in North America, packaged off to be professionally made through an online service and delivered to your door straight from Elements. Non-US residents can still get a bound copy, of course: the Mac has inbuilt support for creating PDF files via its print dialog. For Windows users there is a free utility called CutePDF (www.cutepdf.com) which gives the same functionality; rather than printing to paper, it creates a PDF file which can then be printed as a whole. The best way to do this is through Lulu.com. They have an excellent range of media options and will work directly from the PDF file. There may also be local print stores that you can take the file to directly on a memory stick or CD.

This is the perfect way to show prospective clients what you're capable of in a clean, professional-looking portfolio.

We can add a text caption for our image. Select the Type tool . Click to the right of the image and drag out a paragraph boundary. Use the faux page shadow as a guide for the right edge. Now we can add an image title and even a short description.

1 We've opened a batch of images and selected Create mode from the button panel on the right. The Photobook option is at the top of the list. We have various options here but we'll use the Print with local printer option to be as accommodating as possible.

4 Click Create and Elements will begin creating the layout. We start with the title page. Here we can click the frame to bring up the Open dialog or drag an already open file in. Make sure the Project Bin is visible. As we're using photos from the book, we'll insert our fairy image.

The facing page can be used for a before and after display. We've added our images and given them a slight tilt and overlap by using the rotate handles on the sides of the image bounding boxes. We can also add layer styles from the Effects panel. Here we've added a drop shadow.

2 First we'll choose our layout style. We'll use the Choose Photo Layout option, as the Random option may not suit our needs. Click Choose Photo Layout. Leave the size at 8.5"x11". We've chosen a single portrait image on the left page and a double on the right. Click Next to move on.

We'll skip the theme to keep it simple. Uncheck Fill with Project Bin Photos; we will need to select them ourselves to make sure they're in the correct places. Also deselect Include Captions. We'll make our own, but see the Hot Tip for more details. Keep the page count as it is.

Our original image has been cropped to fit the size of the frame. We'll keep the dimensions but scale it up to fill the page more. Hold all Shift Shift to scale proportionately from the center then drag one of the corner handles out. Press Enter to apply.

Move onto the next page using the control bar. We have our single image on the left page. We'll drag our wizard image here. We don't want this one cropped so right-click on the image and select Fit Frame to Photo. We've nudged it in from the edge a little to widen the border.

9 We can add to the layout, of course. Instead of a caption on this page we've dragged another image from the Project Bin and scaled it to fit. If we want to swap an image we can either drag it in over the existing one or right-click the current image and select Replace Photo.

10 Once we've added all the images we can print our book. Save the file first – this will save all the pages in a special file format. Now press Print on the Control Bar and a dialog will appear. Here we can make size and page alterations before producing the finished article.

HOT TIP

The option to include captions will take information from the image's info data which is stored as part of the file's nonimage data. This can be added and edited in the Organizer in Windows or Bridge on Mac. You can also use the File Info dialog from the File menu of the Editor. Here you will need to use the Description field to create your text. The captions will be placed beneath each photo by default but can be edited and repositioned when in the Photo Book dialog.

SHORTCUTS

MAC WIN BOTH

Animated GIFs

OVEMENT IS ONE of the characteristics that most distinguishes the internet from printed books. We can create short animations right inside Elements, using the Save for Web feature.

In this example, we've made a simple montage containing just five layers: the background, with the road and sky; the clouds; the car; the crate on the back of the car; and the shadow beneath it.

By moving each of these layers around and making a new composite copy as a separate layer, we can create our animation as a series of separate Elements layers. It's then an easy matter to string these together to make a moving image.

We can't show our finished animation in this book, of course, but it is on the CD if you want to see how it looks when it's moving.

Begin with Select All etc. A. **A. then by Merged Copy etc. Shift C. This makes a copy of everything in the artwork. Now choose Paste etc. V. ** V. and move that copy to the top of the pile, as shown in the Layers panel (right).

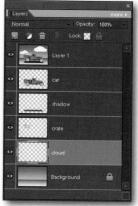

The same process once more: move the clouds and jiggle the car and the crate, then Select All, Merged Copy, and Paste. Remember to hide the previous composite copy by clicking its Eye icon in the Layers panel before you attempt to move anything. When moving the clouds, hold the horizontally.

When we get the big cloud over to the far left (frame 4 in our animation), we need to make a copy of this cloud layer and drag it over to the right, so the small cloud is just creeping in from that side. This will allow us to make the animation run for ever.

For frame 5 and for subsequent frames, we need to move both the original clouds layer and its copy. In Elements 5 and later you can select both layers together in the Layers panel, but it's just as easy to use the to merge the two layers together, so you can move them as one.

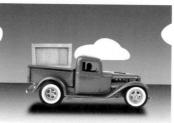

You can make as many frames as you like in your animation; we're using just six. In this final frame, the small cloud, which has been sliding in from the right, is now approaching its original position, and we can see the copy of the big cloud starting to make an appearance too. By duplicating the cloud layers in this way we're able to create an animation which appears to run seamlessly for ever.

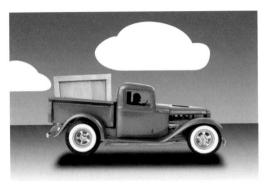

2 That's frame 1 done. To make frame 2, first hide the first merged copy, then drag the clouds layer to the left a little way. Move the car up a fraction and rotate the crate to give the impression of them jiggling around as they move.

Now repeat the Select All. Merged Copy, Paste procedure as before to create another new layer - and, once again, make sure it's at the top of the layer stack. Each of these new composite layers will form a single frame in our animation. Here's how the Layers panel will look after the second frame is complete.

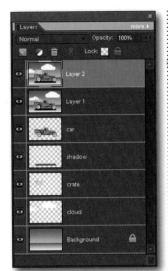

HOT TIP

Although we've gone to some lengths to wrap the background clouds around so that the animation will loop convincingly. you don't need to do this with every animation. However you choose to animate your constructions, do be sure to save a copy before deleting all the original layers: Elements can only work with one layer equaling one frame of animation, and you don't want to accidentally lose all your hard work.

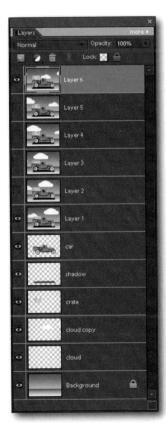

Here's how your Layers panel will look after all six frames have been completed. We now need to delete all the original layers – including the background – leaving just the six composite frames of the animation.

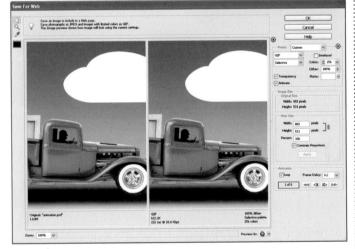

9 Now's a good time to save your document. But, rather than overwriting the original, choose Save As and give it a different name: we don't want to lose all those individual layers that we had to delete in the previous step.

Choose File > Save for Web to open the dialog, which will look exactly as it did on the previous pages. This time, though, check the Animate box near the top of the dialog window.

The number of frames in the animation is set by the number of layers in the document – one for each layer. But we can specify the time each

frame is to last for, as well as whether the animation will run just once or will loop forever. This is the option we'll choose here: that's why we wrapped the clouds around in that way.

Adjust the Dither and number of colors, if you like, to reduce the size of the file; our example weighs in at over 600K, larger than a standard web animation would normally be.

Click the Preview button at the bottom to see how your animation will look in a browser: this is the first time you'll be able to see it moving. When you're happy with the timing, press OK to save the animation as a GIF file.

Easy print matching

ITH COMPUTERS BECOMING EASIER and easier to use, it's something of an irony that the biggest stumbling block seems to occur when we revert to older technology – and that's in getting our images onto paper.

There's no real substitute for having your printer properly calibrated, perhaps investing in a monitor calibration device as well. But many of us don't have the money, the time, or the inclination to get this involved in our printing.

Instead, here's a simple workaround that may help to fool your printer into producing results that more closely match the image you see on your monitor. It's not 100% guaranteed, but the chances are it will fix a lot of print problems. Here's the problem. You've downloaded your photos to your computer and you've adjusted them in Elements so that they look their best. But when you print them out, the results look quite different to what you see on screen: the prints may be darker, they may have a strong color cast, and so on.

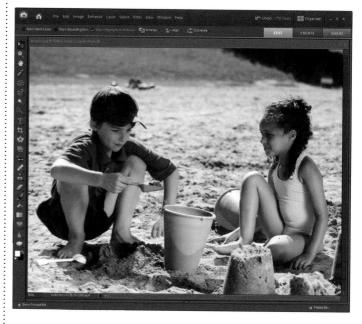

3 Back in the original file, make a new Levels Adjustment Layer. With this one, adjust the image – as seen through the first adjustment – to make your image look as close as possible to the original. By doing this, we're (hopefully) reversing the process of color change produced by the printer.

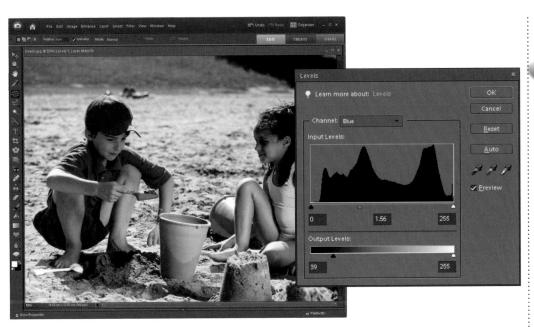

2 With the image you've just printed open in Elements, make a new Levels Adjustment Layer. Tweak the Levels settings to make the image on screen match the printout as closely as possible. What we're doing here is simulating the color shift your printer will have upon the image so we can compensate for it.

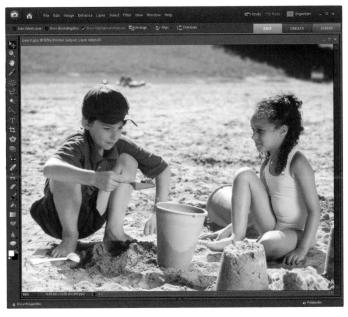

4 Now hide the original Adjustment Layer, leaving just the second. The idea is that by then printing this file, the printer will produce the same color shift it did before; and, as we saw from the original Adjustment Layer, this should produce a print that's far closer to your original photograph.

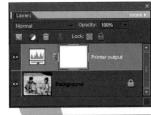

5 Save your second Adjustment Layer by dragging it into a new, empty file. When you next print, drag it into the document for improved results.

HOT TIP

You may find this technique produces too strong an effect, with a print that's skewed the other way. If so, try lowering the opacity of the Adjustment Layer until you get a result that works.

Once you're happy with the result, you can drag this second Adjustment Layer into any of your images before printing and it should help to compensate for the misdoings of your printer.

Actual size

Displaying the image on screen so that one pixel in the image exactly matches one pixel on the monitor. This is not the same as print size, which is determined by the resolution of the image.

Adjustment layer

Special layers that perform non-destructive tonal and color adjustments to all or part of the artwork; they can be turned on or off and altered as required.

Aliasing

The opposite of anti-aliasing: no attempt is made at blending elements of the artwork to avoid jagged edges. This does have its uses, for example with very small fonts to avoid them becoming unreadable.

Alignment

A set of tools on the Options bar to force multiple layers to line up with each other using edges or centers.

Alpha channel

An area used to store a layer's selection information. This can be loaded and saved whilst the document is open; some file types can store alpha channels permanently with the image information.

Anti-aliasing

The method of creating a smooth transition between contrasting colors to avoid harsh, jagged lines.

Background layer

By default, this is the base layer upon which all others are added. Most operations can be performed on this apart from moving and applying styles.

Bitmap

The method of creating an image by adding individual pixels of a specific color in a two-dimensional grid. Most images produced in Elements use this process.

Blend mode

Used to combine the content of two or more layers by blending the upper layer with the layer beneath in different ways to produce a variety of effects.

Brightness/contrast

An adjustment method used for enhancing the strength of layers and images.

Channel

The area that holds the color information of an image. In Elements there are three channels: red, green and blue, that are mixed together in varying amounts to define all the colors.

Clipping group

Hiding areas of the artwork by grouping two or more layers: the base layer acts as a mask template, its pixels defining what is visible on the layers above.

CMYK

Abbreviation for cyan, magenta, yellow and black – the colors used for reproducing images in printed materials.

Color settings

A section of Elements' preferences that sets whether images are displayed for on-screen viewing or optimized for printing.

Compression

The method of reducing image file sizes using complex algorithms. There are two types: lossless, which does not affect the quality of the image and lossy, which sacrifices some quality in favor of smaller files.

Contiguous

This is an option for tools such as the Magic Wand: when enabled, only the local area around the cursor will be affected; otherwise, instances will be selected from the entire document.

Constrain

Forces the direction of movement when using a particular tool, usually adhering to 45° angles. This is often used to ensure layers remain aligned when they are moved around the artwork.

Constrain proportions

When enabled this function maintains the dimensions when resizing an image, shape, or bounding box. When used with the Marquee tools it ensures a perfectly circular or square selection.

Cropping

Reducing the frame around an image to focus on an area of interest.

Depth of field

This is the area of an image that remains in sharp focus whilst the rest is left softer. The technique is often used to draw attention to a point of interest in a picture.

Desaturate

Removing the color information of an image leaving only grayscale tones describing the shadows, midtones, and highlights.

Dingbat

A font style that uses monotone images in place of standard letter characters. These can be anything from a simple symbol to a famous person's face. Being text, all the usual effects can be applied as you would normally.

Displacement

A method of distorting an image according to the brightness values in an associated grayscale image file.

Distribute

A method of arranging layers to produce equal spacing between their centers or edges.

Dithering

The method of making an image appear to have more colors than it actually has by creating a patterned transition with a mixture of the available colors.

Dots per inch (DPI)

A measure of the output resolution of an image. On-screen images are typically displayed at 72 or 96 dpi whilst professional quality prints are 300 dpi or sometimes more.

Feathering

The method of smoothing and blending a selection to avoid jagged edges. This differs from anti-aliasing as the edge is blurred against the destination rather than bridging using a gradient.

Filter Gallery

The dialog that lets you browse and apply individual filters or stack several filters together as layers to achieve different effects. These can be previewed prior to committing them to the image.

Gaussian Blur

A filter that uses a bellshaped curve to give the impression of soft focus.

Gaussian Noise

A filter that adds random pixels in black and white (or in color) to create the effect of tight texture.

GIF

A lossy file format used in the early days of the internet. Today, GIF images are used for creating animations, a feature not possible with most other file formats.

Graphics tablet

A device connected to the computer that allows you to control the cursor with a pen-shaped stylus instead of a mouse. Many are pressuresensitive, allowing much more accurate control of the tools.

Grayscale

An image composed of black, white and shades of gray, with no color component.

Hard Light

A blend mode in which midtone gray is invisible, leaving just the highlights and shadows on view.

Hue/saturation

An adjustment method used for changing the color of layers and images.

Interpolation

This is the method of resizing up or down by adding or removing pixels. When upsizing an algorithm works out the average between adjacent pixels and places new ones in between.

JPEG

A method of compressing images to take up less space on disk. JPEG files can have a variety of settings, offering smaller file sizes at the expense of some quality.

Layer

All images in Elements consist of at least one layer: they are equivalent to laying sheets of acetate on top of each other to build up areas of the artwork.

Layer linking

Layers can be linked together, allowing them to be moved and transformed as a single item. This is useful if you need to uniformly reposition or scale multiple sections of the artwork

Layer mask

Masks are used to selectively hide parts of the artwork by painting in shades of gray: black hides the area, white reveals it, and anything in between makes it transparent.

Layer style

These add effects to a layer without permanently affecting the artwork. Examples include drop shadows, bevels and glows. These can be combined and their attributes adjusted to suit the image.

Leading

The adjustable spacing between lines of text. The term originates from the early days of printing when lead blocks were placed to keep the type separated.

Levels

An adjustment dialog for correcting and enhancing the shadows, midtones and highlights of a photo. They can be applied to the image as a whole or to the individual color channels for finer control.

Liquify

A powerful self-contained filter with which you can distort an image as though it were oil floating on water. This is very useful for flowing, organic substances and also for retouching photos.

Magic Wand

A selection tool that finds areas of an image of a similar color to the area in which the tool is clicked. Commonly used for selecting and removing backgrounds.

Marquee

This is the outline that defines a selection. It's often called the 'marching ants' because of its continuously moving dotted line.

Merge

The Merge Down command will combine one layer with the layer directly beneath it. Merge Visible will produce a single layer from all visible layers in the artwork.

Modifier keys

The keys ctrl, shift and alt (on PC) and cmd, shift and option (on Mac) that provide additional functions when held down in conjunction with certain tools, usually serving as shortcuts for switching between a tool's modes.

Non-destructive

A term used to describe an effect which does not permanently alter the image and remains editable, even after the image is saved and reopened.

Opacity

Determines how transparent the content of a layer appears. 0% is completely invisible, 100% is solid. Adjustments of this value can be used for blending components of the artwork or for creating special effects.

Options bar

The contextual toolbar that sits across the top of the Elements window. This provides specific options and controls for the currently selected tool.

Out-of-bounds

A framing technique whereby parts of the image extend outside of the frame's boundaries; often used to emphasize the action of a photo.

Painting tools

Any tool such as the Brush, Clone tool, Smudge tool, and so on, that affects the area of an image over which it is dragged.

Palette

An area in the workspace containing sets of items such as styles, brushes or layers. These can be collapsed or hidden away when not in use.

Preset Manager

A dialog with which you can load, save and organize any brushes, gradients, color swatches and patterns you may have downloaded or created, along with the program's built-in presets.

Photoshop CS4

The 'big brother' of Elements, which offers superior controls and a range of additional features.

Pixel

A loose abbreviation of 'picture element'. The individual dots which make up a digital image; each can be one of the millions of colors available.

Pixelation

Visible degradation often caused by scaling the image to larger than its original size. Also used to describe the stepping effect caused when anti-aliasing is disabled.

Print size

A viewing mode in which an image is displayed at approximately the size it will print, using the current resolution settings.

RAM

Random access memory: the part of the computer that holds running programs and their data; for Elements this would be open images and the undo history.

Raster image

An image that is formed of individually colored dots (pixels). This is the most commonly used format for digital painting and photo editing.

Resolution

The method of describing the quality of a digital image by the number of individual pixels it contains. The higher the resolution, the more defined the areas of the picture can be.

RGB

Abbreviation for red, green, blue – the colors used by a computer monitor for displaying images.

Saturation

The depth and intensity of the colors in an image.

Scratch disk

A special area of the computer's hard drive reserved for temporary data storage when system RAM is running low.

Scrubby slider

An alternative method of increasing and decreasing the value of a particular attribute in some dialogs by positioning the cursor over the value and dragging right or left.

Shadows/Highlights

An adjustment method for recovering image data from the darkest and brightest parts of an image without affecting the midtones.

Simplify

Also referred to as rasterizing. The method of converting a shape or text layer to a regular bitmap layer; this can also be applied to layer styles to make them permanent.

Smart Fix

A simple method of automatically enhancing images that requires minimal technical knowledge on the part of the user.

sRGB

A color space devised to make graphic elements look better on computer screens. sRGB is a limited space that's best avoided for printing purposes.

Swatches

A collection of favorite colors and gradients stored in an easily selectable panel.

TIFF

A lossless image file format (see JPEG). Some digital cameras have the option of saving images in TIFF format.

Tolerance

This setting determines the precision of the associated tool. The higher the value, the larger the area of similar tones that will be affected and vice versa.

Unsharp mask

An adjustment that attempts to make the image appear crisper by enhancing the contrasting edges. The 'mask' element allows the area of the effect to be fine tuned by means of a tolerance-like setting.

Vanishing point

Used when working or drawing in perspective: these mark the position on the horizon where two or more lines converge, for example as when looking down a straight road or railway tracks.

Vector graphics

A way of creating images using interconnected points, lines and curves generated by mathematical formulae. Unlike pixel-based artwork they can be scaled to any size without losing definition.

Visibility (layer styles)

Similar to changing a layer's opacity except it only affects the pixels of the layer, leaving the style itself untouched. The three modes, Show, Hide and Ghosted, turn the pixels on and off or render them semi-transparent.

What's on the CD

Project files

This symbol indicates that you'll find an Elements file on the CD to accompany the tutorial. They're in

a folder called Tutorial Files and each one includes the starting point for each workthrough. The project files are sorted according to the chapter to which they belong and each file has a name that relates to the headline on that page.

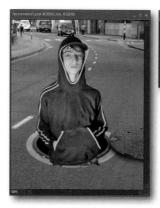

This symbol means that there's also a QuickTime movie on the CD that shows the tutorial played out in real time. Sometimes it's easier to understand a concept when you see it acted out live, rather than just by reading about it. They're in the Quicktime Movies folder. To view them, you'll need the free QuickTime player from www.apple.com/quicktime if you don't already have it installed.

Layer mask file

Unlike Photoshop, Elements doesn't support layer masks. Well, yes it does – but it can't create them. Elements can import a file containing layer masks that was created in Photoshop and then make full use of it. You'll find full instructions on how to use this file on page 52.

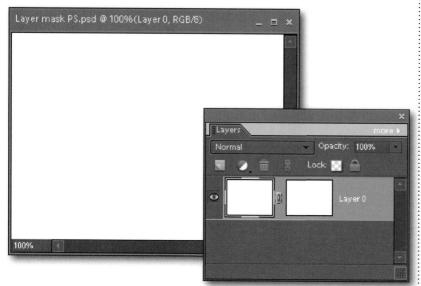

Shapes

The custom jigsaw pattern shapes, as described on page 286. We've also included a small selection of stars so you can make your own starbursts to place behind text announcements.

To use them, open the Goodies folder on the CD; there is a text file with instructions on where to place the files on your hard drive depending on which operating system you are using (Vista, XP or Mac OS X)

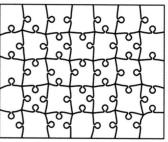

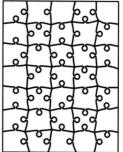

Above: Jigsaw Landscape

Left: Jigsaw Portrait

Layer styles

We've included a range of useful layer styles to complement those already present. As well as the neon text effects used in the book, we've added a range of inner shadows, some metallic styles and two new types of inner and outer glow, the difference being that their blend mode is set to Multiply, rather than the usual Screen; this can be useful for creating shadows which are centrally placed, rather than offset to one side.

Smart brushes

The Smart Brush presets for the project on page 94 can also be found here. Refer to the text file on the CD for details on how to install them for your version of operating system.

Gold paint

Silver paint

Metallic paint

Diamond paint

Neon blue

Outer glow multiply

A Clone Stamp tool 103, 177 doors, opening 282 Clouds filter 121, 155, 165, 199, 267, draw from center 6 Add Noise filter 181 280 dust 190 CMYK 290 Adjustment Layers 38, 49, 54, 301 Levels 107 collage images 44 F Solid Color 119, 183 color correction 39, 90 adjustments Color Dodge mode 161 Elements interface 20 Hue/Saturation 86, 173, 175, 179, Colorize 155 Ellipse Shape tool 146 187 Color replacement 89 Emboss 286 Levels 76, 86, 239 color, selective 92 exposure 84 Shadows and highlights 78 columns 224 eyes, opening 244 Threshold 101 compression 293 age and youth 236 F corner folds 131 align and distribute 42 Correct Camera Distortion filter 69. Andy Warhol 246 247 faces, changing 230 animated GIFs 298 correcting perspective 162 Fibers filter 173, 175 Auto Levels 155 creases 131 file formats 256 Auto Select Layer 21, 27 Create mode 294 Fill dialog 281 creating brushes 196 Auto Smart Fix 65 filling selections 19 Crop tool 64, 69, 167, 176 Film Grain filter 184 B film negative 32 curls and folds 152 curtains 172 filters background elements 56 curved surfaces 150 Add Noise 181 Background Eraser tool 96 Custom Shape tool 33, 36 Clouds 121, 155, 165, 199, 267, 280 badges 216 cutout text 222 Correct Camera Distortion 69, 247 bevel and emboss 221 Difference Clouds 135, 165, 185 Blending images 54 Diffuse Glow 179, 246 blend modes 40 Displace 157 bling 94 Darken mode 41 Fibers 173, 175 blueprints 200 day into night 118 Film Grain 184 blur 103 Define Pattern 177, 281 Find Edges 178, 280 bobbleheads 250 depth of field 104, 142 Gaussian Blur 64, 109, 143, 173, boxes 276, 278 design 224 195 brightness and contrast 76 design, elements of 224 Gaussian Noise 108 brush creation 196 Detail Smart Brush tool 93, 95 Glass 197, 198, 267 Brush tool 108 Difference Clouds filter 135, 165, 185 High Pass 81 Burn tool 108, 123, 152 Difference mode 41 Lens Flare 128 buttons 216 Diffuse Glow filter 179, 246 Lighting Effects 194 Direct Selection tool 224 Liquify 151, 160, 175, 235, 236 Displace filter 157 Motion Blur 98, 103 Dissolve mode 41, 190, 221 Noise 191 Camera RAW 82 distortion 140 Offset 176 candlelight 122 Liquify 234 Plastic Wrap 155, 189, 195, 250, caricatures 250 perspective 144 269 cars 212 distribute 42 Polar Co-ordinates 99 chrome 212 Dodge tool 123, 152, 159 Radial Blur 103, 127, 193

dogs 254

Ripple 155

clipping group 58, 225

distributing 42

duplicating 26

Shear 150, 153, 157 Smart Blur 251 Spatter 183 Spherize 159 Texturizer 59, 203, 215 Torn Edges 182 Twirl 165 Unsharp Mask 81 ZiqZaq 154 Find Edges filter 178, 280 fire 120, 122 fireworks 60 flags 156 flames 120, 123 flowers 142 Frame layers 30 frames 32 free images 204 Free Transform 115, 126, 140, 144, 151, 154, 281 fur, cutting out 254 Fuzziness 89 G Gaussian Blur filter 64, 109, 143, 173, 195 Gaussian Noise filter 108, 180 GIF 292 GIFs, animated 298 glass 270 Glass filter 197, 198, 267 gold text 219 Gradient tool 99, 172, 260, 263 graph paper 201 grid 225 Guided Edit 240 quides 44, 224 gutters 224 Н hair 237 hallway, creating 285 Hard Light mode 40, 117, 128 Hard Mix mode 40

heads, changing 228

Healing Brush 232, 236 High Pass filter 81 histogram 76 Hue/Saturation 39, 86, 164, 175, 179, 187 iconic portraiture 246 image compression 293 images, free 204 image size 226 image templates 66 inkjet printers 291, 300 Inner Bevel 59 Inner Shadows 223 internet, saving files for 292 jars 271 jigsaws 286 JPEG 256, 292 JPEG 2000 256 laptops 144 Lasso tool 8 layer masks 48, 50, 52, 55, 65, 239 layer modes Color Dodge 161 Dissolve 190, 221

laptops 144 Lasso tool 8 layer masks 48, 50, 52, 55, 65, 23 layer modes Color Dodge 161 Dissolve 190, 221 Hard Light 117 Multiply 221 Screen 61, 200 Soft Light 80 layers 2, 30 adjustment 38, 49, 54 align and distribute 42 Auto Select 27 background 25 basics 24

blend modes 40

deleting 25

clipping groups 58

constraining movement 27

Frame 30 Hard Light 128 hiding & showing 24 importing 28 mask 52 masks 48, 50, 55 opacity 125 ordering 24 shape 37 Simplify 209 Smart Objects 30 styles 34, 37 transparency 25 layers, importing 28 Layers panel 2 layer styles 34, 36, 208 carving 209 chrome 212 Inner Bevel 59 neon 210 Wow Chrome 199 lavout 224 leaves 154 Lens Flare filter 128 Levels 76, 86, 239 Levels Adjustment Layer 107 lids, creating 278 lids, removing 276 Lighting Effects filter 194 lighting, stage 124 lightning 134 Line tool 225 liquid, simulating 268 Liquify filter 151, 160, 175, 235, 236 Luminosity mode 41

M

magical vortex 164
Magic Extractor tool 16
Magic Selection Brush 14
Magic Wand tool 8
Magnetic Lasso tool 10
magnifying glass 158
Make Selection 147

maps 153 Photo Layout 295 S marbling 280 Photomerge 69, 84, 230, 240 Marquee tool 6 photorealism 272 sand, writing in 220 memory 46 photos Save for Web 293, 299 metallic effect 95 ageing 186 scaling 140 models 104 tearing 188 Scene Cleaner 242 molasses 268 Photoshop 168 Scene, cleaning up 242 montages 56 Place command 67 Scotch tape 188 Motion Blur filter 98, 103 Plastic Wrap filter 155, 189, 195, 250, scratch disks 47 Multiply mode 40, 221 269 Screen mode 40, 61, 200 PNG 256, 292 seamless 176 N Polar Co-ordinates filter 99 season shifting 90 Polaroid-style photos 58 Selection Brush tool 8 Natural Tone 92 Polygonal Lasso tool 9, 57 selections 6 night, creating 118 pop art 246 circular 18 Noise filter 191, 221 portfolios 294 draw from center 6 notepaper 180 portraits 246 elliptical 6 posters 130 expand 191 printing 300 feathered 19 Project Bin 29, 241 filling 19 Offset filter 176 pumpkins 214 Lasso 8 old paper 184 loading up 18 opacity 114, 125 Magic Extractor 16 Options bar 21 Magic Selection 14 origin 225 Quick Selection tool 12, 66 Magic Wand 8 out of bounds 288 Magnetic Lasso 10 Overlay mode 41 R modifier keys 6 modifying 18 Radial Blur filter 103, 127, 193 Paste into selection 148 rain 99 Quick Selection tool 12 paintings 288 rainbows, making 98 rectangular 6 panoramas 68 RAW adjustment 82 Save Selection 101 paper Recompose tool 166 saving 101 old 184 Refine Edge 12, 93 Selection Brush 8 parchment 184 reflections tricky 146 ruled 180 complex 262 selective color 92 tearing 182 in window 264 setting up 20 paragraphs 225 simple 260 shadows 53, 78, 114 parchment 184 Replace Color tool 88, 91 on ground 114 Paste into selection 148 **RGB 290** on walls 114 patterns 176 Ripple filter 155 soft, painting 116 pdf 257, 294 ripples 154 Shadows and highlights 78 people, adding 238 rotation 140 shadows, reflected 261 people, removing 240 rubber stamp effect 196 Shape Selection tool 32 perspective 144, 162, 265, 277, 280, rulers 225 Shapes tool 32, 285, 286

sharpening 80

Shear filter 150, 153, 157

282, 284

photo-books 294

Show Highlight on Rollover 21 silhouettes 106 sketch drawing 202 skies 96 slime 268 Smart Blur filter 251 Smart Brush 92, 94 Smart Objects 30 smoke 160 Smudge tool 52, 121, 254 snow 108 soft focus 246 Soft Light mode 41, 80, 185 Solid Color Adjustment Layer 119, 183 Spatter brush 255 Spatter filter 183 speed 102 Spherize filter 159 Spot Healing Brush 232, 237 spotlights 124 stained glass 126, 198 stitching 68 stone carving 208 storm, creating a 134 Stroke 181, 198, 220

templates 66

text
chrome 212
neon 210
stone carving 208
Warp 216
textures
blueprint 200
crumpled paper 186
curtains 172
dust 190
notepaper 180
old paper 184
satin 178
stained glass 198
wax 194

wood grain 174

Text Warp 216

Texturizer filter 59, 203, 215

Tiff 256 tiled floors 280 tiles 29 tilt-shift 104 Toolbox 3 tools Background Eraser 96 Brush 108 Burn 108, 123, 152 Clone Stamp 103, 177 Crop 64, 69, 167, 176 Custom Shape 33, 36 Detail Smart Brush 93, 95 Direct Selection 224 Dodge 123, 152, 159 Free Transform 115, 126, 140, 151, 154 Gaussian Blur 109 Gradient 99, 172, 260, 263 Healing Brush 232, 236 Lasso 8 Line 225 Magic Extractor 16 Magic Selection 14 Magic Wand 8 Magnetic Lasso 10 Marquee 6 Polygonal Lasso 9, 57 Quick Selection 12 Recompose 166 Replace Color 88 Selection Brush 8 Shape 32, 146 Shapes 285, 286 Shape Selection 32 Smart Brush 92, 94 Smudge 52, 121, 254 Spatter Brush 255 Spot Healing Brush 232, 237 Type 217 tool tolerance 8 Torn Edges filter 182 transparency 25

Twirl filter 165

Type tool 217

three-dimensional text 218

U

Unsharp Mask filter 81 upgrading 46

V

vanishing point 284 vector shapes 32 Vibrance 85 vinyl record 192

W

Warhol, Andy 246
watermark 36
wax 194
weight loss 234
windows 78, 264
wizards 162, 164
wood grain 174
work, protecting 36
Wow Chrome 199, 213
wrinkles 131

Z

ZigZag filter 154